In spite of the increased popularity of travel in recent years, most people—aside from the inhabitants of a few great cities—are largely dependent, for their opportunities of seeing major works of art, upon touring exhibitions. These exhibitions have become, more especially since World War II, such immensely important features of our cultural life that people are inclined to regard them as permanent features. So indeed they may prove, but I think there are compelling reasons for doubt. The number of masterpieces, even the number of works of high importance, is not unlimited, and private owners are growing tired of being continually deprived of their most prized possessions, and public owners of the dislocation involved in the making of continuous loans. Moreover, both private and public owners are increasingly aware that, in spite of the excellence of modern packing and transport facilities, their possessions are exposed to the risk of steady deterioration owing to changes of temperature, movement, and the like— to say nothing of the risk of accident in continuous travel and handling.

The splendid, continuous series of touring exhibitions, generally regarded as terrestrial equivalents of the stars in their orbits, will, I believe, someday be looked back upon as extraordinary phenomena. Of course there will be exhibitions so long as an art trade exists, and so long as nations seek to project abroad their culture and their way of life in terms of their artists' work. But the great retrospective displays of the art of a nation, a movement, a great master, or the treasures of a royal house are likely, I believe, to become much less frequent than they have been during the first two-thirds of the twentieth century.

As there is no sign of any more serious consequence than local or temporary satiation, it is reasonable to assume that the public appetite for art will continue, and indeed to expect that it will increase. And yet public art collections, in spite of their phenomenal multiplication during the past hundred years, are still, for reasons partly of geography and partly of time, difficult of frequent access for very large numbers of people. It is therefore likely that the principal means of satisfying this appetite will become, to an even greater degree than it is at present, the color reproduction—the color reproduction rather than the black-and-white partly because it resembles the original (and even at the worst produces an illusion of resemblance), and partly because of a growing delight in color for its own sake, itself a compensation, perhaps, for the drabness of industrial civilization.

VAN EYCK

1370/90 – 1441

In Jan van Eyck's painting the spiritual and the temporal meet in the still medieval atmosphere of fifteenth-century Flanders. The man himself was actively in touch with both worlds — a solitary conscience involved with the symbolism of medieval religion, a man of the world involved with international diplomacy. Van Eyck served in the government of Philip, Duke of Burgundy. He helped negotiate the marriage of Philip to the daughter of the King of Portugal — and at the same time painted a portrait of the princess. His work reflects the three-dimensional vision of one who is simultaneously a believer and a realist.

The *Madonna of the Canon van der Paele* is complex and dazzling proof of Van Eyck's gifts. Its qualities of light, color and surface were unknown at the time, for the master of Bruges pioneered the use of oil paint, experimenting with the manipulation of opaque and transparent pigments, and making of the new medium a new art.

Van Eyck has been credited with the "discovery of the visible world" in painting, a claim based upon his poetic rendering of the concrete fact. And yet his ultimate greatness lies rather in his discovery and articulation of an invisible world, implied in his work and distinctly felt, but difficult to analyze.

FRA ANGELICO

1387 – 1455

The work of Giovanni da Fiesole Guido di Pietro, known as Fra Angelico, blended two intellectual impulses within a unique and lyric vision. One was the beatific instinct of a devout monk. The other was the instinct of an acute fifteenth-century Renaissance painter to amplify and expand his visual means. When Michelangelo saw Fra Angelico's work, he said, "Surely this good monk has visited Paradise" — a tribute to both facets of the painter's genius.

Fra Angelico was commissioned to execute frescoes — among them is the famous *Annunciation* — for the Convent of San Marco in Florence and a painting for each of the monks' chambers. In his paintings, he was above all a colorist. He developed his haunting, often medieval, compositions with incisive reds and blues and yellows, sometimes sweet, but always registering harmonies and unforgettable chords of color. The frescoes, no less alive and sensitive in line and volume, tend to be far more muted in color, as in *The Annunciation*. The work has an austere and formal presence that is highly medieval, but it also has an intimate warmth and conscious humanity that reflect mid-fifteenth-century perspectives. Fra Angelico adapted many of the humanistic techniques of his age to conjure up the forms of a spiritual world no less real to his imagination.

The Annunciation

N.D., FRESCO, 100⅞ X 132 INCHES
MUSEO DI SAN MARCO, FLORENCE

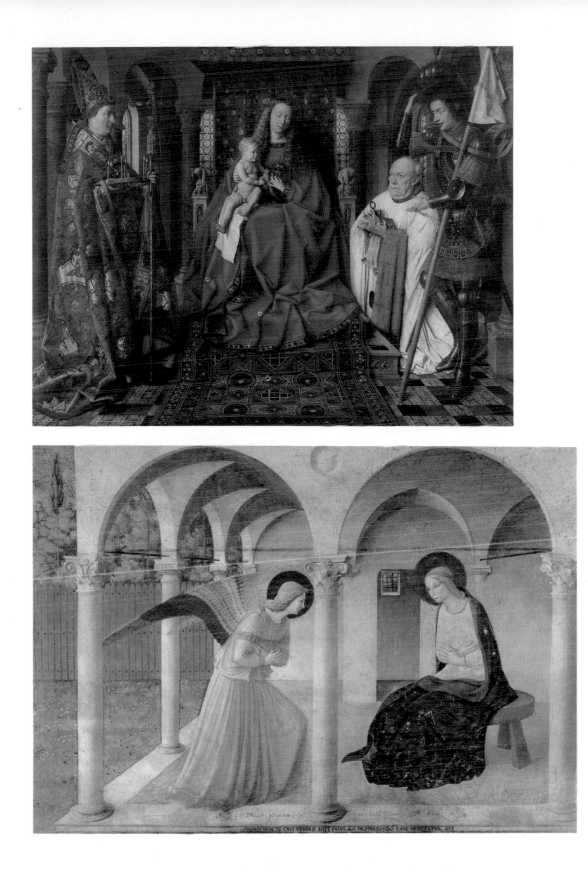

SASSETTA

1392–1450

Temperamentally, the Sienese master, Sassetta, ranks among the great innocents of painting. His work, while large of spirit, is intimate and refined—and although he worked in the fifteenth century, he remained faithful to the spirit of medieval painting.

Sassetta's contact with the developments of his own day cannot have been too limited. Historians like to point out that in his *Last Supper*, the fragment of a larger work now preserved in the Pinacoteca at Siena, he utilized architectural elements —not at all Gothic—which imply an acquaintance with the Renaissance architecture of Brunelleschi. Aesthetically, however, Sassetta chose to develop the formal purities and spiritual dignity of the preceding centuries. As a Sienese he inherited the penchant for rich, warm color that especially characterizes the vision of a city which remains largely medieval, even to this day. And some scholars feel the direct influence of early Flemish miniature painting as well. Sassetta absorbed these influences and produced a harmonious vision that is his alone—lyric, liquid, stately. The *Journey of the Magi*, a comparatively early work, is a glowing gem of color that introduces the entirely sympathetic power of Sassetta's gentle expression.

Born Stefano di Giovanni di Consolo, he came early to Siena and soon enrolled in the city's guild of painters. With other painters, he worked in the great cathedral, and there can be no doubt that the crystalline splendor of "Sienese Gothic" had a great impact upon him. By 1444, he had finished a great multipartite altarpiece for the church of San Francesco at Borgo Sansepolcro. Its panels have since been dispersed to collections, public and private, throughout the world and now constitute the main source of Sassetta's renown. It was not, in fact, until the twentieth century that the world rediscovered Sassetta, who had long been ignored in favor of the more historically evolutionary painters. Indeed, in his own time, Sassetta's great talents did not save him from poverty. He died leaving his family without means.

Journey of the Magi

circa 1430
TEMPERA ON WOOD, 8½ x 11⅝ INCHES
THE METROPOLITAN MUSEUM OF ART, NEW YORK

GREAT PAINTINGS OF ALL TIME

100 Masterpieces from the

Early Renaissance to

Abstract Expressionism

INTRODUCTION BY SIR JOHN ROTHENSTEIN

COMMENTARIES BY PAUL WALDO SCHWARTZ

SIMON AND SCHUSTER · NEW YORK

7475

The Publishers of *Great Paintings of All Time* have made
every effort to trace the ownership of the paintings re-
produced in this book and to make full acknowledgment
for their use. If any errors remain, we shall be happy to
correct them in subsequent editions.

INCLUDING THE RIGHT OF REPRODUCTION

IN WHOLE OR IN PART IN ANY FORM

COPYRIGHT © 1965 BY SIMON AND SCHUSTER, INC.

PUBLISHED BY SIMON AND SCHUSTER, INC.

ROCKEFELLER CENTER, 630 FIFTH AVENUE, NEW YORK, NEW YORK 10020

FIRST PRINTING

TYPE DESIGN: HELEN BARROW

LIBRARY OF CONGRESS CATALOG CARD NUMBER: 65-27472

MANUFACTURED IN THE UNITED STATES OF AMERICA

Contents

CONTENTS

CONTENTS

CONTENTS

CONTENTS

Introduction

Sir John Rothenstein

CHANGE AND REVOLUTION *wear a less radical aspect for posterity than they do for contemporaries. Who, reading history, has not sometimes wondered at men's willingness to provoke cataclysm, to go into exile, to suffer imprisonment and death for causes that no longer appear vital? Our own posterity may regard the series of changes and revolutions that have transformed the arts during the past century as less radical than they seem to us. But we, however earnestly we peer down the darkening corridors of the past, can discern no epoch of such total transformation as our own.*

It will be my purpose in these pages to offer a few reflections—not on this transformation itself, but on another intimately related to it and no less radical: the relation of the spectator to the arts, and the significant part played by photography, especially in its most influential and pervasive form—books of reproductions.

Only during quite recent times have works of art come to be regarded almost exclusively as works of art. In earlier times they served human purposes: religious, patriotic, decorative, status-enhancing, imitative, anecdotal, and others, or a combination of these.

Everywhere today—except where authoritarian governments decree otherwise—painting and sculpture have come to be pursued as autonomous activities, performed for their own sake and existing in their own right. The spectator, too, as he turns the pages of a book comprising reproductions of works of art isolated from their environment, sees them not as serving a religious or a social function, but solely in aesthetic terms.

The art lover of today takes very much as a matter of course the accessibility—through reproductions—of works of art of every conceivable kind. Yet this accessibility (together, of course, with the accessibility of the large majority of the world's masterpieces in public collections) represents a state of affairs unique in the history of mankind—a state of affairs scarcely imaginable even at the beginning of the last century. There are very few public museums two centuries old; most are of far more recent foundation. Masterpieces were once largely in private collections, mostly difficult of access; many were in churches and other public buildings situated in remote towns or even villages, and placed where they were difficult to see. And no less discouraging to the study and enjoyment of works of art was the virtual absence of reproductions. A number of colored mezzotints after well-known paintings were made in the eighteenth century, but these represented a tiny minority and afforded little indication of the colors of the originals. Even travelers with the means and influence to enter private collections would have found it difficult to compare, say, an example of a given painter's work in a Roman palace to another in a house in Norfolk; almost invariably, they would have had to depend on hasty sketches or unreliable memory.

There is an illuminating book to be written on how much (or how little) evidence earlier writers on painting—even those we admire most—depended on in forming their

ideas. We should be astonished, I believe, at the smallness of its extent. Baudelaire, for example, never saw a major work by Michelangelo or Masaccio—indeed he never visited Italy. Some great critics visited Italy only as children, others not until middle age; only a very few (not even the relatively widely traveled Ruskin) had been to Spain.

Today the position has been transformed, owing to the facts that the large majority of the world's masterpieces have passed into public possession, and are accessible in a vast number of art museums throughout the Western world; that travel has become rapid and easy, and hence popular; and that photography has enabled a nearly infinite number of works of art to be reproduced. Private collections, of far less relative importance than formerly, are also far easier of access, especially for scholars. And so, today any student, in fact anyone at all, has access to almost the whole world of art: if not yet to every original, at least to a reproduction closely comparable to it.

The world of art itself, meanwhile, has undergone a thousandfold expansion. Not so long ago "art" was thought of mainly as the legacy of Greece and Rome and the embodiment of this legacy in a living tradition flowing down to us in revived form through the Renaissance; even the art of the Middle Ages was looked on as something of an aberration, if a noble one—the product of an interlude of barbarism. The arts of Asia and Africa, and of pre-Columbian Central and South America, were regarded as peripheral, and often dismissed as "primitive." Certain of them, Chinese art for example, exercised an ephemeral influence on the West, but all non-European art, and even such European art—folk art and the like—as was not produced for the educated, was likewise dismissed as not being, in the strict sense, art at all. Many of these arts admittedly attracted curiosity and study and the attention of a few collectors, but they impressed ordinary educated taste as "lesser breeds without the law," as oddities, as the products of activities dissimilar in kind from those, for example, of Raphael or Guercino.

During the nineteenth century the canon was widely extended. Napoleon's invasion of Egypt prepared the way for the study of Egyptian art; Sir Austen Henry Layard stirred the popular imagination with his archaeological discoveries in the Holy Land and with the great Assyrian reliefs he brought to London, and the arts of China and the Islamic world—and later on of India—began to engage the serious attention of scholars and collectors.

The field of enjoyment and study is today indeed so wide that it can be said without exaggeration that it is almost as wide as the world. And it includes the art of children, of the insane, and even of animals. So quickly do people take their advantages for granted that it is scarcely realized that our ready access to the art of the whole world is without precedent. By visiting a public library every day for a week anybody may become acquainted with a range and diversity of art that Diderot, Winckelmann, Baudelaire, the De Goncourts, or even Ruskin (who died only sixty-four years ago) could scarcely have conceived.

Of the several agents behind this change, the most influential is probably the invention and development of photography. In spite of the rapid multiplication of public art collections, there are still large areas where there are none; in Asia and Africa they

are a very rare phenomenon indeed. If people in such underprivileged areas had to rely for their knowledge of works of art solely on visits to public collections, their opportunities for contact with the visual arts would in general be extremely restricted. But thanks to photography their situation, although unsatisfactory, is very far from hopeless, for photography can project the visual arts on a vast scale. Those for whom access to originals is difficult or impossible are still, of course, at a serious disadvantage, for reproductions are not substitutes for originals: their value lies in preparing the spectator for his encounters with the originals and, what is still more useful, in enabling him to preserve and refresh his memory of them.

No reproductions are quite perfect—not even facsimiles of drawings or water colors, almost miraculous as these occasionally are—and perhaps it is as well that an element of imperfection should remain, to remind us that what we are looking at is, after all, not the original work, but a mechanical replica, devised to deepen and prolong our response to the work of the artist's hand. No technical advance can, in fact, eliminate imperfections, because the radical problem of color reproduction is, in the last analysis, not a technical one at all. A color reproduction is not a copy so much as a translation. The greater the reduction in scale from original to reproduction, for instance, the greater the element of translation, for the necessary reduction in the intensity of tone—necessary, I mean, to fidelity—is not a technical matter but a matter of human judgment. How bright, for instance, should be the colors of such big paintings as Raphael's Stanze reproduced on the scale of postcards? If the reduction of intensity were commensurate with the reduction in scale, virtually all the color would be eliminated. In order to preserve some semblance of it, a more or less arbitrary equivalent must be found by trial and error.

Translations are not originals, but there is no reason for despair if they are not; for although, as the Italians put it, "every translator is a traitor," this only means that one cannot substitute translations for originals—it does not mean that translations cannot be very good indeed. In any case, translations are indispensable. Certainly no one, layman or scholar, now dispenses with them.

It would indeed be hard to exaggerate the influence of the color reproduction, not only on our vision of the art of the past, but on the practice of the artists of our own day as well. It has completed the process that the art museum had begun: namely, because the work of art has been isolated from its original environment, we are persuaded to forget its significance as an object and the religious or social function it was made to serve, and to regard it simply as art, *in fact as an exhibit. According to André Malraux's concept of the Museum without Walls, "picture, fresco, miniature and stained-glass window . . . have all become 'colour-plates'." Sir Kenneth Clark, in his book* Landscape into Art, *pertinently remarks: "Museum art, therefore, in the sense in which I am using it, implies the existence of the pure aesthetic sensation. It implies that the value of art depends on a mysterious essence or elixir which can be isolated, almost tapped off from the body or husk of the work—and this elixir alone is worthy of pursuit."*

It is natural, then, that the color plate is on its way to becoming the medium on

*which the painter increasingly relies to make his work's impact—or "aesthetic shock"—
on the public, and even to enable it to survive. Artists are already disposed to emphasize
those qualities that can be effectively brought out by photography, and to avoid com-
plexities—required by inner necessity—that cannot. It is much more difficult—confining
ourselves to long-established reputations—to reproduce the work of "painterly" paint-
ers, such as Titian or Cézanne, than that of artists who are essentially draftsmen, such
as Picasso. When a painter is working among all the facilities of color reproduction, the
temptation is obviously very great indeed to use such reproducible color-draftsmanship
and a similarly reproducible dominance of the primary colors.*

*A heavy responsibility thus rests upon the makers and publishers of color repro-
ductions. Technical imperfections are being overcome, but fears have been expressed
by respected authorities at the coarsening of perception resulting from the proliferation
of distorting reproductions.*

*While far from insensitive to the harm likely to result from such reproductions, I
am inclined to believe that the very scale on which these are being disseminated offers
ample compensation. For even a coarse color reproduction may well stir a response in
people who might otherwise remain ignorant or indifferent; if they happen to be peo-
ple of perception, they are likely to become aware of the defects of the reproduction
when they encounter a better one, and much more so if they are impelled by the repro-
duction to seek out the original. In the same way, translations may correct one another
and effect better approximation to their common original. In short, I think that, in view
of the steady improvement in the level of color reproduction and the wide accessibility
of originals, the field is one in which the bad is being, however gradually, driven out by
the good.*

*One of the inevitable effects of progress is the creation of new, and generally un-
foreseen, problems. The sudden accessibility of great numbers of works of art, master-
pieces as well as other works beyond counting, and the projection of a multitude of
them by reproductions, is proving no exception. The art lovers among our ancestors
were frustrated by the difficulty of seeing more than a relatively few works of art and
of preserving any effective memory of what they had seen. Today, instead of being
starved, the art-loving public at times shows symptoms of satiation. What is more seri-
ous, young artists are often confused by the multiplicity of possible models, and their
discovery of the means of giving form to their own particular vision of things is delayed.
Moreover, for many painters the color reproduction is now the final product, and the
original no more than the preliminary study—the equivalent of the drawing or water
color of an earlier age made specially to be engraved. The temptations to assume this
attitude are great: there can be no reasonable doubt that the popularity with the general
public of both Picasso and Van Gogh, for instance, has been vastly enhanced by the
suitability of much of their work for reproduction in color. This was brought home to
me by direct experience: of the long succession of one-man retrospective exhibitions
held at the Tate Gallery during my directorship, by far the most popular were those
devoted to the work of these two masters. In the case of Van Gogh (whose work had*

previously been comparatively rarely seen in London) it was manifest, from the moment of admission, how effectively the public had been prepared by color reproductions to admire what it had come to see.

None would dispute, I think, that for the reasons I have given and for others as well, the habit of color reproduction exposes both artist and public to certain risks. The important question is whether, on balance, it affects creator and spectator for good or ill. Many eminent scholars consider its effects baleful. With respect, I believe their misgivings excessive and their disregard of its benefits difficult to understand.

Access to the art of the past and to that of contemporaries, although it may well confuse the weak-headed artist, saves his stronger brother time in finding the examples best suited to clarify his own ideas and gives him the confidence to express what is most personal in himself; a wide knowledge of what has been done and what is being done by other artists is likely to foster in him a sense of proportion and to diminish conceit. Artists—even realists—are rather more affected by other works of art than is generally supposed, and rather less by their subjects. To have available the widest possible range of examples is quite simply, therefore, to have at hand the means of education. Even most Sunday painters, I suspect, have wider knowledge of the work of other painters than their own work might suggest. I am not forgetting the fear, prevalent among artists and critics today, that the imagination and the creative faculties tend to be inhibited by knowledge. This fear—deriving from the Romantic movement—may well be regarded by our posterity as unjustified at least as far as major talents are concerned. But justified or not, it is no longer possible for artists to preserve a genuine innocence of knowledge (although pretended innocence is not uncommon). What forbids genuine ignorance is, of course, the reproduction, in particular the color reproduction (for there is much painting, especially that being done today, whose reproduction in black and white would empty it of meaning).

Nothing more forcibly demonstrates the power of the color reproduction than the influence it exerts on the far side of the Iron Curtain. Abstract art, not being didactic, can have no part to play in revolutionary education or propaganda and is therefore severely discouraged in the Soviet Union as an expression of antisocial individualism. (In the satellite countries official discouragement is rather less positive, and proximity to the West involves infection.) But even in Russia I for one—and my experience is far from unique—found painters extremely well informed about what their Western avant-garde contemporaries were doing, and even impatient of modes of expression which had only recently ceased being the foci of interest. If the influence of reproductions is so pervasive in the most adverse conditions, it is easy to appreciate how dominant a role it has elsewhere.

It is a role which is likely to increase, and not only because the improvement in the fidelity of color reproductions is likely to make them more desirable in themselves and to allay the criticism of influential scholars. There is another factor, more important although as yet scarcely apparent: namely, the slowly but steadily stiffening resistance on the part of collectors to lend their works of art for exhibition.

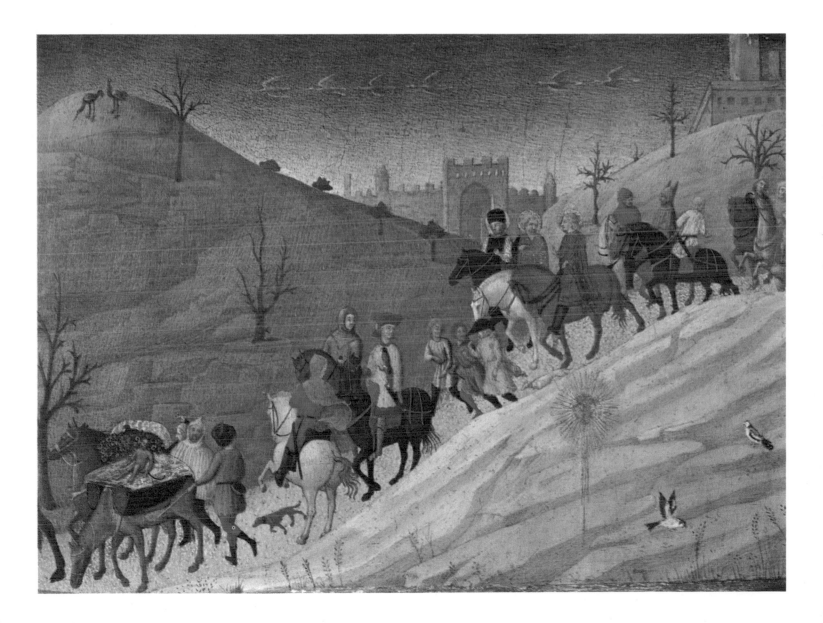

PISANELLO

circa 1395 – 1455

The deft and elegant Antonio Pisano, known as Pisanello, produced some of the most gracious and sympathetic works of the Italian Renaissance. At heart, Pisanello was a lyricist. He loved the felicities of subtle color and he took delight in fashioning gardens of rich pattern, even in as intimate and simple a work as the *Portrait of a Princess of the D'Este Family*.

Unfortunately, the bulk of Pisanello's painting is lost, though a good representation of drawings helps to complete the now fragmented evidence of his career. He was noted in his own time as a portrait painter and traveled to the courts of Milan, Mantua, Rimini and Naples to fulfill commissions. These portraits with their august formality and almost heraldic economy are heir to an elaborate Gothic impulse that dominated Europe just as the Middle Ages began to eclipse. And yet, they possess qualities that belong to the activity of a renascent Europe. The powerful sense of characterization which is so strong in the profile of the Este princess marks the human concerns of the Renaissance thinker. And while the treatment of the background is a flat tapestry of color, it also teems with acute detail in which a butterfly in flight and a flower in bloom become objects of inquiry and delight.

Early in his career, Pisanello worked under Gentile da Fabriano on decorations for the Doges' Palace in Venice, works now lost. The experience proved crucial for the young painter. Gentile's sense of decorative lyricism profoundly influenced him, and Pisanello was later called upon to complete the master's unfinished frescoes in the church of St. John Lateran.

Pisanello's chief work, a great fresco known as *Saint George Rescuing the Princess of Trebizond*, still exists in its place at Verona. The dulcet elegance of the portraits is present in the fresco but on a more expansive scale. There, the artist was able to give rein to a sense of fantasy in which the medieval image of knights and steeds becomes a complex composition of human observations and imaginative insights.

Portrait of a Princess of the D'Este Family
circa 1441 – 1443
TEMPERA ON WOOD PANEL, 16⅞ x 11¾ INCHES
LOUVRE, PARIS

[20]

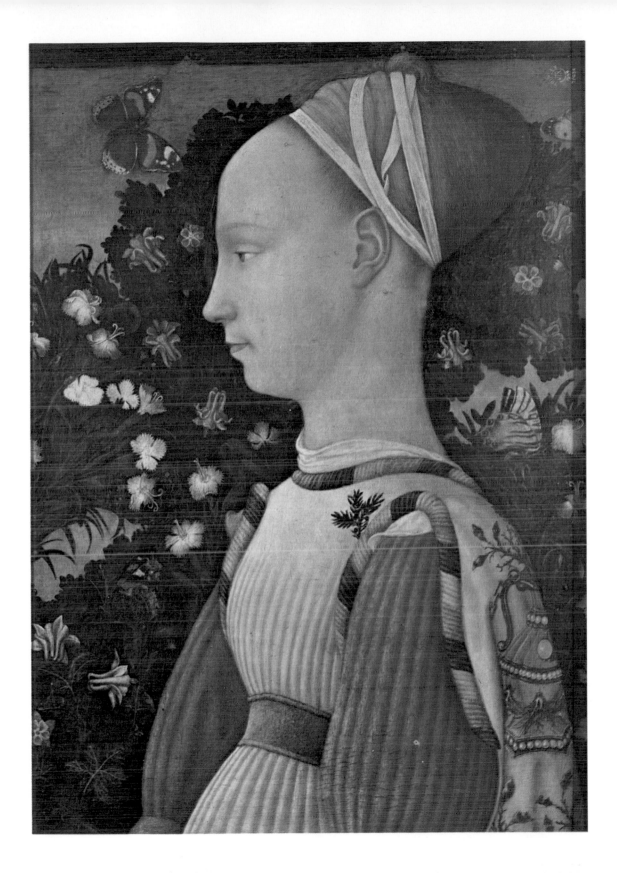

LOCHNER

circa 1400 – *circa* 1451

Stephan Lochner was a German contemporary of Fra Angelico's and a painter who remarkably paralleled the lyrical innocence of the great Florentine (p. 16). Whether any direct contact ever existed between the two men in their work is a problem beyond documentation, for the facts of Lochner's existence have been almost entirely effaced by time. Even the dates of his birth and death are lost. In fact, only about seventy years after the time Lochner must have died, the councilors of his native Cologne showed his work to Albrecht Dürer and were unable to add any real information. Dürer left believing that Lochner had come to Cologne from Meersburg on Lake Constance and that he died in a poorhouse. And except for that lamentable testimony, no clues have come forth.

The *Madonna of the Rose Arbor* survives as Lochner's best-known work. Its symmetry and formality are more strictly medieval than were the compositions of Fra Angelico, but the soft, decorative patterning and sweet color move away from the austerity and tension of the medieval vision. Surely Lochner had seen and studied Italian painting, for, along with Fra Angelico, the works of Simone Martini and Pietro Lorenzetti immediately come to mind as possible inspirations.

Except for an example in the National Gallery, London, all of Lochner's known major works remain in Germany, and for the most part in Cologne.

Madonna of the Rose Arbor

N.D.
OIL ON WOOD, 20 X 15¾ INCHES
WALLRAF-RICHARTZ MUSEUM, COLOGNE

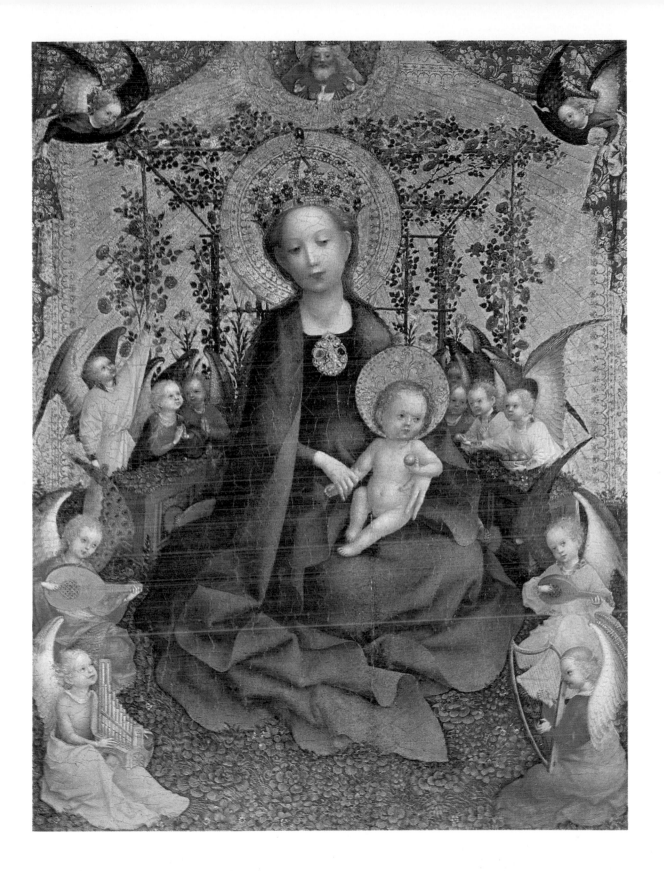

FRA FILIPPO LIPPI

circa 1406–1469

Fra Filippo Lippi was a young contemporary of Fra Angelico, a disciple of the elder master and, like him, a great colorist and son of the church. Yet circumstance and temperament created major divergences between the two Florentines. Lippi's style, less poetically pure and whole than Angelico's, is alive with inquiry, invention and a searching energy. Lippi's aesthetic intelligence was able to blend a wide range of influences, as in the *Adoration of the Child*. He involved himself with a concern for perspective and modeling in the round that came from Masaccio and Masolino. His personages are highly humanized and very much in tune with the front ranks of Italian Renaissance thought at mid-century. Yet his color, especially in the great frescoes, has a transcendent, medieval purity. And his line, as in the robes of the Madonna in the *Adoration*, is distinctly Gothic.

Lippi's talents won him the patronage and protection of Cosimo di Medici as a special favorite of the Florentine court. Indeed, he needed ducal assistance more than most of his contemporaries. Despite his being a member of a Carmelite order since the age of fifteen—having been orphaned—Lippi's tastes and habits were less beatific than his work. He reneged on church contracts to accept private commissions—and was sued for breach of contract. During the 1450's, while at work on the great San Stefano frescoes for the Cathedral of Prato, he was appointed chaplain to the Convent of Santa Margherita and there became involved with a nun, Lucrezia Buti. They had two children—one a daughter, the other a son, the painter Filippino Lippi. The Medici faithfully defended their wayward protégé and Pope Pius II even gave the lovers a special dispensation to marry—an option Fra Filippo chose to decline. At the death of the painter, the grateful Lorenzo the Magnificent, grandson of Cosimo, had a tomb erected to Lippi's memory.

Adoration of the Child

before 1435
TEMPERA ON WOOD, 50 x 45⅝ INCHES
STAATLICHE MUSEUM, BERLIN

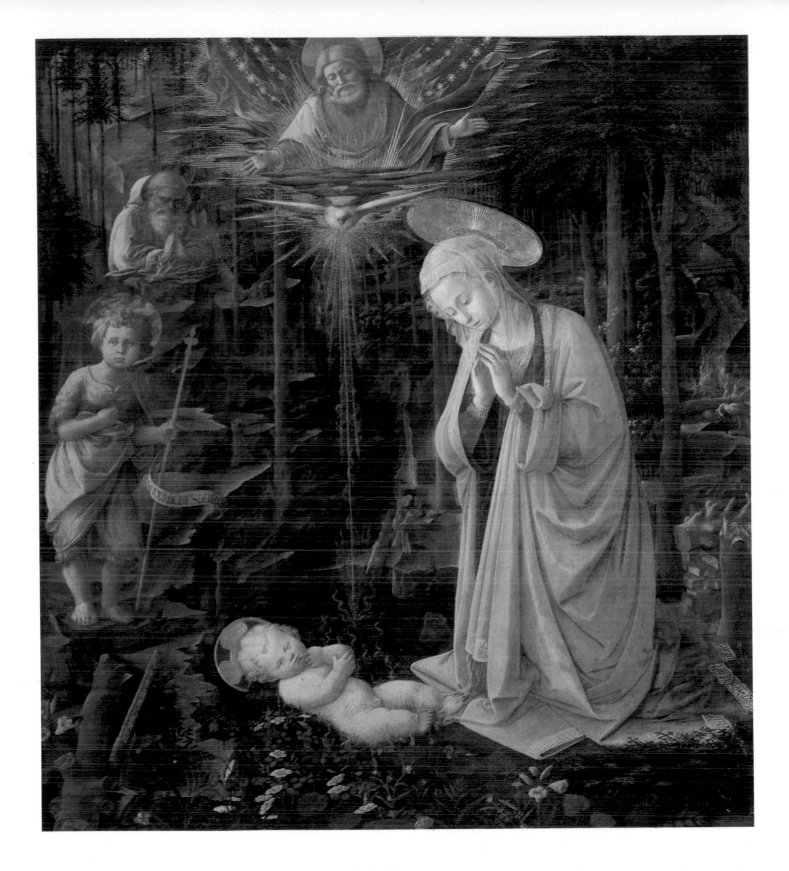

VAN DER WEYDEN

circa 1400 – 1464

It was Rogier van der Weyden who succeeded Jan van Eyck as court painter to the Duke of Burgundy. The two contemporary artists knew the highest esteem in their own Flanders, and in matters of temperament one complemented the other. Where Van Eyck was sculptural, Van der Weyden was linear. Where Van Eyck dwelt upon the physical fact, Van der Weyden more directly courted a psychological presence.

The spirit of Van der Weyden's *Portrait of a Lady*, or *Saint Madeleine*, is largely medieval in its austere, almost emblematic, delicacy. At the same time, its depth and precision of observation are striking. A quiet sense of drama derives from its broad, uncomplicated areas—the background, the coif, the pristine shape of the breast. Each element is carefully restrained to establish the delicate focus of the work—the face—and yet each is defined and caressed for its own sake. These quiet planes have a quality of tactile richness despite their austerity, and the face of the lady has a sensuality which came naturally to the medieval Flemish mind—no more a contradiction than the blending of Van Eyck's material graces with his spiritual intentions.

As a native of Tournai, the young Van der Weyden grew up in a city famous for its craftsmanship and its artistic traditions. He became apprenticed as sculptor and metalworker, and soon turned his hand to painting. He did many religious works, and perhaps the greatest of all his paintings is the powerful *Descent from the Cross*, now at the Prado in Madrid. Largely because Van der Weyden in his simplicity was easier to follow and imitate than the complex Van Eyck, his work attracted an ultimately larger following. He died a hero among the Flemings and was buried in the Brussels Cathedral.

Portrait of a Lady

N.D., OIL ON WOOD, 14¼ x 10½ INCHES
REPRODUCED BY COURTESY OF THE TRUSTEES
NATIONAL GALLERY, LONDON

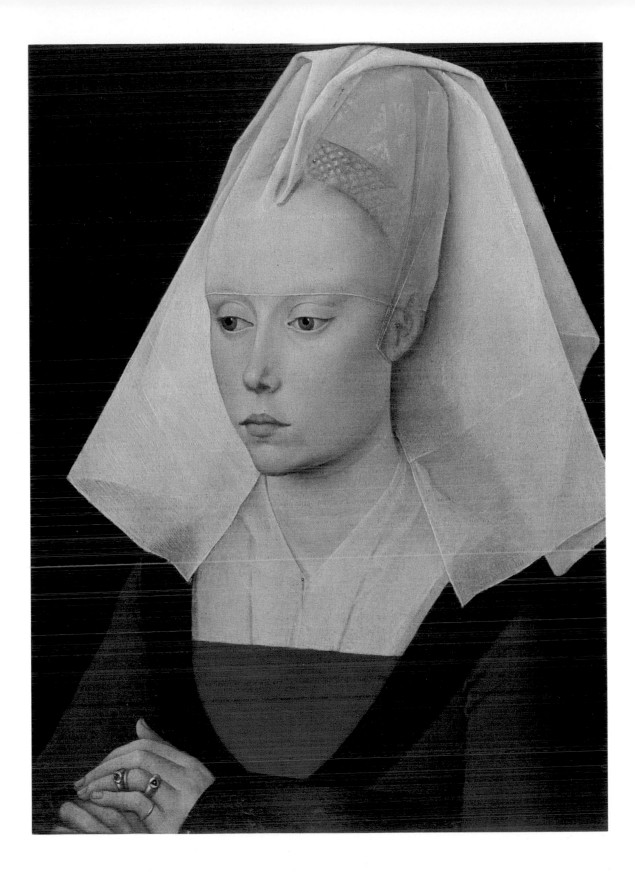

PIERO DELLA FRANCESCA

circa 1420–1492

Piero della Francesca, described in his own time as "the monarch of painting," stands between Giotto and Tintoretto as a giant whose contribution to art far outpaces its place and time. Like Giotto and Tintoretto, Piero gave birth to a mystifying synthesis of the physical or monumental fact with a quality of space that creates a spiritual force of its own. Like them, Piero was equally a colorist and an architect. His technical means were immense, and served to give form to a profound vision that is truly awesome, a living, personal world unique in the history of painting.

The *Portrait of Federico di Montefeltro* is modest in scope, powerful in effect—an uncompromising profile of Piero's great patron, the Duke of Urbino. The head is intricately and subtly observed, and yet monumental. Its striking clarity creates an unexpected chord when juxtaposed with the distance and delicacy of the landscape. Piero was a disciple of the ancient Byzantine and Gothic visions, and in the Duke's portrait, as in many of the vaster compositions, this becomes evident in a regal and highly formalized austerity. Thus, an impressively sober dignity and a daring use of visual ingenuity are ever entwined in Piero's work. Great art has been defined as the harmonious resolution of contradictions, and in that sense Piero is an especially potent force.

He was a cultivated man of precise tastes—a gifted mathematician grounded in Euclidean geometry, a Latin scholar, a participant in the advanced thought of his day. As a true poet, he placed these skills at the service of an internal, unspoken vision. His involvement with space bespeaks the pure researches of the mathematician-poet. His mastery of color is the work of a poet who constructs his metaphors with no lesser exactitude.

Though born in the region of Siena, Piero worked with Veneziano in Florence and was influenced by Florentine painting. He also had contact with Flemish art and was influenced by its magical serenity. He knew the work of Mantegna and Masaccio. All of this can be seen in his work, transformed by his own vision. The height of Piero's accomplishments came with the great frescoes for the church of San Francesco in Arezzo, picturing the *Legend of the True Cross* (1452–1459). These works are marvels of color in which Piero's most distinctive talent comes to fruition—a capacity to evoke unworldly stillness amidst a ceaseless interplay of light, color and line, in motion.

Portrait of Federico di Montefeltro

1465–1466, TEMPERA ON WOOD, 18½ x 13 INCHES
UFFIZI GALLERY, FLORENCE

[28]

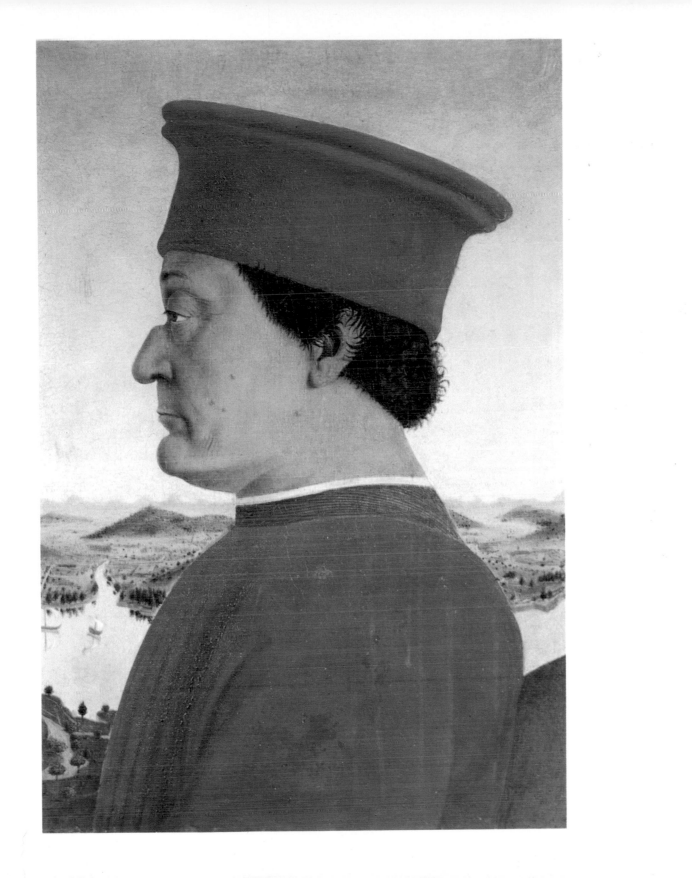

ANTONELLO

circa 1430–1479

Antonello, of the Sicilian city of Messina, developed a rapport with the art of northern Europe, a synthesis that greatly influenced the high Venetian school. The facts of his life are intertwined with legend, and it becomes difficult to establish the true sequence of events. Some say Antonello saw the paintings of Van Eyck in Naples and immediately went to Flanders to study the techniques of the school. Others say the Flemish influence was inculcated entirely by a contact with Van Eyck's work in Naples and Milan.

Saint Jerome in His Study is a comparatively early work, and one in which the Flemish influence is clearly visible. An extreme placidity of light developed through even warm and cool tones, the integration of architecture and landscape, the preoccupation with meticulous and evocative detail, are all Flemish traits that can be traced to Van Eyck.

In 1475, Antonello arrived in Venice, where his work fascinated Bellini, whose influence upon Venetian painting was in turn so broad. Here, too, Antonello's contribution is clouded by legend. There are those who stress his mastery of Flemish techniques—the sophisticated handling of oil paint as opposed to the Italian use of tempera. One story has it that Bellini, in disguise, commissioned Antonello to do his portrait in order to glimpse the preparation of the pigments. According to another story, the Venetian Republic appropriated a pension for Antonello in exchange for technical secrets. Far more certain is the fact that Antonello's vision, with its native Italian warmth and acquired Flemish clarity, impressed a host of possibilities upon the Venetian mind. The light, structure and spirit of *Saint Jerome in His Study*, for instance, may well have influenced Carpaccio.

In later years, Antonello's Flemish enthusiasms waned in favor of a largely Italian vocabulary and a more theatrical spirit. Many of the late Antonellos are monumental in their simplicity and even seem to presage the achievements of Caravaggio.

Saint Jerome in His Study

N.D., OIL, 18 x 14¼ INCHES
REPRODUCED BY COURTESY OF THE TRUSTEES
NATIONAL GALLERY, LONDON

[30]

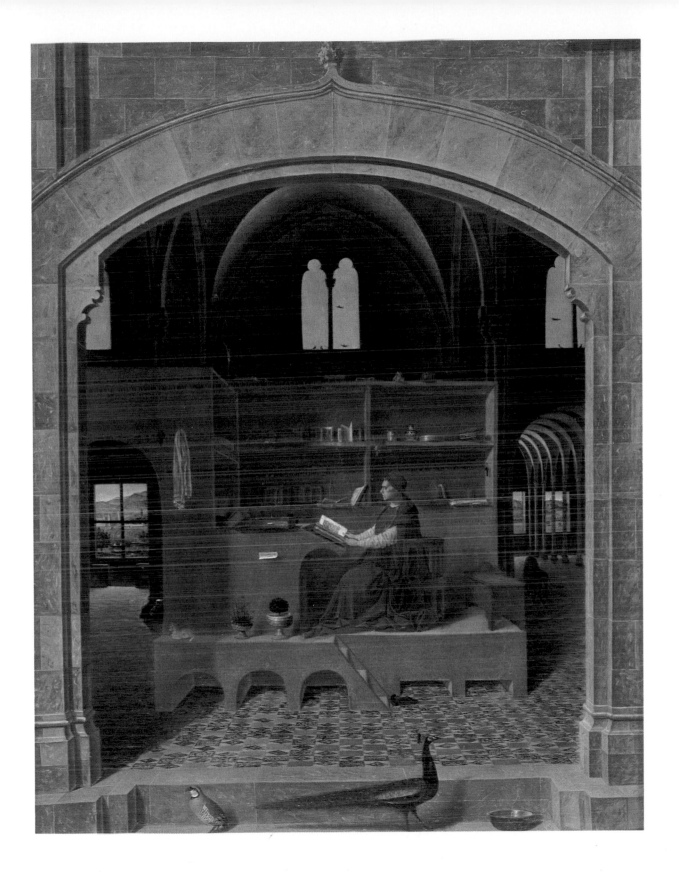

BELLINI

circa 1430–1516

The workshop of the Bellini family, Jacopo and his sons Gentile and Giovanni, had an unparalleled effect on Venetian art in the fifteenth century. Giovanni lived until the age of eighty-six, long enough to be influenced in turn by some of his own pupils, and in the activity of his workshop, Venice found a crucible blending mastery and innovation. His father, Jacopo, held firm to the tradition of the Middle Ages and his brother, Gentile, inherited this spirit of medieval formalism. But Giovanni was above all the great experimenter. He absorbed the influence of Antonello da Messina (p.30) and of his own brother-in-law, Mantegna (p. 34), who in turn learned from him. During Albrecht Dürer's second visit to Venice (p.52), he and Giovanni exchanged paintings and ideas.

In the *Portrait of Doge Loredano*, the only surviving canvas in a series portraying the city's elected executives, Bellini arrives at the high Venetian Renaissance. The point of view is totally humanistic, the new technique of oil painting has been perfected, the subtleties of light are indicated with supreme skill.

Giorgione and Titian, as well as Palma Vecchio and Sebastiano del Piombo, were students of Bellini's. Later, he himself willingly studied, adapted and developed their accomplishments, as evident in the portrait of the Doge. Great strides were being made in the exploration of light and space, and because Bellini's vision never became static, his work reveals a wide range of variations. Unhappily, almost the whole of his secular work was destroyed in 1577, in a fire at the Palazzo Ducale, and the world tends to remember him as a religious painter. The lost works included some of the most ambitious and important of Bellini's career and yet those that survive describe a remarkable evolution. The moving *Agony in the Garden*, also in the National Gallery, London, is a work cast in the mellow light associated with Giorgione. In contrast, the great *Saint Francis in Ecstasy* in the Frick Collection, New York, takes up the challenge of light and space in another dimension entirely, less mellow, more specifically architectural, and brilliantly lucid — a crystalline vocabulary more closely akin to Mantegna.

Portrait of Doge Loredano

circa 1501, OIL ON CANVAS, 24 x 17½ INCHES
REPRODUCED BY COURTESY OF THE TRUSTEES
NATIONAL GALLERY, LONDON

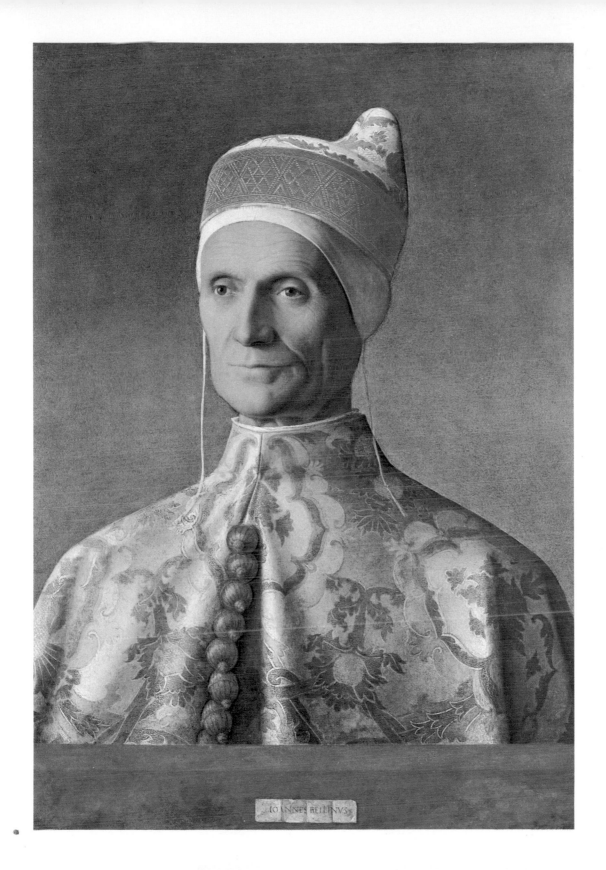
IOANNES BELLINVS

MANTEGNA

1431–1506

Andrea Mantegna united the objective precision of a great draftsman with a nostalgic love of antiquity and an innate sense of the dramatic. He experimented boldly with the possibilities of extreme perspective, and delighted in evocative detail. Above all, he was in no sense a sentimentalist. Mantegna's statements are linear, crystalline and succinct.

Mantegna served as court painter to the Gonzagas of the house of Mantua, and as painter in the service of Isabella d'Este of Ferrara. Though, unhappily, the bulk of his work is lost, the few examples that remain confirm his stature. His frescoes for the Ovetari Chapel in the church of the Eremitani, Padua, survived more than four centuries, only to be destroyed by bombing in 1944. It was while painting these frescoes that Mantegna, a native of the Venice-Padua region, met Nicolosia Bellini. Their marriage made him a son-in-law of Jacopo Bellini, a brother-in-law of Giovanni and Gentile, and thus a member of the greatest family of Venetian masters.

Mantegna's sculptural solidity and audacious drawing are evident in his *Saint George* and still more remarkable in his paintings of the Passion, which he executed with an implacable detachment. *The Dead Christ* in Milan, for example, is a startling composition in which the figure of Christ is placed in extreme perspective, feet in the foreground, head in the far background.

Anyone acquainted with Mantegna through reproductions is invariably shocked to see how small, in fact, his towering compositions are. *The Crucifixion* in the Louvre is almost a miniature, considering its richness of detail, its physical grandeur, its earnest concentration upon landscape as well as upon the central theme.

Mantegna's drawings are no less extraordinary than his paintings. He drew with the hard definition of an etcher and, again, with the voluminous solidity of a sculptor. Anatomically, his early drawings are as advanced as many of the High Renaissance experiments which took place in Florence and Rome a half-century later.

Saint George

circa 1468
TEMPERA, 26 x 12⅝ INCHES
GALLERIE DELL' ACCADEMIA, VENICE

[34]

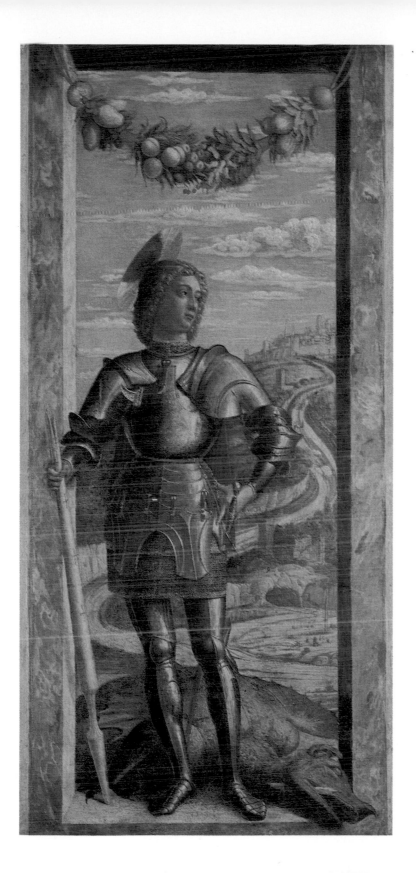

MEMLING

circa 1430–1494

Hans Memling, though he is counted among the great painters of the Northern Renaissance, was a medievalist at heart. His delicate, lyrical, devotional masterpieces are landmarks of Flemish expression.

The Arrival in Rome is one of a set of six panels painted for a shrine to Saint Ursula, each panel relating an episode of the saint's life. The composition is intricate, a composite of sacraments, with baptism, confession and communion administered simultaneously in the background, and Saint Ursula receiving the Pope's blessing against an imagined panorama of Rome. A wonderful clarity of light pervades the complicated ensemble, and this luminous serenity is perhaps the finest achievement of Memling's work. He painted in oils and built up color through successive applications of transparent, tempera-thin tints which—as may be seen in *The Arrival in Rome*—produced a counterpoint of warm and cool areas bathing a typically Flemish angularity of line and shape in a depth and unity of light.

Memling was born in Seligenstadt but settled in the city of Bruges, whose medieval purity and cool light were in themselves an inspiration. He is said to have been a man of means, a respected burgher and property holder. But his education and career are largely undocumented. Vasari wrote that he studied with Rogier van der Weyden, and catalogue references indicate that the two men may subsequently have collaborated. The last fragment of information, before Memling's death in 1494, is the acknowledgment of his completion of the altarpiece for Lübeck Cathedral in 1491.

The Arrival in Rome

circa 1489
OIL ON OAKWOOD, 14¾ x 10 INCHES
HOSPICE OF SAINT JOHN, BRUGES

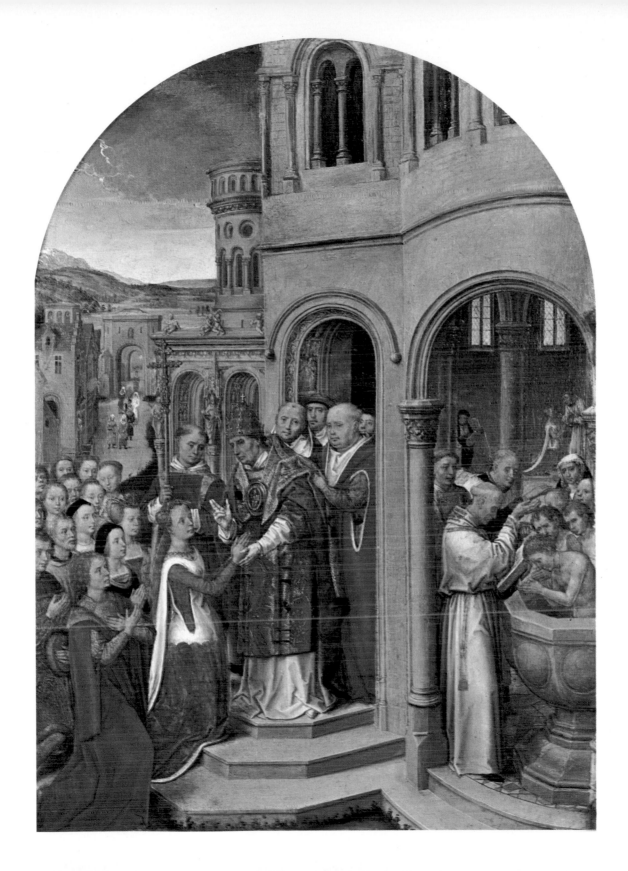

BOTTICELLI

circa 1444–1510

A giant of the Renaissance, Sandro Botticelli gave visual splendor to the wave of pagan thought that enthralled fifteenth-century Florence. His career linked the spiritual austerity of the waning Middle Ages with the temporal enthusiasms of the new classical revival. And in Venus, he dealt with a madonna of his time.

The prodigious work accomplished by Botticelli as a pupil of the brothers Antonio and Piero Pollaiuolo, and later as a deft portraitist, won him a place of high favor in the flourishing Medici court. He painted *The Birth of Venus* about 1486 to decorate the country estate of a cousin of Lorenzo the Magnificent. The birth of the goddess of love paralleled the birth of a new hedonism and a new humanism—via Greek and Roman texts ignored by the Middle Ages in favor of scholastic thought. These newly discovered antique sources were blended with the active genius of an awakened Italy and celebrated in music, painting, architecture and verse. Botticelli's painting was based upon a poem by another Medici favorite, Poliziano. The poem told how Venus had been born on the white, foaming waves off the Phoenician coast and then carried to the island of Cyprus on a seashell. At the painting's left side, Jupiter and Diana, parents of Venus, speed their daughter's progress with mythological winds. Exultant yet modest, Venus proudly shields a nudity frowned upon by medievalism in the person of Eve.

The work is not realistic. It is highly formalized and archly symbolic—a link with the medieval past. But its handling is joyous, lyrical and hedonistic. Its modeling is sensual. Its composition maximizes a delightful interplay of decorative elements. Where the medieval eye gave shape to pure spirit, Botticelli finds a commanding spirit in the physical shape. He painted another large canvas as companion piece to the *Venus*—the *Primavera*, which also hangs in the Uffizi. This evocation of the rites of spring is another poetic variation upon a pagan theme. Both are done in a tempera medium that antedates the widespread use of oil paint.

The Birth of Venus

circa 1486
TEMPERA ON CANVAS, 68⅞ X 109⅜ INCHES
UFFIZI GALLERY, FLORENCE

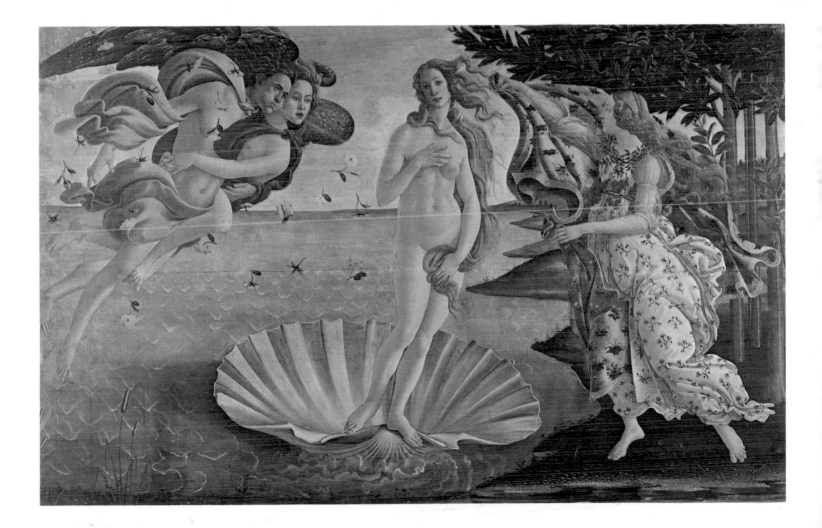

GHIRLANDAIO

1449–1494

It was as the eldest son of a goldsmith and heir to a family tradition of craftsman-ship that Domenico Bigordi took the name of Ghirlandaio—or "maker of wreaths." In collaboration with two younger brothers, a painter and a mosaic worker, he set up a *bottega*, or workshop, to decorate the churches and villas of Florence and the Tuscan countryside. The brothers Bigordi were a great success, and to this day their amazingly prolific output of altarpieces and frescoes can be seen throughout Tuscany.

As a much-sought-after craftsman, Domenico tried to assimilate the epoch's most popular trends. He courted the fashionable, which resulted in a certain eclecticism of style. The influence of Baldovinetti, his teacher, and of Fra Filippo Lippi is to be found in his work, as is the realistic observation of the Flemish School, then in Florentine favor. Shrewdly, Ghirlandaio made much of the practice of including his clients as participants in the various sacred episodes of his frescoes. The device met with approval on the part of the temporal powers of the city.

The *Old Man and His Grandson* is one of Ghirlandaio's finest and most convincing works, a study of character, appropriately constructed in a composition of great placidity. The color, with its pellucid reds and greens, is distinctively Florentine, but there are decided Flemish influences in the accentuated detail of the subject, the attitude of the grandfather's head, the coolness of the delicate landscape. Both figures are painted with a highly observant humanity, though the unrelenting realism with which Ghirlandaio treats the old gentleman seems somewhat out of key with the generally diplomatic maneuvers of the *bottega*.

For two years, Ghirlandaio labored at decorations for the Sistine Chapel, along with Botticelli and Perugino. The industrious Bigordi workshop thrived and expanded, possibly undertaking too many commissions for consistent quality. A large staff of apprentices joined to work and to learn, among them one who would become the titan of the age—Michelangelo.

The Old Man and His Grandson

circa 1480
TEMPERA AND OIL ON WOOD PANEL, 24⅜ x 18⅛ INCHES
LOUVRE, PARIS

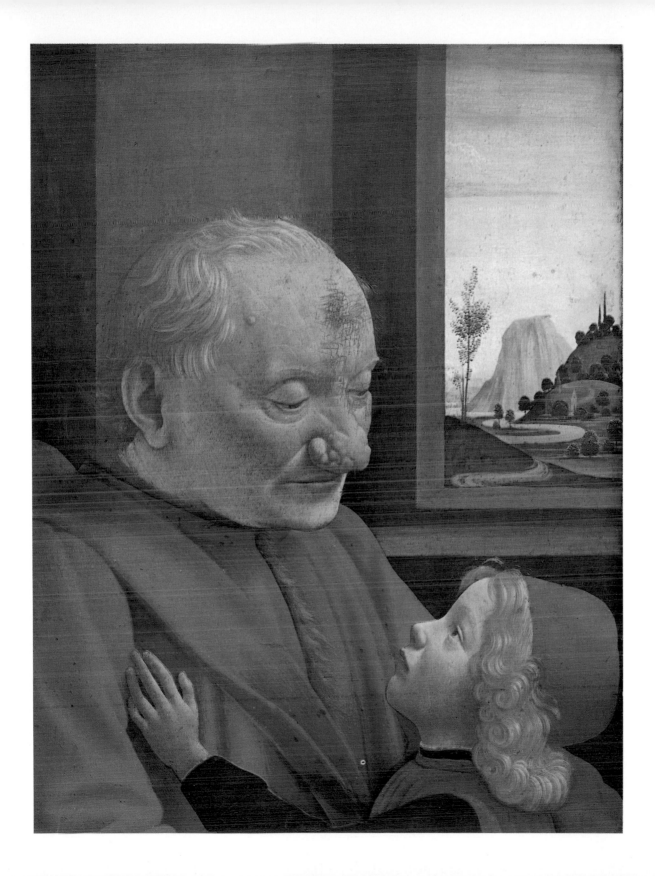

BOSCH

circa 1450–1516

The extravagant dream of Hieronymus Bosch constitutes one of the great imaginative epics in all painting, and for that matter in all literature. *The Garden of Earthly Delights*, the central panel of the Prado triptych, represents Bosch at his most brilliant and most mystifying in a vast poetic harmony whose symbolic parts defy interpretation.

Bosch's life span seems to have been almost identical with that of Leonardo da Vinci, and yet the walled city of 's Hertogenbosch in fifteenth-century Holland knew few Renaissance influences. It was still vividly medieval, with all the startling contrast of passions sacred and profane typical of the Middle Ages. A debate exists as to whether Bosch intended his earthly garden as an object of moral censure or rather as an image of the proper harmony of flesh and spirit before the Fall. The suggestion has been raised that if the latter is true, Bosch may have belonged to the heretical Gnostic sect that advocated licentiousness as a form of spiritual exaltation. His panorama of symbolic elements unites many traditional medieval devices with symbols of an entirely original stamp. The crystal globe, the egg and the unicorn were all alchemic symbols, and some scholars presume that Bosch may have been a disciple of the ancient practice.

Yet, in the case of Bosch, conjecture far outpaces actual knowledge. It is known that he and his wife were both members of the Brotherhood of Our Lady, a lay society, and that the painter knew great honor as a craftsman and as a prominent citizen. The brotherhood, along with its philanthropic functions, produced mystery plays, provided the cathedral with an orchestra, and supplied it with ornaments. Thus, the versatile Bosch, who wore the monkish garb of the society, acted in church dramas, sang in the choir, decorated masks and costumes, designed stained-glass windows for the cathedral, and supervised the polychroming of the brotherhood's altarpiece in St. John's Church.

Any further evidence gleaned from the paintings themselves becomes entangled in a diverse and bewildering plethora of suggestion. On an aesthetic level, however—as an overwhelming expanse of brilliant and subtle color, as a virtuoso performance of technique and as an astounding testament of the creative imagination—the greatness of Bosch's masterpiece is unmistakably clear.

The Garden of Earthly Delights

circa 1500–1516
OIL ON PANEL, 88⅝ x 76¾ INCHES
PRADO, MADRID

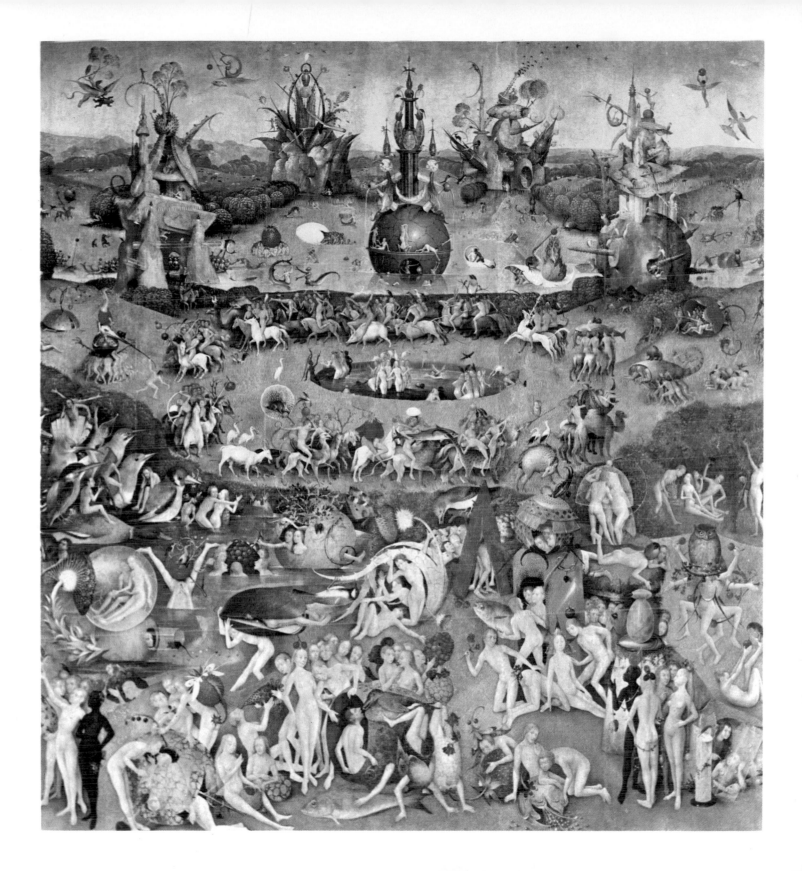

LEONARDO DA VINCI

1452 – 1519

As a Renaissance man of incomparable and incomparably varied gifts, Leonardo da Vinci ranks as perhaps the most striking intelligence of his day. Beyond his talents as a painter, he was an architect, sculptor, engineer, philosopher, an able experimenter in matters of science, and an articulate writer about the principles of his crafts. He exerted immense influence upon European painting, and became the object of adulation among the intellectual circles of Florence and Rome.

Even in his painting, the architect and engineer in Leonardo is visible. He was an incessant investigator. Many of his compositions were left unfinished in early or late stages because he was more interested in exploring the mechanics of shape and spirit than in producing finished works. Many of his canvases, like the *Mona Lisa*, are exceedingly fragile because Leonardo went so far as to devise his own pigments, tints suited to his needs but which have proved vulnerable to the chemistry of time.

During the nineteenth century, the *Mona Lisa*, or *La Giaconda*, was stolen from the Louvre by an Italian fanatic obsessed with the idea of returning it to Italy. Since that romantic incident, the picture has become so emblematically famous that it becomes difficult to see it with a fresh eye. Yet, it is an extraordinary achievement. Leonardo was deeply concerned with subtlety of characterization, fascinated by beauty, but drawn as well to the eccentric and the bizarre. His *Mona Lisa* is beautiful in her wistful detachment and yet highly enigmatic. The painting projects a haunting and almost surreal dissonance. The tender harmonies of the landscape, their crisp but mellow resonance, their union with the figure in a veil of cool green light, are another identifying signature of Leonardo.

As the son of a notary in the house of the Medici, Leonardo was born into the very center of Florentine culture. Verrocchio became his teacher and remained an abiding influence. In short time, the courts of Europe recognized Leonardo's genius: the Medici, the Sforza of Milan, the Este of Ferrara, the popes of Rome, and at last King Francis I of France. While serving as engineer to the French monarch, Leonardo died at Cloux.

Mona Lisa

circa 1503
TEMPERA ON PANEL, 30¼ X 20⅞ INCHES
LOUVRE, PARIS

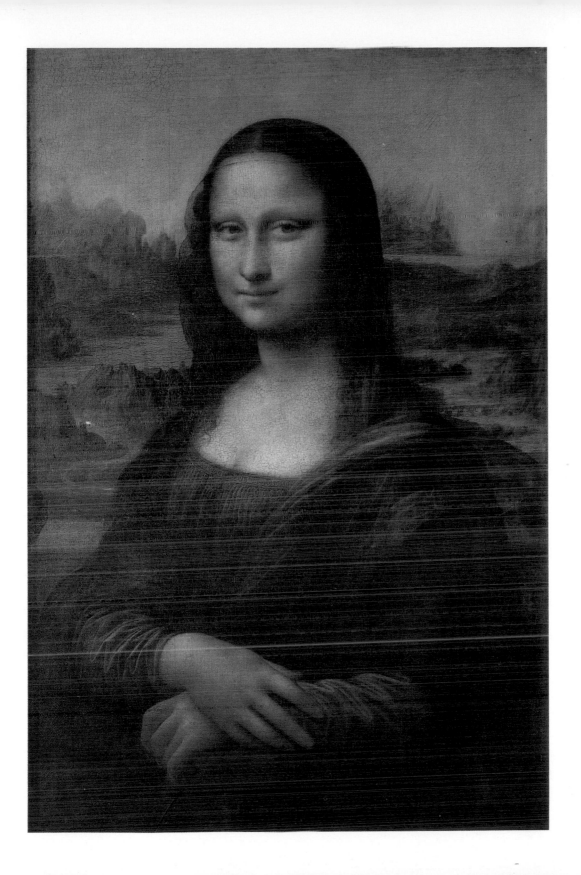

CARPACCIO

circa 1455 – *circa* 1526

The visual world of Vittore Carpaccio is a feast of dreams in which observation, ingenuity, opulence and reverie are blended with mystifying skill. Though a contemporary of Mantegna, Carpaccio had little interest in modifying his vision to incorporate the many innovations that so greatly affected painting during the fifteenth century. His was the tradition of Gentile Bellini, formal, lyric, aristocratic. In Carpaccio's hands, the tradition took on a new imaginative dimension and a new brilliance.

In fact and in spirit, the art of Carpaccio is completely Venetian. His work, with its delightful narrative quality, remains a priceless anthology of the Venetian life of his day. But Carpaccio's world surpasses the dimensions of reality. Its radiant gold-amber light and the curious blending of formal color with shimmering detail create an aura of fable, a captivating, unworldly experience. Five centuries later, the Surrealists were to look upon Carpaccio, along with Bosch, as a giant of the imagination.

The Legend of Saint Ursula is an especially brilliant achievement, impeccably conceived and poetically resolved. In *The Dream of Saint Ursula*, one of nine panels that make up the great narrative work, an angel announces to the sleeping Ursula a portent of her future martyrdom. An involvement with the courtly symbolism of the Renaissance accompanies the more encompassing magic of light and line: the flowers at the window, myrtle and carnation, express in the rebus language of flowers, "I love you."

Early in his career, Carpaccio worked as assistant to Giovanni Bellini on frescoes for the Doges' Palace. Bellini taught him much, especially in respect to color, though Carpaccio refused to follow the elder master in his later developments. On the other hand, Carpaccio was influenced by the example of the Flemish masters, with their extreme clarity. Like them, he took an abundant delight in the poetry of detail and drew a transfiguring beauty from the material charms of fabric and stone, earth and flora. His work was highly esteemed in the city, his major clients being the *scuole,* or beneficent fraternities, which commissioned cycles portraying then popular legends—among them the legend of Saint Ursula.

The Dream of Saint Ursula

circa 1495
TEMPERA ON CANVAS, 107⅞ x 105⅛ INCHES
GALLERIE DELL' ACCADEMIA, VENICE

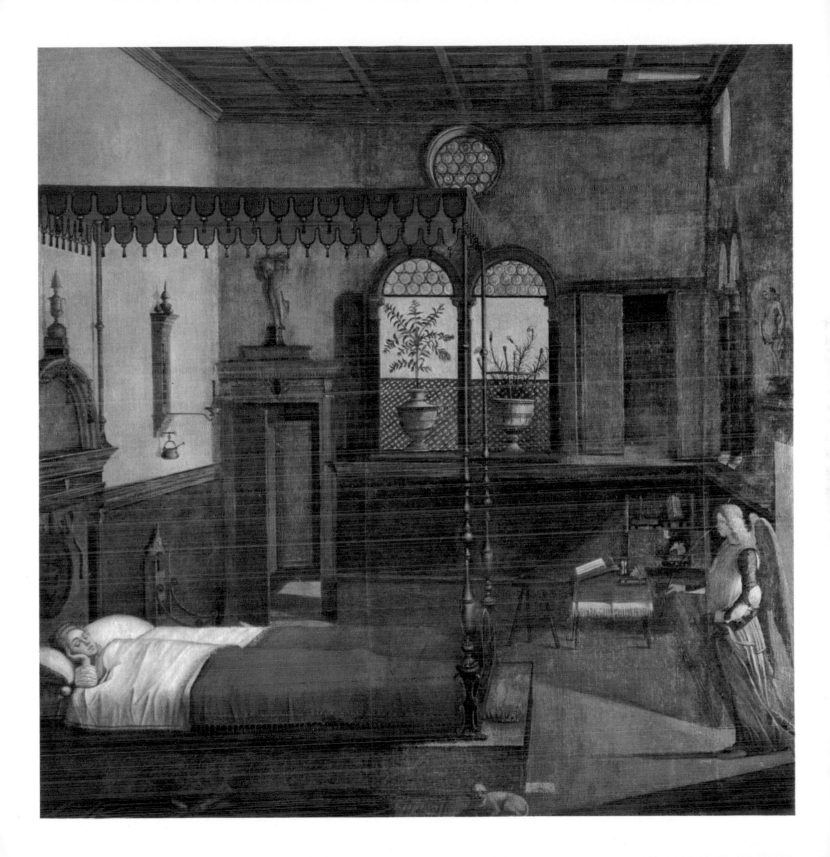

GRÜNEWALD

circa 1445/80 – *circa* 1528

The inspired works of Matthias Neithardt-Gothardt, called Grünewald, are startlingly original statements of northern European painting in the early sixteenth century. Their most remarkable feature is their range of expression. Grünewald's work has a strongly Gothic flavor that evokes the Middle Ages and a lyrical warmth that touches upon the spirit of Italian Renaissance painting. Yet, at the same time, it preserves the crystalline, linear spirit of German Renaissance art.

The Virgin and Child forms one panel of the great Isenheim Altarpiece, keystone of Grünewald's present fame. The altar, now at the Colmar museum, was originally constructed for a hospital maintained by the Church of the Acolite Monastery. The hospital, in that age of still-primitive medicine, dealt with blood diseases, skin diseases and epilepsy. Grünewald's work was used in the treatment of patients. For before the doctors begin their ministrations, patients were taken to the altar to observe the efficacy of miracles—a tragic but astonishing tribute to the power of Grünewald's art. The altarpiece is actually an eleven-winged polyptych. When shut, it displays a *Crucifixion.* Opened, it reveals *The Virgin and Child* and *The Concert of Angels,* flanked by an *Annunciation* and a *Resurrection.* The third section deals with *Saints Anthony and Paul Meeting in the Wilderness* and *The Temptation of Saint Anthony.*

Though Grünewald was greatly esteemed during his own time, few facts about his career are available today. Guesses as to his birthdate vary from 1445 to 1480. It is known that he traveled considerably throughout Germany in response to numerous commissions. He served as court painter to Cardinal Prince Albert of Brandenburg and painted a good many portraits of noblemen. He was a skilled craftsman, adept as a goldsmith and accomplished as an etcher and master of woodcuts. He was the teacher of Dürer and later his associate in Nuremberg. There has been speculation that Grünewald converted to Protestantism a few years before his death in 1528, the year that also saw the death of Dürer.

The Virgin and Child

circa 1515
OIL ON WOOD, 105¾ x 55⅛ INCHES
MUSÉE D'UNTERLINDEN, COLMAR

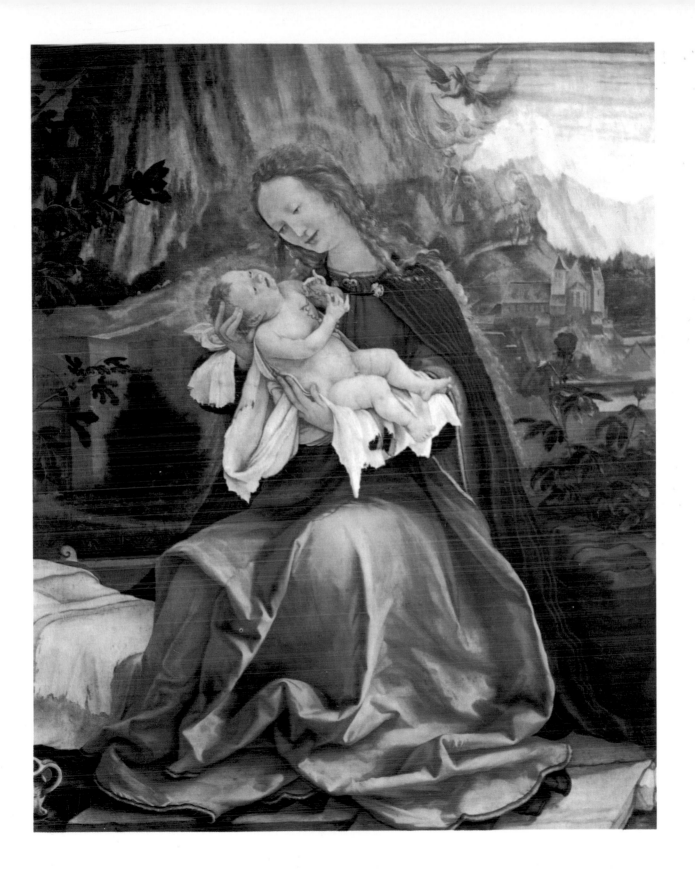

MATSYS

circa 1466–1530

The life work of Quentin Matsys traces an evolution from the influence of Van Eyck and Van der Weyden in Matsys' early years to the later impact of Leonardo da Vinci and the Italian Renaissance. A true son of the Renaissance, Matsys was skilled as musician, poet and student of humanist letters. A man of the Reformation, he was friend to Erasmus and Sir Thomas More and was keenly aware of the moral issues of his day. *The Banker and His Wife* encompasses all these successive influences and impulses. The vivid, almost overabundant, detail recalls Van Eyck (p. 16). The treatment of the banker's wife in broad, serene areas of color and tone is a link to Van der Weyden (p. 26). The banker's head—its fleshly realism and its nevertheless delicate luminosity—suggests Leonardo (p. 44). And the strong portrayal of character and personality is of course a legacy of the Renaissance. One might assume that the diversity of technique, the presence of several varying influences, and the extraordinary manner in which the left and right sides of the composition are painted in different color keys must result in a disorganized whole. Yet, despite these theoretical dissonances, the work is perfectly coherent.

Matsys was born in the university town of Louvain. His father was a blacksmith—a trade which in those days involved not only shoeing horses but also the fashioning of architectural ornaments and decorative objects. It may have been in his father's smithy, as well as from the influence of Van Eyck, that Matsys acquired his love of ornamental detail. In *The Banker and His Wife*, he obviously delights in the convex mirror with its playful reflection parenthetical to the larger composition.

Matsys was twenty-five when he arrived in Antwerp and became a member of its painters' guild. Two years later he was already a master of the guild and a luminary of the art of his time.

The Banker and His Wife

1514
OIL ON WOOD, 27⅞ x 26¾ INCHES
LOUVRE, PARIS

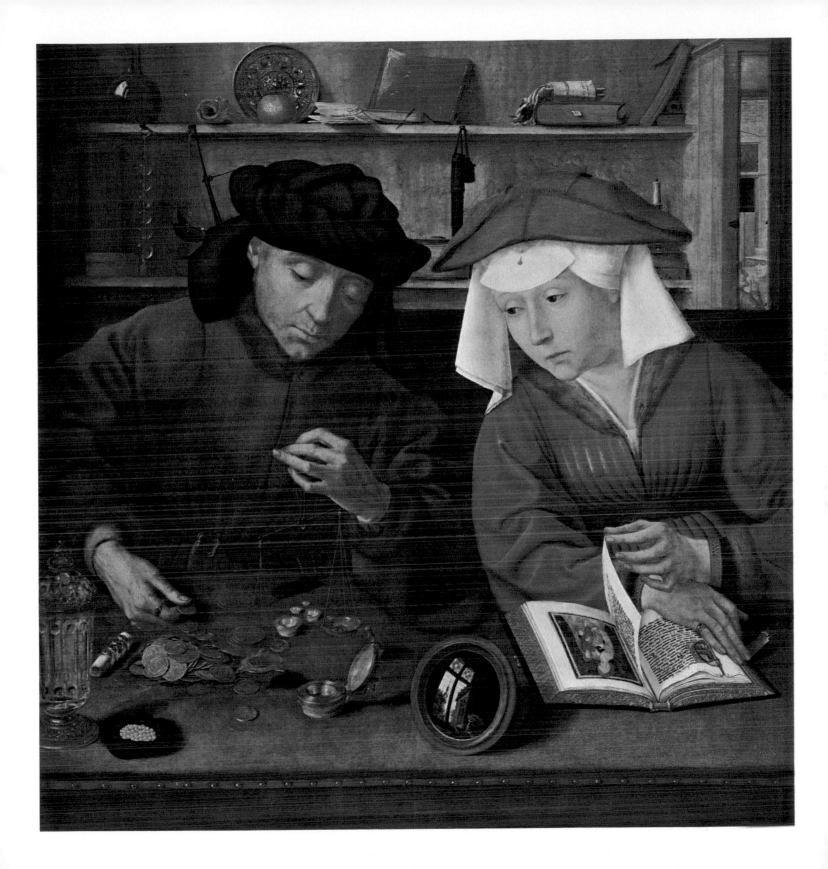

DÜRER

1471–1528

Albrecht Dürer was a great draftsman, an able painter, and one of the guiding spirits of the German Renaissance in art. He has been compared to Leonardo as a craftsman whose intellectual gifts spanned a broad range of perception; and, like Leonardo, he composed formal studies of the mechanics of anatomy, perspective and architecture. The son of a goldsmith and heir to a tradition of craftsmanship, he learned enameling, embossing, enchasing and engraving, traveled for four years as a journeyman artist, and at last studied with Grünewald in Basel.

The Four Apostles, portraying John and Peter, Mark and Paul, was a gift from the painter to his native city of Nuremberg. The painting is heavily Germanic in its literal devotion to detail and its conscious sense of drama. At the same time, its color and to some extent its handling of the heads suggest the Italian influence that made so strong an impression upon Dürer. It was in Venice that he discovered Italian painting. The sculptural, crisply forged techniques of Mantegna and Crivelli affected his work, as did the example and formulas of Leonardo.

Dürer wrote that he felt rather more appreciated in Italy than in Germany. Yet in Nuremberg he was accepted as a substantial figure, in part because of his work, in part because of a socially distinguished marriage. Assisted by Grünewald, he set up his own printing establishment and eventually found himself in so comfortable a position as to be able to lend money to the city. His graphics, principally etchings, rank as Dürer's finest achievements, sensitive, taut, complete. As a celebrity of the age he traveled considerably, and in the Netherlands was welcomed, feasted and honored as a hero.

The Four Apostles

1526
OIL ON WOOD, TWO PANELS, EACH 84⅝ x 29⅞ INCHES
ALTE PINAKOTHEK, MUNICH

[52]

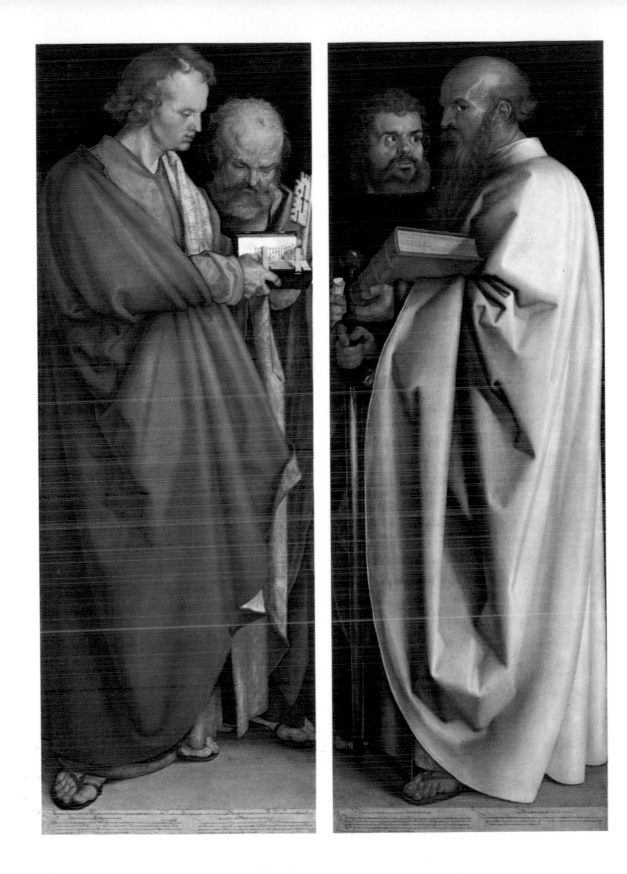

CRANACH

1472–1553

Lucas Cranach the elder painted amid the sober influences of the age of Luther. He was a compatriot and contemporary of Dürer's, but a painter more at home with a poetry of color than the great draftsman of Nuremberg. *Portrait of a Young Man of the Von Rava Family* is typical of Cranach's aesthetic—almost austere in its simplicity of form and terseness of statement, yet vibrant and alive in its haunting color and spirited play of contrasting detail. It demonstrates his gift for balancing solidity of shape with a skillful animation of line.

Cranach was a native of Bavaria who spent the greatest part of his career in Wittenberg as court painter to the electors of Saxony—Frederick the Wise and his successors John the Constant and John Frederick the Magnanimous. In the Renaissance tradition, politics and the arts were closely intertwined. Cranach himself served as burgomaster of Wittenberg—and one of his sons as mayor. He impressively asserted his fidelity to John Frederick when the latter was taken prisoner at the defeat of the League of Schmalkalden. Cranach joined the prince in the prison at Augsburg "to keep him company." Later, when John Frederick was transferred to a prison at Innsbruck, Cranach accompanied him and spent no less than two years in voluntary custody with his friend and patron—emerging one year before his own death.

Cranach had also become a friend of Martin Luther, whom he met in the Netherlands in 1508, the year of his conversion. Yet, despite his Protestant restraint and Northern temperament, he also painted classical and mythological themes as in the great *Judgment of Paris* at the Metropolitan Museum in New York. Here he eulogized the charms of Venus in a richly patterned work, ingenious in construction and vivacious in mood.

Portrait of a Young Man of the Von Rava Family

1539
OIL ON PANEL, 24 x 16⅞ INCHES
MUSEU DE ARTE DE SÃO PAULO, BRAZIL

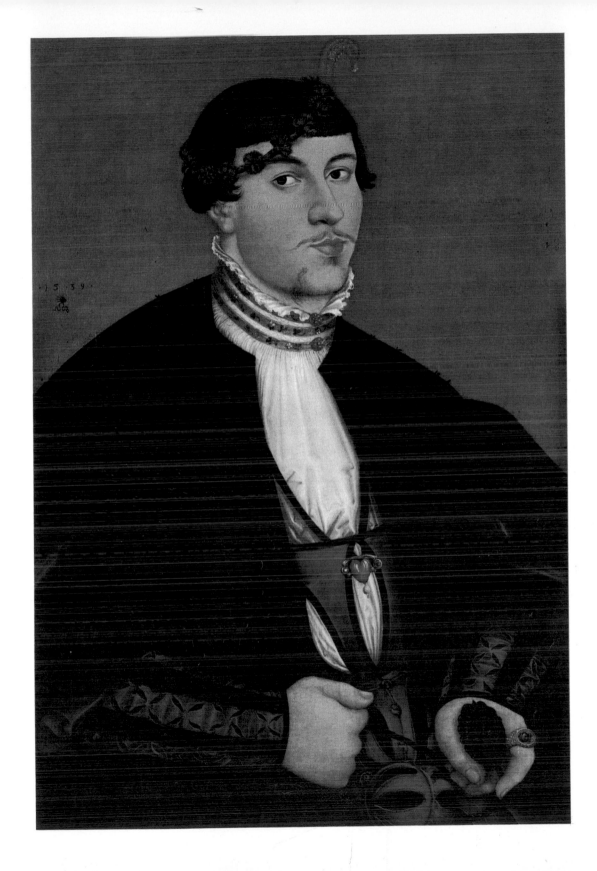

MICHELANGELO

1475–1564

Michelangelo Buonarroti was one of those rare geniuses whose immense intellectual capacity is matched by an enormous spiritual power. He painted during the turbulent and climactic latter years of the Italian Renaissance when active forces of spiritual faith and humanist principle were in conflict. Michelangelo evolved a personal resolution of that conflict in evoking the life of the spirit through the life of the body.

The Delphic Sibyl is a fragment of Michelangelo's greatest work, the titanic frescoes of the Vatican's Sistine Chapel. As one of twelve prophets and sibyls surrounding the architectural border of the ceiling, the figure takes its place as a symbol of creative inspiration, in preface to the narrative above it. For the Sistine frescoes are an epic account of the events of Creation, ending in the Deluge, and epilogued by a symphonic Last Judgment painted more than thirty years later. The Delphic Sibyl is tinted with a warm and delicate color that can be traced to Michelangelo's Florentine origins, but its physical monumentality and its vibrant sense of drama—even in so limited a subject—reflect the dimensions of Michelangelo's own vision, the source of his overwhelming impact upon painting.

Both Florence and Rome claimed him as a native son, and Michelangelo traveled often between the two cities, impelled by commissions as well as by the vicissitudes of political conflict. In his day, he worked under the powerful and philosophically articulate regimes of Lorenzo the Magnificent, Savonarola, and of the Renaissance popes Julius II, Leo X, Clement VII, Paul III, Julius III and Paul IV, the last of whom ordered the nudity of the Sistine figures to be covered. The forces of spiritual decay in Italy and of the Reformation abroad were at work. These questions profoundly troubled Michelangelo, who devoted himself to their theological as well as aesthetic solution.

Michelangelo was as great a sculptor and as great an architect as he was a painter, and these disciplines interact dynamically in all of his work. He was a classicist whose last works prefigure the baroque, a realist whose vision was infinitely imaginative, a mystic whose observations are carved with the most articulated gifts of reason.

The Delphic Sibyl

1508–1512
FRESCO, 23½ x 17½ INCHES
SISTINE CHAPEL, VATICAN, ROME

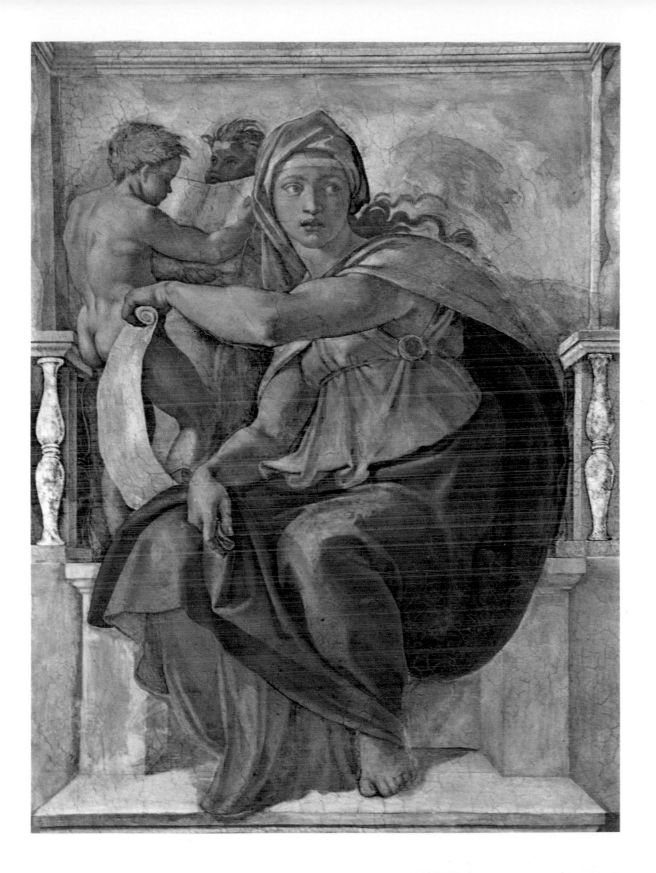

GIORGIONE

circa 1478 – 1510

Giorgione's *The Rustic Concert* is a marvel of light and color that marks a vital turning point in the history of Italian painting. For the accomplishments of Giorgione's short career introduced an entire vocabulary of light and form to the workshops of northern Italy. Before his death at the age of thirty-one, this lyric poet presaged the vision of Tintoretto and of all the high Venetian school.

Giorgione developed the possibilities of sheer light until he had constructed an entire orchestration of radiant color. The historian Vasari claimed that Giorgione worked directly with color, without first preparing his statements through drawings. His predecessors tended to be far more linear and more graphically sculptural, but Giorgione went so far as to seek out delicate and transient moments of vibrant light as the objects of his craftsmanship. *The Tempest*, a great Giorgione in the Accademia in Venice, shimmers in the silvered brilliance of a flash of lightning. *The Rustic Concert*, a later work, captures the brief magnificence of a flushed twilight. Yet, there is no sacrifice of volume or solidity. *The Concert* is aesthetically complete and no breakdown of its admirable parts can quite explain its total, magical presence.

The very subject is unconventional, for Giorgione was markedly original in constructing the symbolic content of his painting. One can try to interpret mystical or philosophical motives in the formulations and allusions of his work — he is known to have been closely in touch with the intellectual currents of his time — but any conclusions drawn from the few surviving examples remain entirely conjectural. Some admirers feel that the tenebrous quality of his painting parallels the mystery enshadowing the facts of his life. He is known to have been a student of Giovanni Bellini, a colleague of Carpaccio and Veneziano, and the teacher of Titian. But little else is known.

The Giorgione enigma is further complicated by the fact that after his death many of his works were completed by students and disciples, among them Titian and Palma Vecchio. Some scholars have even gone so far as to claim — an attribution difficult to accept — that *The Rustic Concert* was in fact painted by Titian.

The Rustic Concert

1509
OIL ON CANVAS, 43¼ X 54¼ INCHES
LOUVRE, PARIS

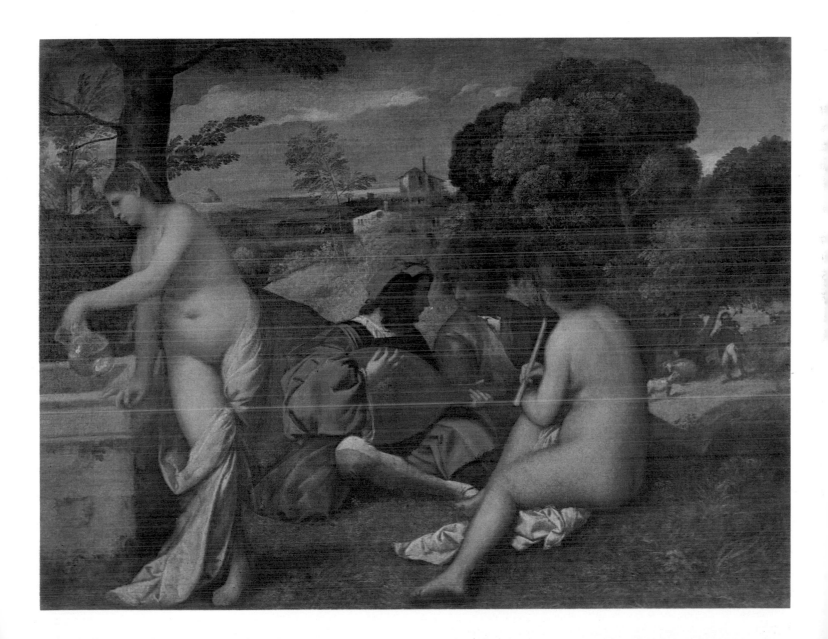

RAPHAEL

1483–1520

Raffaello Sanzio lived only thirty-seven years. But his achievement is often ranked with Michelangelo's and Leonardo's in the forefront of sixteenth-century Italian painting. The artistic genius of the Italian Renaissance was in a sense already spent by Raphael's time. The intuitive leap had been made—and now the formalized principles of classical thought and architecture were being coldly pursued. The humanists saw in Raphael's work a *mirabile giudizio*, or marvelous judiciousness, and they admired the subtle insight and tact of his portraits. His vision was indeed thoroughly humanistic, and as it developed, it became more and more idealistic, culminating in sweetness.

At the age of twenty-five, Raphael was summoned by Pope Julius II to Rome, and before long he became the undisputed artistic master of the city, succeeding Bramante as architect of St. Peter's. He had been commissioned by the Pope to paint a series of frescoes for the Vatican apartments—the Stanze. And to this series, which includes his famous evocation of classical wisdom, the *School of Athens*, he addressed the last seven years of his life.

Though Raphael, during his years in Rome, felt the impact of Michelangelo, the greatest single influence on his work was that of his Umbrian master Perugino. And it might be said that too little credit has been given to the latter's example. For, while Raphael's poetic feeling is his own, the technical mastery associated with his work is already present to a surprising extent in Perugino.

It was the nineteenth century that made a god of Raphael and valued his narrative grace even above the majesty of Michelangelo. Twentieth-century observers, however, are in a better position to appreciate the earlier Raphael—less psychologically subtle but even more plastically compelling than in his later works.

Saint George Slaying the Dragon

circa 1502
OIL ON WOOD, 12⅝ x 10⅝ INCHES
LOUVRE, PARIS

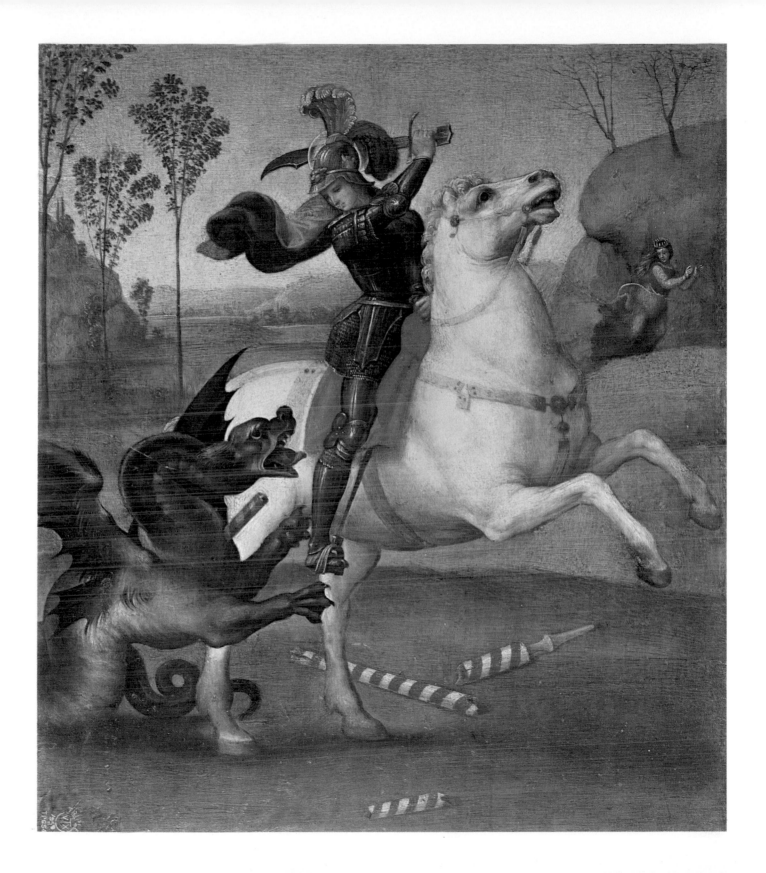

CLOUET

circa 1485 – circa 1540

Jean Clouet, born in the Netherlands, became the father of a great tradition of French painting. Under the flourishing monarchy of Francis I, France was emerging rapidly as a great Renaissance power in politics and in cultural affairs. The king, whose portrait by Titian also hangs in the Louvre, became the eager patron of Italian and Flemish masters, and it was his learned enthusiasm for the arts that made an authentic national French school possible. When Clouet arrived in France, his style was preponderantly Flemish. He responded swiftly, however, to the elegances of French taste and his work became less Gothic, more supple and headier in color.

As a draftsman, Clouet excited great admiration. An entire school of French contemporaries recognized him as their leader, and his own son François ranked first among his disciples. After the painter's death, his son not only succeeded to the honorary title of "Painter and Valet to the King's Bedchamber" and inherited his father's French sobriquet of "Janet," but was even absolved of debts owed by the family to the royal house.

The *Portrait of Francis I* is something of an enigma. Its abundance of pattern and texture risks overwhelming the canvas as a whole, and yet the picture functions superbly. The head of Francis is its most subdued area, and this in itself provides an element of contrast with the rest as well as an occasion for delicate and masterful drawing. The work has a great and vital rhythm, a quality of brilliantly fluid line and impressive volume. In its material opulence and brisk spirit, the painting is in fact emblematic of its subject, the robust giant who wrestled with his royal peer Henry VIII, the wily strategist and cultural overseer of a maturing nation.

Portrait of Francis I

circa 1524
OIL AND TEMPERA ON WOOD, 37⅝ x 29⅛ INCHES
LOUVRE, PARIS

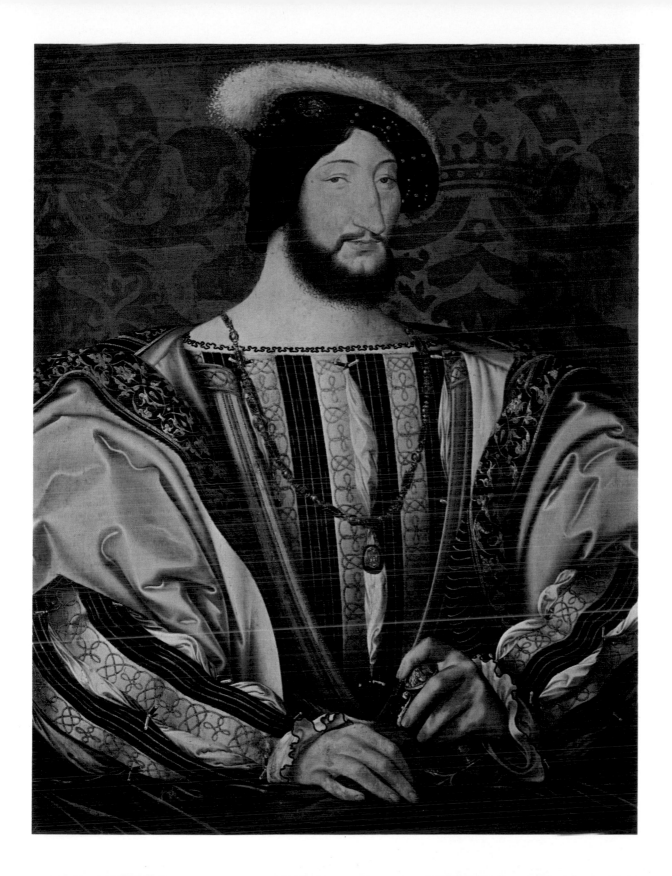

ANDREA DEL SARTO

1486–1531

Andrea del Sarto painted during the climactic twilight of the Italian Renaissance. It was an age in which Leonardo and Michelangelo were massing the human precepts of the day in epic statements. For Andrea, it was an epoch of acute observations on a more intimate scale. He painted Madonnas and religious episodes, yet in terms of a temporal sympathy far from the dramatic spiritualism of his Florentine predecessors.

The *Portrait of a Sculptor* is an especially fine example of Andrea's talents. It can be called a psychological portrait in view of its narrative concern with the personality of the sitter. The character of the sculptor becomes the focus of all Andrea's skills, of the firm angularity of line, of the diffused and smoky quality of light and shadow, of the simply defined composition.

Andrea was born the son of a tailor, and it was from his father's trade that the name del Sarto derived. In 1511–12, he embarked upon the first of his great commissions, the painting of highly chiaroscuroed frescoes for the church of the Scalzi in Florence, a project that involved him for more than a decade. His subtle and greatly expressive technique earned him a superlative reputation as "the perfect painter," and after making his mark in Florence, where he was greatly influenced by Michelangelo and Leonardo, he was commissioned by Francis I to work on projects for the French court. Yet, through the vagaries of chance—some cite financial peccadilloes, others say his wife longed for Italy—his stay abroad was brief. Andrea had the ill fortune to be in Florence during the plague year of 1531. The scourge took his life.

Portrait of a Sculptor

1524
OIL ON CANVAS, 28½ x 22½ INCHES
REPRODUCED BY COURTESY OF THE TRUSTEES
NATIONAL GALLERY, LONDON

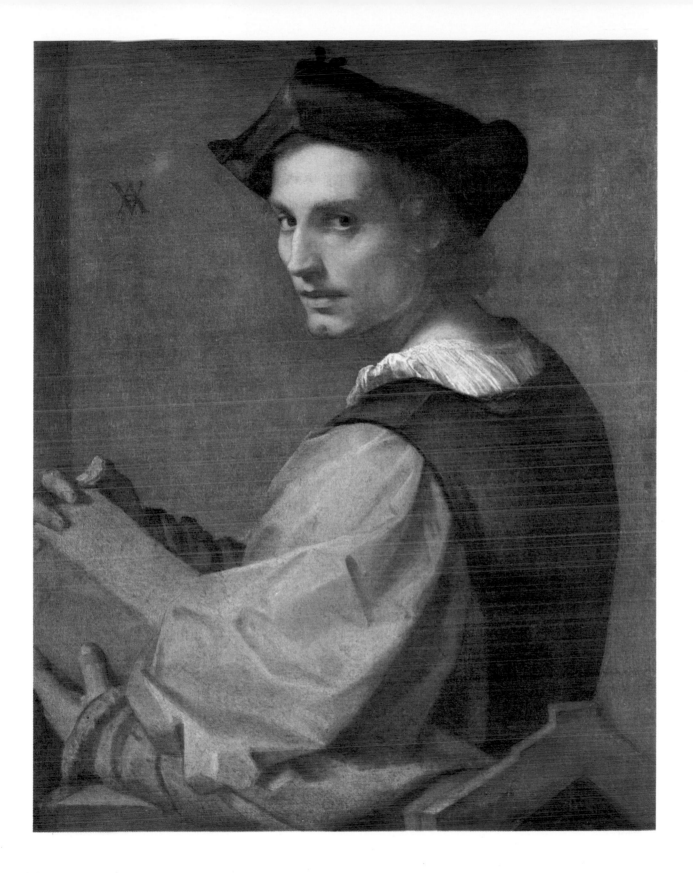

TITIAN

circa 1477–1576

Titian's *Venus of Urbino* is a masterpiece of sensual intelligence that exudes the life and spirit of Venice in the sixteenth century. Its opulence is balanced by a precise delicacy. Its richness is opposed by what might even be called austerity—in the absolute purity of the composition. Anything Titian painted became monumental, and yet, in that his vocabulary stressed an elusive and mystifying use of light, his magic is dramatically Venetian.

During his long life span of some ninety years, Titian came to be recognized as a major figure by Venice and by all of Renaissance Europe. First apprenticed at the age of ten, he blossomed under the teaching of Gentile Bellini, then Giovanni Bellini, and at last, Giorgione. In Venice, he acted as sage in the affairs of the arts, which were then more closely entwined with the concerns of state than during any epoch since. At the invitation of Pope Paul III he visited Rome and left as an honorary citizen of the papal city. He painted the Holy Roman Emperor, Charles V, and became a Count Palatine, Knight of the Golden Spur. His work came to the attention of Philip II of Spain, and for a period of about twenty years the Spaniard became his chief patron. A favorite of Francis I of France, he displayed his brilliance at the French court.

The special savor of Titian's light came directly from the young Giorgione, and when Giorgione died, Titian was immediately hailed as his successor. By the time of the *Venus of Urbino*, 1538, the glowing Giorgione influence still radiated from within, illuminating and transfiguring the virile solidity and tactile magnificence that is the special genius of the mature Titian. Each element of the painting is caressed with a surety of tone and volume—the flesh and hair of the goddess, the small dog, the "titian red" radiance of the couch answered by the robes of the standing figure. Yet, all of these elements are skillfully wedded to evoke a total serenity, an entirely resolved whole. Later, during his last years, Titian developed more mystical concerns in a series of great religious works.

Venus of Urbino

1538
OIL ON CANVAS 46⅞ x 64⅞ INCHES
UFFIZI GALLERY, FLORENCE

[66]

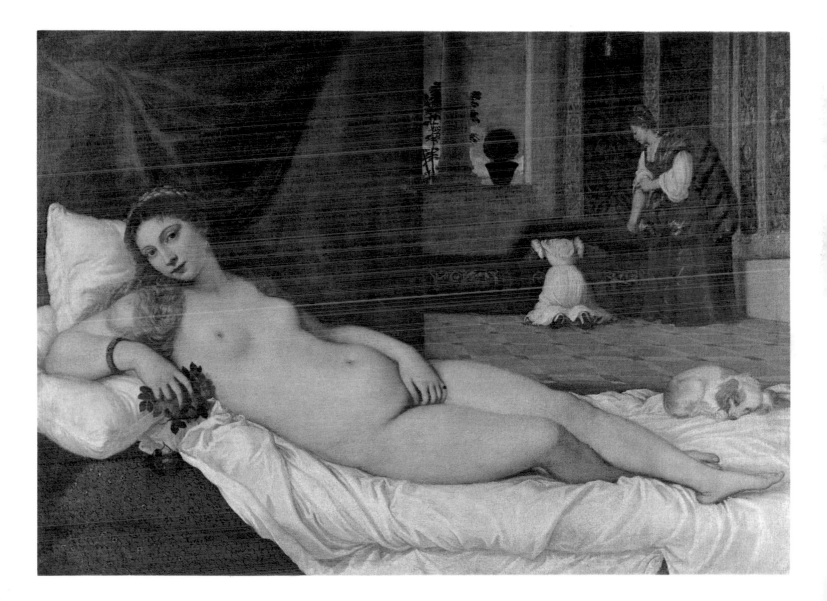

CORREGGIO

circa 1494–1534

The sensual art of Antonio Allegri, known as Correggio, was an advanced and individualistic product of the late Italian Renaissance. The example of Michelangelo, for whom the human body became a means to spiritual expression, had a great effect upon Correggio, and in his work the profane influences of classical literature—the influences which had precipitated the Renaissance itself—are interwoven inextricably with Christian themes.

Little is known of Correggio's history. He was born in the town of Correggio about 1494. Nothing is known of his family. He spent most of his life in the town of his birth and seems to have lived outside the intellectual currents of the Italian states. In 1511, however, a plague struck the city and Correggio fled to Mantua, where he stayed for two years. There he saw the work of Mantegna, whose solidity and stability taught him much. When he visited Rome several years later, he discovered and was inspired by the works of Michelangelo and Raphael. Subsequently, the sensuality evident in his neoclassical nudes became an attribute of his religious pieces. He experimented widely with extreme perspective and elaborate artifices of composition. He used chiaroscuro technique, playing with deep shadow and high areas of light, with a virtuosity displayed clearly in *The Holy Night, Adoration of the Shepherds*. This work was completed as a panel for an altar in Dresden, and is often referred to simply as *Night* in opposition to its companion piece, a *Madonna of Saint Jerome* known as *Day*.

In a flourish of technical ingenuity, Correggio painted the cupola of San Giovanni Evangelista in Parma. The dome portrays an *Ascension of Christ* with elongated nudes rising in perspective through a funnel of clouds toward heaven. For almost two centuries after Correggio, baroque painters were to look to his work as the origin and inspiration of their efforts.

The Holy Night, Adoration of the Shepherds (Night)

1530, POPLAR WOOD, 112⅛ x 74¾ INCHES
STAATLICHE KUNSTSAMMLUNGEN, DRESDEN
GEMÄLDEGALERIE ALTE MEISTER

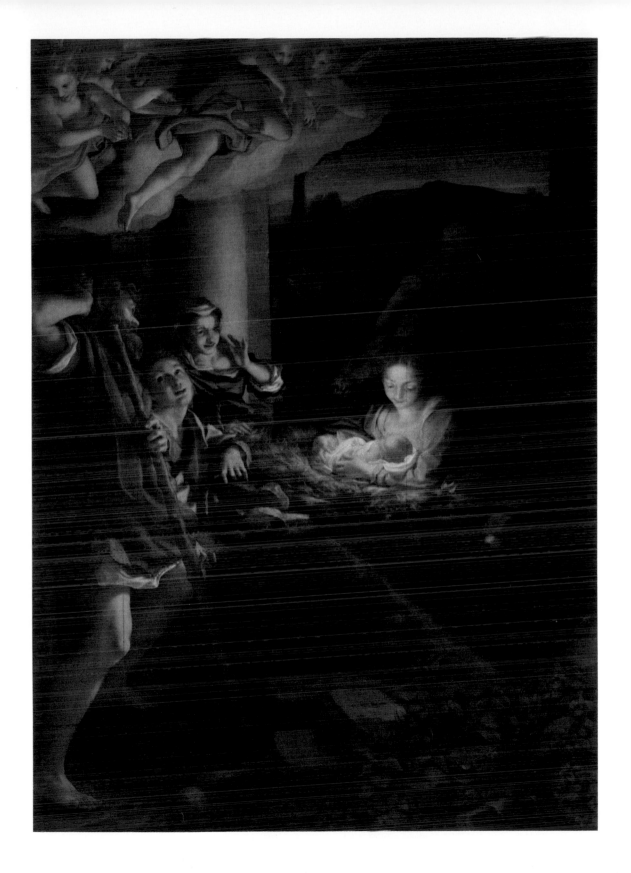

HOLBEIN

circa 1497–1543

As a northern European master of the sixteenth century, Hans Holbein func-tioned amidst the rapid currents of the Protestant Reformation. Politically, the great movement shaped his career. Intellectually, his cool, reasoned, highly individual observations paralleled the logical humanism of Erasmus and Sir Thomas More, both subjects of brilliant Holbein portraits.

Though a native son of Augsburg where his father reigned as a master, the young Holbein chose to settle in Basel, Switzerland. But the passions of the Reformation were to make Basel's intellectual climate intolerable. When the city council began ordering the destruction of religious paintings on doctrinal grounds, Holbein left for England. Erasmus furnished him with a letter to Sir Thomas More, then chan-cellor to Henry VIII, and thus Holbein was brought into the British court and into the favor of the irrepressible king. It was in London that he spent his last and perhaps most fruitful years.

The portrait of *Anne of Cleves* is one of several paintings whose purpose was to give Henry previews of possible future queens, and this particular work paved the way for a royal marriage of six months. The painting, still fresh after four centuries, is a masterpiece of poetic restraint and incisive, if tactful, observation. Holbein emphasized the regal elegance of the princess' couture, building up areas of rich color that respond to a sure and sinuous linear flow. The head, a masterly bit of succinct and delicate painting, is perhaps at the same time a tour de force of euphemism and diplomacy. It suggests a demure and feminine princess, if not an especially brilliant one.

Holbein's work is imbued with a spirit of detachment, a calm sense of observa-tion and inquiry in the best manner of the age, but apart from its passions. In Switzerland, the painter adopted the official Lutheran faith of the city, but with inner reservations. In England, he painted with deft precision a series of portraits that document years of turbulence—but as human vignettes and formal poetic statements independent of the historian's text.

Anne of Cleves

1539
OIL AND TEMPERA ON VELLUM MOUNTED ON CANVAS
25⅝ x 18⅞ INCHES
LOUVRE, PARIS

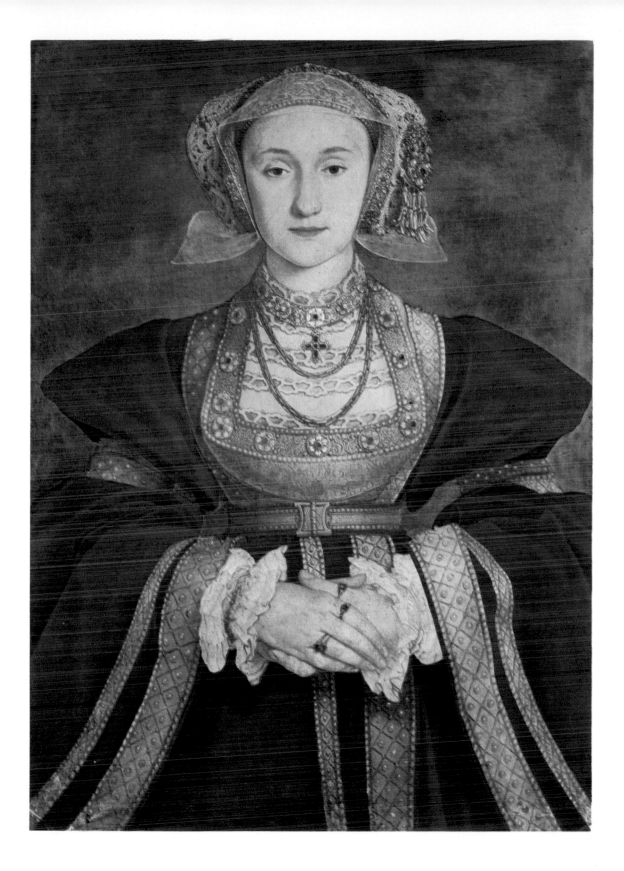

BRONZINO

1503-1572

The powerful work of Agnolo di Cosimo, called Il Bronzino, came out of an epoch of hesitancy and anticlimax. The colossal forces of the Renaissance had passed. In their wake, able painters, impressed with the great example of Michelangelo and his contemporaries, sought for expression in a world of style and gesture. This impulse and this moment in mid-sixteenth-century Italian art have recently been given the very general label of "Mannerism." But out of a long list of colleagues, Bronzino survives as one of the most virile and most expressive.

The Florentine's work as decorator of the Medici villas, as portraitist, and as painter to the chapel of Eleanor of Toledo, the duke's wife, brought him high esteem and eventual preeminence as chief portrait painter to the Medici court. The work of Pontormo, under whom he studied and with whom he continually worked, influenced him greatly. And in the *Portrait of Eleanor of Toledo and Her Son, Giovanni*, painted almost at mid-century, Bronzino's skills and Mannerist devotions become clear. The highly formal, nearly theatrical dignity of the pose has a dimension of its own. The most striking element in the canvas is of course Eleanor's elaborate robe, with its jewelry and its lavishly textured brocade. Yet, the durability and success of Bronzino is that as an artist he was able to rise above the limitations of his precepts. Despite all the deliberate elaborateness, his work has a dominating simplicity in conception and an economy of statement. Despite his concern with intricate texture, the portraits have a largeness and an unimpeded clarity. In that sense, they might be compared to the work of the great Flemish painters. As a portraitist, Bronzino possessed a considerable power of insight into the expressive potential of the human face, another major source of spontaneity and integrity in his work.

Portrait of Eleanor of Toledo and Her Son, Giovanni

circa 1545
TEMPERA ON BOARD, 45⅛ X 37¾ INCHES
UFFIZI GALLERY, FLORENCE

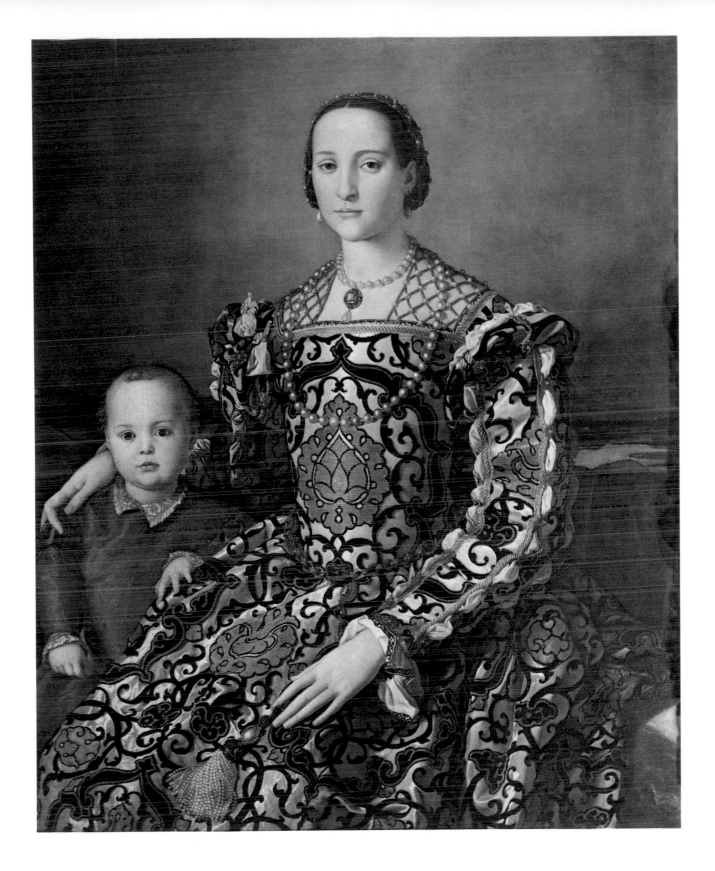

TINTORETTO

1518–1594

Tintoretto lived the whole of his seventy-six years in the city of Venice and gave the high theater of Venetian art its most dynamic expression. As a master of ingenious, daring composition and as a painter who blended the physical and spiritual with magical skill, he had no equal, with the possible exception of Michelangelo. He worked until his death and fulfilled immense projects with a capacity for hard labor that remains astonishing in itself.

The climax of Tintoretto's career came with the great canvases painted to decorate the walls and ceilings of the Scuola di San Rocco. These panels took twenty-three years to complete, and were they all of Tintoretto's output, they would still amount to an impressive lifework. But he painted much more. Some of his works, like the great *Susanna and the Elders* in the Louvre, make one think of Titian in their glowing solidity and warmth. Others, like the two canvases of *The Miracles of Saint Mark* in the Accademia, Venice (a third in the series hangs today in Milan), are alive with the linear electricity and spatial dynamism that are Tintoretto's most indigenous qualities. The famous use of white line and transparent, silver color in El Greco's painting came out of Venetian art, and there is a *Nativity* by Tintoretto in Santa Maria Maggiore, Venice, which shows how much of El Greco may have come directly from his work. *An Allegory of Fidelity* may not demonstrate the extraordinary breadth and imagination of Tintoretto, but it suggests his skill as a master of the brush, of rich Venetian color, and of a potent luminosity.

He was born Jacopo Robusti. The name Tintoretto came from *tintore*—the Italian for dyer, his father's trade. He may well have studied with Titian but he also took Michelangelo as an inspiration and kept the latter's drawings in his studio. In 1577, much of his painting was destroyed in a fire at the Doges' Palace, the same fire that ravaged a major part of the work of Giovanni Bellini. Tintoretto then began to decorate the restored palace, and his efforts there include the most panoramic of all his masterpieces, the great *Paradise*, cited, with Michelangelo's *Last Judgment*, as one of the great landmarks of Western art.

But along with these ambitious works, Tintoretto's portraits rank as masterpieces more intimate in scale, yet no less important. He painted numerous heads of Venetian doges and senators, marvels of human observation, delectable color and magnificent draftsmanship.

An Allegory of Fidelity

1570–1580, OIL ON CANVAS, 43¼ X 41 INCHES
FOGG ART MUSEUM, HARVARD UNIVERSITY
CAMBRIDGE, MASSACHUSETTS
GIFT OF MRS. SAMUEL SACHS IN MEMORY OF SAMUEL SACHS

[74]

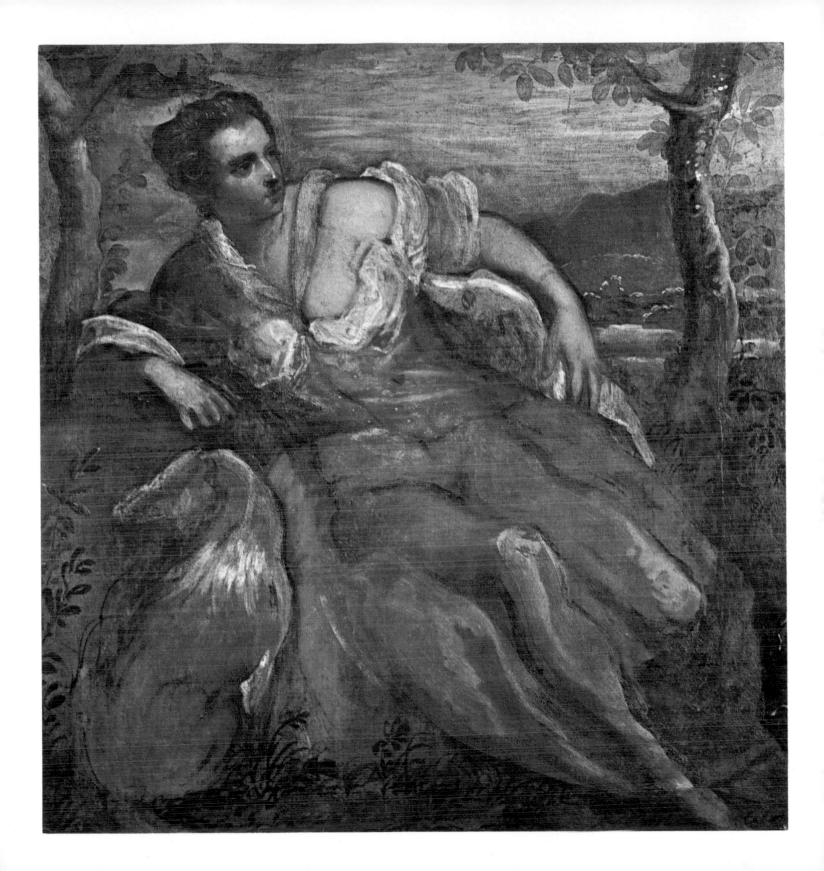

BRUEGHEL

circa 1525 – 1569

The imagination and high craftsmanship of Pieter Brueghel dominated Flemish painting during the mid-sixteenth century. Where Van Eyck and Van der Weyden had been able to conceive images of faith and tranquility, Brueghel inherited a world of turmoil and terror. The Netherlands of his day was in the hands of Spain, of a crown unwilling to tolerate the spectacle of a Protestant Reformation. Troops dispatched from Madrid ravished the lowlands, killing and raping with bestial savagery.

Before the massacre, Brueghel had devoted himself principally to landscape painting and to whimsical engravings that earned him a reputation as Pieter the Droll. But the Spanish invasion provoked him to moral outrage. Though direct political comment was out of the question, he found it possible to express his reactions in oblique, symbolic, often allegorical ways. Hence, his famous *Triumph of Death*, a panorama of horror, starkly and impeccably painted in sulphurous reds and blacks. Paradoxically, the work hangs today in the Prado in Madrid.

The Harvesters is the fruit of happier days. Brueghel had a special talent for constructing compositions of multitudinous parts and broad vistas. He loved to paint village festivals teeming with jovial peasants, who became, through Brueghel's genius, images of warm and vivid color. He had a genuine affection for the Flemish peasants and he painted them with relish rather than with aloofness or condescension. And just as he loved the rustic people, he loved the land. Late in life, he painted four masterpieces depicting the seasons of the year—of which this harvest vignette is the summer panel. The practice was an old one going back to the Middle Ages and the great books of the hours and seasons.

While Brueghel's attitude toward humanity was in no way medieval, his concept of color and of formal, plastic presentation preserved definite links with the richness and dignity of medieval art. His frame of reference was broad, however. He had been to Italy and knew the High Renaissance. His concepts and techniques were advanced and imaginative. After his death in Brussels, his sons took up the craft and carried on a family tradition that survived for two centuries.

The Harvesters

1565
OIL ON WOOD, 46½ x 63¼ INCHES
THE METROPOLITAN MUSEUM OF ART, NEW YORK

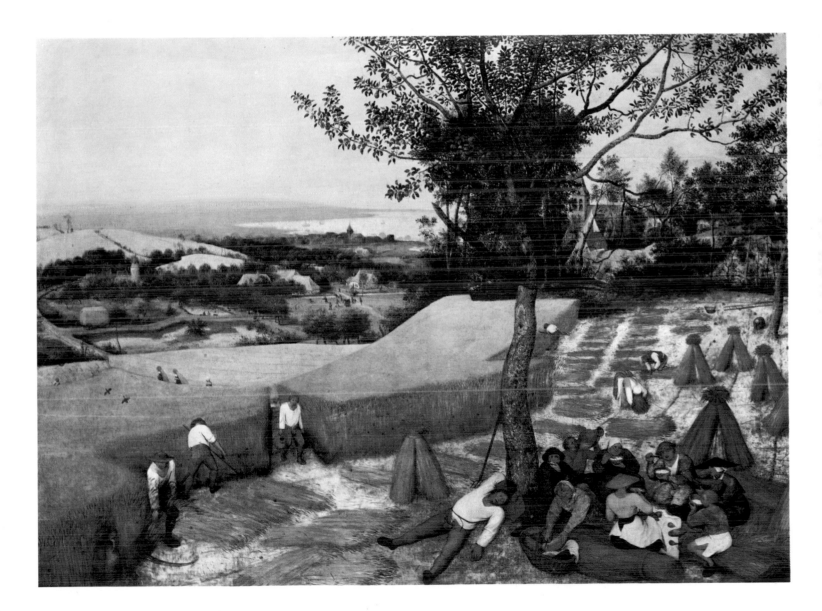

MASTER OF THE HALF-FIGURES

circa 1510 – circa 1550

Young Girl Playing a Lute is the masterwork of a Flemish painter whose name is not known but whose personal style is strongly evident in a number of works. Scholars have been able to establish that he worked during the second quarter of the sixteenth century. They find his craftsmanship present in a number of religious paintings which seem to have been done in collaboration with other painters. But the weight of his accomplishments rests upon a series of small canvases of women reading, writing or playing musical instruments. Each of these is an intimate statement, each deals with a figure from the waist up. Hence the arbitrary identification, Master of the Half-Figures.

The Brussels figure, shown with a lute, is a pure and crisp bit of painting, a concise statement set down in the cool, tranquil tones of northern Renaissance art. Typically, the painter has recourse to a vivid evocation of detail focused with a clarity rather sharper than the normal definition of the human eye. But the precision is far from ostentatious. On the contrary, the canvas becomes a surface of simplified and placid shapes that yield an overall harmony. It is both portrait and genre piece and projects a convincing tenderness without being sentimental.

Much research has gone into deciphering any possible symbolic content of the work, but with limited results. The golden vase may be a symbolic allusion to the worldly life of Mary Magdalene. The second sheet of music bears the word *jouissance* in Old French, the first word of a poem by Clément Marot to which several composers of the day had set music.

Young Girl Playing a Lute

N.D.
OIL ON PANEL, 10¾ x 8 INCHES
PRIVATE COLLECTION, BELGIUM

[78]

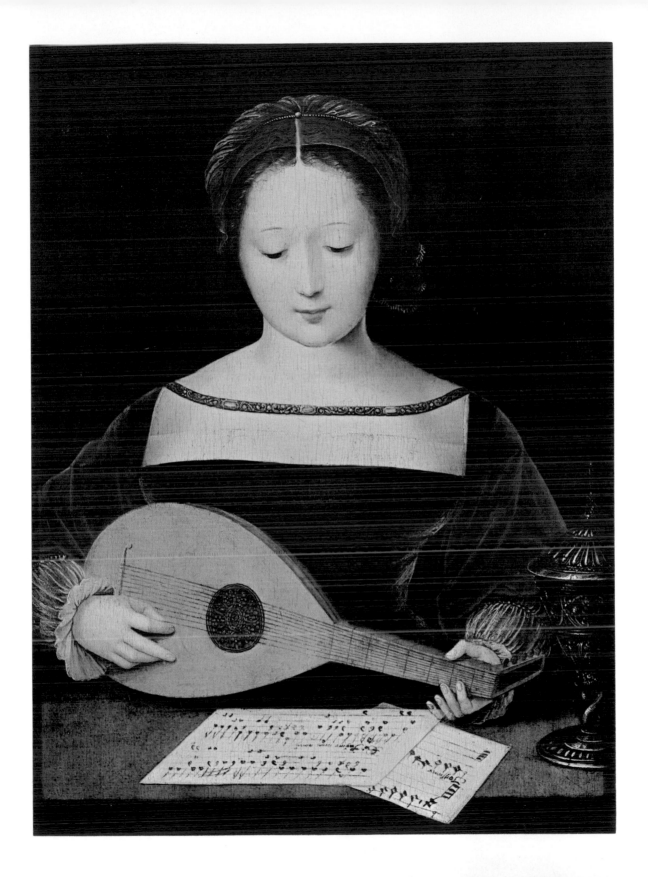

VERONESE

circa 1528–1588

Out of affection for his native city of Verona, Paolo Caliari styled himself "Il Veronese," yet it was as a son of Venice that he found greatness. Veronese was a young contemporary of Titian and Tintoretto, but his was a lighter and more gregarious temperament. He responded to the physical grandeur and temporal riches of the island state whose mercantile fleets, sailing into the Grand Canal, bore exotic cargoes from the East and made Venice a prosperous power. Veronese celebrated the city's worldly grandeur. Where Tintoretto transmuted Venetian color and architecture into a complex and transcendent spiritualism, Veronese expressed through religious subjects the brilliant and sensual personality of Venice.

The immense teeming canvas of *The Wedding at Cana* is an awesome example of Veronese's *esprit*, of his virtuosity, and indeed of his tremendous energy. The composition is a severe and classically influenced whole made up of a multitude of bristling, interacting, independent parts. Veronese's love of texture and opulent detail in marble, fabrics, silver, tile, is demonstrated in the complex fore- and middle ground. It is fascinating to note that in the very center of the foreground, just beneath the figure of Christ, is a chamber music ensemble that blends the arts and religion in a convivial mood: Bassano on the flute, Titian on a bass viol, Tintoretto playing a lute, and Veronese himself with a cello.

Later, Veronese painted a number of more saturnine works, including the *Calvary*, also in the Louvre. But even there he deliberately sets out a balanced composition of distributed parts. The emotional impact comes not through a poignant focus on the crucified Christ, as in Titian, but through a broad, theatrical staging of light and color—a ballet of elements united in diversity, as are the lofty halls and jubilant guests of *The Wedding at Cana*.

The Wedding at Cana

1562–1563
OIL ON CANVAS, 262⅛ x 393¼ INCHES
LOUVRE, PARIS

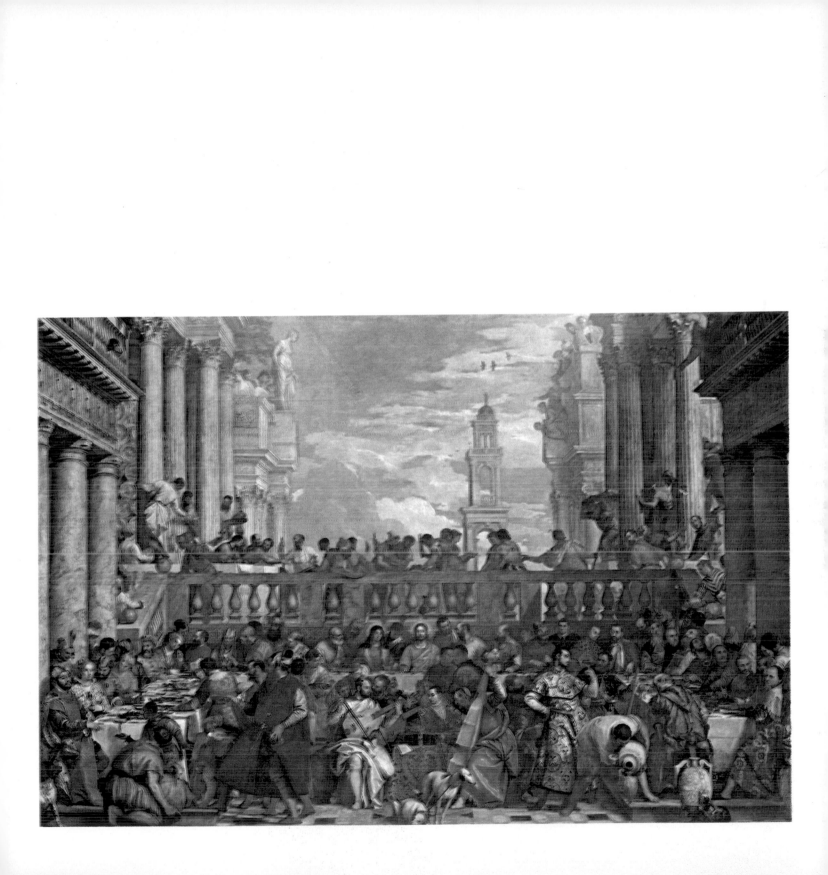

EL GRECO

circa 1541–1614

It was Domenicos Theotocopoulos, born in Crete and trained in Italy, who brought the foundations of a national Spanish art to Castile. Toledo became his spiritual home, and there the Spaniards gave him the sobriquet by which he has ever since been known, El Greco, the Greek.

The epoch was one of fanaticism and torment. Philip II, who was said to love painting second only to religion, waged a holy war for the kingdom of heaven and conducted the Inquisition with cruel enthusiasm. El Greco's perspectives were more moderate. He was well read—he knew Greek, Latin, Italian and Spanish—and aware of the conflict then prevalent between humanism and religion. In Italy, he had seen a Christianity less austere than Spain's, and in Spain he counted among his friends one of the world's great humanists, Miguel de Cervantes. While El Greco's painting reflects one of the most mystical and most spiritual visions in all the history of art, it indicates as well powers of perception that were formidably objective—as in the portrait of *Cardinal Don Fernando Niño de Guevara*.

This work, which has been called the greatest of El Greco's portraits, is the highest of all in color key. Unlike Greco's saints and angels with their ghostly distortion of feature and their shimmering light, the cardinal—and Grand Inquisitor—is executed with a natural solidity and a penetrating attention to temporal character. The portrait's intensity is overwhelming. Affected by the black, burning eyes of the Inquisitor, someone once slashed them with a blade; the canvas has since been restored. The portrait clearly refutes critical speculation that Greco's vertical stylizations were the product of madness or of astigmatism. He chose *not* to distort when his subject evoked no sense of exaltation.

It was in Venice that Greco learned his craft and became enamored of the silvery, linear brushwork of Tintoretto. He may have studied with Titian and the brothers Bassano before leaving for Rome, where he came to know the work of Michelangelo and Raphael. Ironically, the Spain he adopted and enhanced responded only partially to his genius. Philip rejected the great *Legend of Saint Maurice*, commissioned for the Escorial, where it hangs today. El Greco's reputation, after his death, went into eclipse; his works were neglected or denigrated until the present century.

Cardinal Don Fernando Niño de Guevara

circa 1596–1600
OIL ON CANVAS, 67¼ x 42½ INCHES
THE METROPOLITAN MUSEUM OF ART, NEW YORK

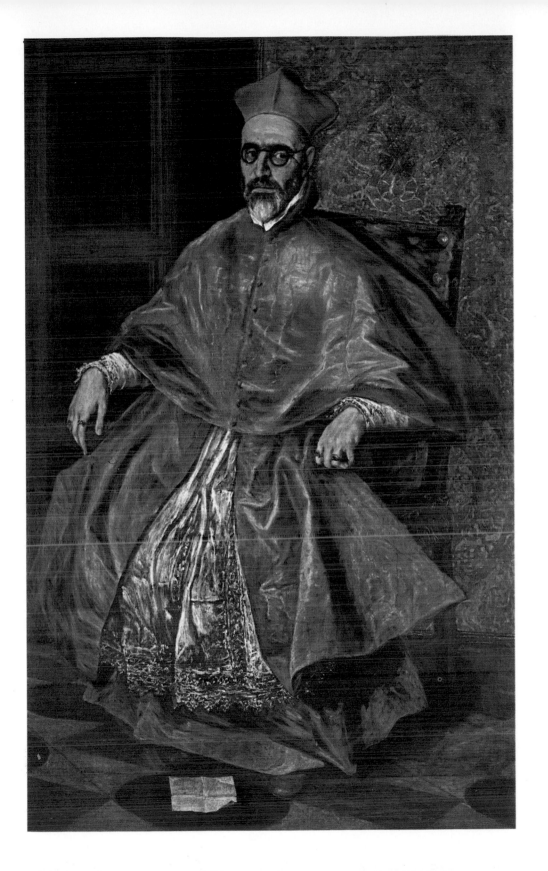

CARAVAGGIO

1573–1610

Michelangelo Caravaggio has been dubbed the father of naturalism in painting. He preferred simple, unhistrionic subjects and treated them with a dramatic and uncomplicated frankness. Yet, the real triumph of Caravaggio's work is its architectural magnitude. His paintings harness light to the purposes of volume. Every tone, color and line in Caravaggio is calculated to participate in a total solidity and an overwhelming resonance, a power nowhere more evident than in the *Bacchus*.

This early work, painted in Rome, probably before 1590, is a marvel of structure and clarity. It might be thought of as an epic still life in which flesh, fabric and the fruits of the earth are organized to achieve a crescendo as architectural and intellectual as it is bacchic.

The actual figure of Bacchus is thought to be a self-portrait—a theory in no way contradicted by Caravaggio's tempestuous career, which ended in a violent street brawl when he was thirty-seven. Caravaggio was continually involved in scrapes with the law, duels, dubious dealings with women, and once even in a fatal stabbing. At the same time, his diligent and sober work was no less destined for scandal—and because of its very simplicity. The realism and natural candor with which he developed sacrosanct themes, and especially religious ones, shocked his sixteenth-century contemporaries. His detached interest in the abstract possibilities of light and form is a markedly modern characteristic, and it becomes interesting to note that the outraged response which greeted Caravaggio's contributions closely parallels the experience of Manet three centuries later (see p.146).

In his later work, Caravaggio turned to a style less linear than that of the early *Bacchus*. He developed a use of dramatic contrast in the interplay of deep shadow and effulgent light—a chiaroscuro technique that greatly influenced two masters of the subsequent generation, Velasquez and Rembrandt.

Bacchus

circa 1589
OIL ON CANVAS, 38½ x 33⅜ INCHES
UFFIZI GALLERY, FLORENCE

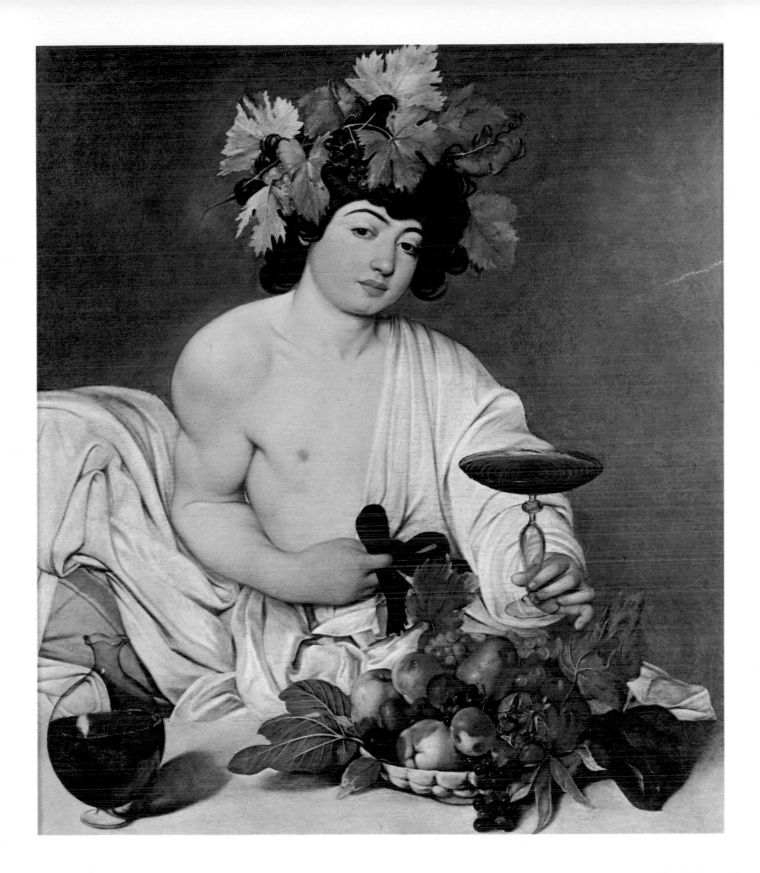

RUBENS

1577–1640

Rubens' *Judgment of Paris* epitomizes the elegance and opulence of the Flemish titan. He was one of the world's most prolific painters, a man of incessant energy whose lifework—as painter and as professional diplomat—constitutes an anthology of forcefulness and refinement.

If his disciple Van Dyck was an irrepressible rake who painted with cool detachment (p. 100), Rubens was exactly the opposite, a prudent man adept in affairs of state, whose work unleashed a world of sensuality and drama. He loved to construct complicated and turbulent compositions, to depict ferocious battles and lusty abductions. Yet, during the years of negotiation for peace between the thrones of England and Spain, Rubens was entrusted with difficult assignments as an official or secret emissary. His life as a diplomat even affected his life as a painter, for not only was he knighted by both Charles I of England and Philip IV of Spain, but he also came to know Velasquez, who was responsible for the acquisition of many important Rubens works for the Spanish treasury.

The Judgment of Paris is one of Rubens' greatest canvases, though more tranquil than many. This is a Flemish *mise-en-scène* of the ancient Greek myth in which Paris chooses Venus as the most beautiful woman on earth by presenting her with an apple. The apple of the legend is golden. Red was good enough for Rubens. The composition itself moves with a natural, sinuous flow whose grace is repeated and expatiated in the treatment of each area—the flesh of the three beauties, the warm and cool tones of the sky, the more opaque masses of Paris and Mars, the dark brilliance of the foliage.

At the age of twenty-three, Rubens went to study in Italy, an experience that completely transformed the already considerable skills he had mastered in Flanders. He was almost immediately employed by the Duke of Mantua who utilized his talents as a painter and, for the first time, his promise as a diplomat. Later, Marie de Médicis of France became his chief benefactor and commissioned a series of twenty-four paintings, now in the Louvre, in homage to herself. Rubens married twice, and both his wives posed for some of his finest works—Isabella Brandt, who died in 1626, and Helena Fourment, who was sixteen when she married the painter in 1630.

The Judgment of Paris

1635–1636
OIL ON WOOD, 56⅞ x 74¾ INCHES
REPRODUCED BY COURTESY OF THE TRUSTEES, NATIONAL GALLERY, LONDON

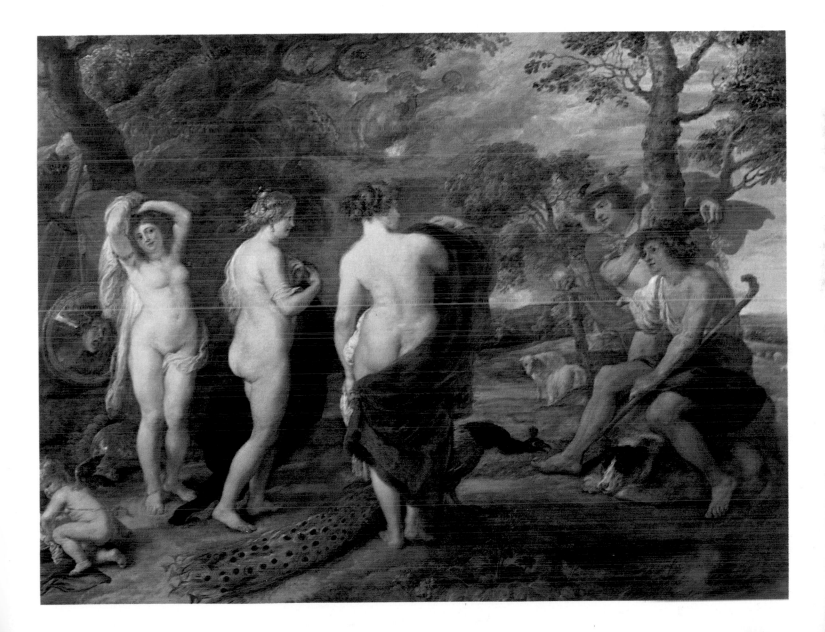

HALS

circa 1580 – 1666

By the seventeenth century, the northern provinces of the Netherlands had declared themselves an independent republic under the reformed church of Martin Luther—and a reaction set in against all symbols of the Catholic past. The familiar sacred art fell from grace, to be replaced by a new and temporal art, the art of Frans Hals.

Though born in Antwerp of Flemish parents, Hals settled in Holland and became the most illustrious of the painters of Haarlem. His brilliant portraits—vivid, incisive, spontaneous—are among the greatest of all time and have been largely underestimated, even to the present day. Hals used a palette of brisk though restrained color, of dominating blacks, silvers, grays and whites, all of which he applied with a slashing energy but with unfailing precision.

In general, his commissions came from substantial Dutch merchants, who rarely offered much opportunity for studies in psychological nuance. On the other hand, Hals's famous portrait of the French philosopher Descartes, also in the Louvre, provides an astonishing insight into the wry and skeptical character of his subject. Hals painted a number of immense group portraits, some of Dutch officers, others of the trustees of the Haarlem old age home—today a museum devoted to his work. These are masterpieces as fresh, alive and cogent as his more intimate works.

La Bohémienne is mellower in color than most of Hals's painting and, however direct, rather more diffuse in brushwork. Hals constructs a cross-movement consisting of a great sweep from lower left to upper right, opposed diagonally by the position of the figure itself. The composition, as well as the brushwork, creates a powerful and electric energy.

Despite a number of important commissions, Hals was plagued by financial difficulties during almost the whole of his prodigious eighty-six years. Two years before his death, the Haarlem town council at last voted him a pension as the belated tribute of a grateful city.

La Bohémienne

N.D.
OIL ON CANVAS, 22⅞ x 20½ INCHES
LOUVRE, PARIS

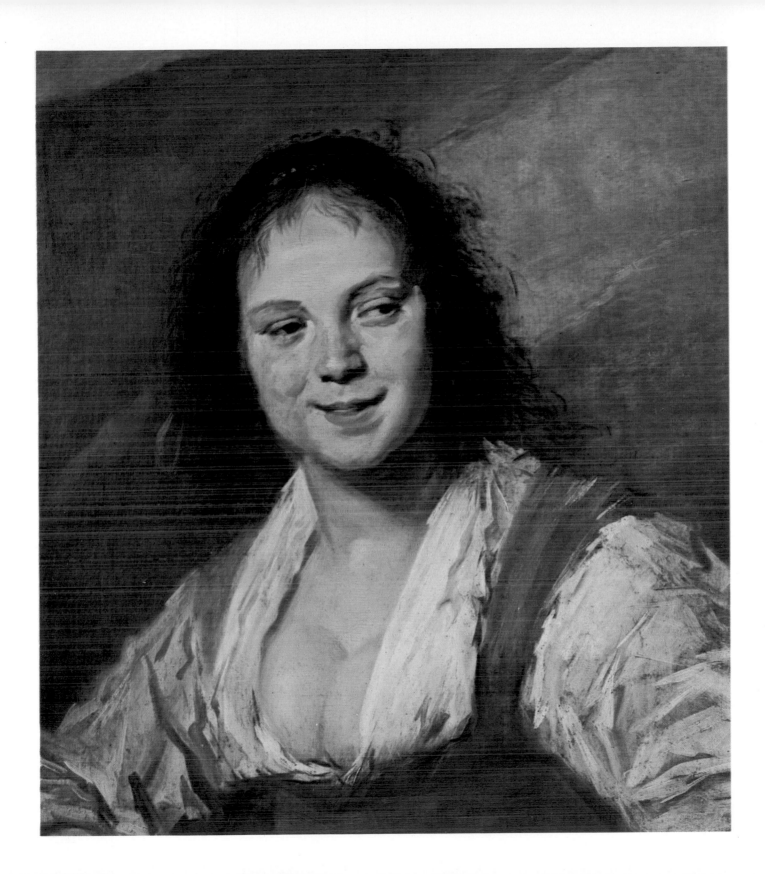

ANTOINE LE NAIN

1588–1648

The brothers Antoine, Mathieu and Louis Le Nain were earnest realists of the seventeenth century, painters whose earthy subject matter automatically opposed the high refinements of Poussin and of the French Academy. Theirs was an epoch in which a bourgeois merchant class began to achieve prominence in France, a group whose taste lent itself to genre themes and frank representations.

The three Le Nains—Antoine was born in 1588, Louis in 1593 and Mathieu in 1607—worked closely together and arrived together in Paris in 1629. Though not alike in temperament, they collaborated on many canvases, and in most cases it is difficult to attribute a Le Nain definitively to one or another. Although they came of well-to-do peasant stock, Antoine seems to have had influence in Paris, for he succeeded in winning a place as a master, entitled to his own workshop, without apprenticeship in another atelier. Naturally, he immediately employed his brothers. Their work met with favor, and despite their divergence from the studied elegance of court art, Antoine and Louis became founding members of the new French Academy in 1648. It was toward the end of the same year that a deadly epidemic swept Paris, taking the lives of the two laureates. Mathieu was to survive his brothers by almost three decades.

The Village Piper dotes upon the theme most native to the Le Nains, peasant life in the small villages of northern France. Louis painted a series of peasant families in which he used a dramatically lit, monumentally carved technique that parallels the naturalism of Caravaggio. Antoine's work has a rather more primitive quality, an almost awkward Norman frankness appropriate to its theme, a freshness and immediacy. He loved to deal with landscape, to define the crystalline shapes of a cathedral spire or group of cottages clustered in the silvery gray of northern light.

The Village Piper

1644
PAINTING ON COPPER, 8½ x 11½ INCHES
THE DETROIT INSTITUTE OF ARTS

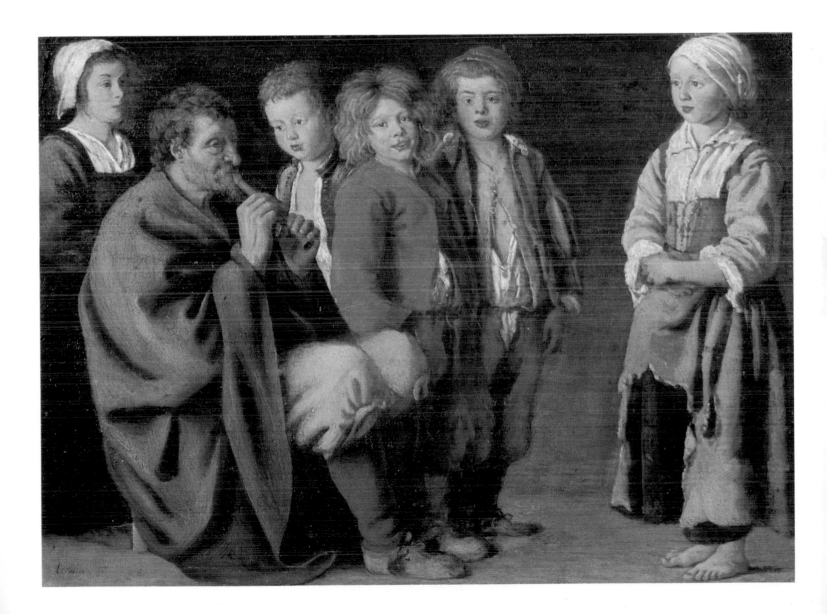

POUSSIN

1594–1665

Nicolas Poussin worked at the moment in history when French genius courted the spirit and mythology of the classical past. In letters, it was the age of Corneille and Racine—*Le Grand Siècle*. In painting, it was Poussin who gave a full and contemporary dimension to the Greek and Roman inspiration.

Today, Poussin is recognized as a wholly French personality, in his balance of intellectual and emotional elements, in his unfailing sense of proportion—qualities that make a living entity of what otherwise might have been a stultified nostalgia. But in his own day, Poussin's powerful talent was constricted by the nature of art officialdom in Paris. During the period when he occupied the high post of "First Painter to the King," his energies were continually channeled into marginal decorative projects. It was in Rome, the meeting point of classical and Renaissance forces, that Poussin's gifts were unshackled.

There, in the service of Cardinal Barberini and hence in the heart of Roman intellectual circles, he absorbed the influences of Italian art, of Titian, Raphael and Leonardo. He read Dürer's treatises on anatomy and developed a rapport with the sense of proportion and structural harmony that the Renaissance inherited from Greece and Rome. He evolved an art of pure form which lives independent of its literary connections. Almost three centuries later, Cézanne was able to look to Poussin as a dynamically modern influence.

Et in Arcadia Ego is a work perfectly harmonized in all its components. The composition of figures and landscape is arranged with a sinuous and circular flow in counterpoint to the actually linear delineation of each of its parts. Its architectural volume is complemented by a dark and dulcet light that evokes memories of Giorgione. Its idyllic theme—the happy and innocent land of Arcadia—expresses in a brilliant unity the pastoral sensibility of Poussin, son of Normandy, and the Greco-Roman vision of Poussin, formal poet of neoclassic strophes.

Et in Arcadia Ego (The Shepherds of Arcadia)

1637–1638
OIL ON CANVAS, 34¼ x 47¼ INCHES
LOUVRE, PARIS

[92]

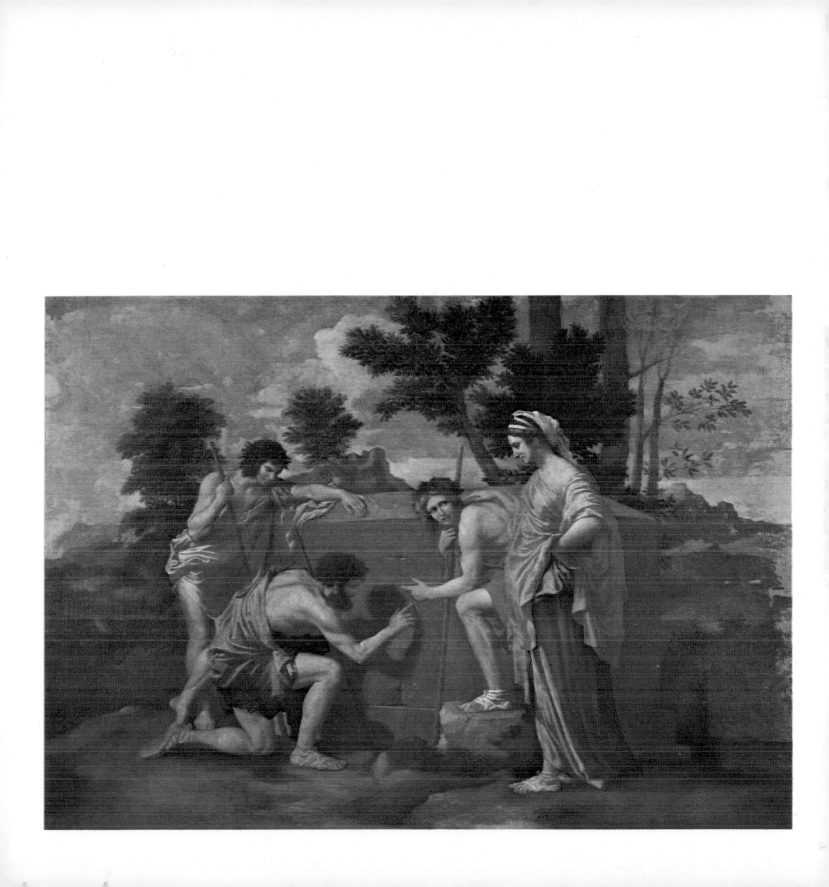

LA TOUR

1593–1652

The work of Georges de La Tour was governed by an idea and by a spiritual presence. Like Claude Lorrain, he was born in the Duchy of Lorraine before that almost Germanic region had been annexed by France. Lorraine knew a strong Franciscan tradition whose spare asceticism toward temporal realities affected La Tour's view of the world and of painting.

Saint Joseph the Carpenter, like all of La Tour's sacred works, is sharply illuminated by a single light source—in this case a candle held by the Christ child. For La Tour, this source of light epitomized a source of life and a symbol of divine presence. His works construct an atmosphere of high drama in which considerable tension is produced by the very stillness and silence of the effect. Broad structural areas combine and succeed each other in the pervasive shadows. The brilliant white light emanating from the candle gives breath to the living presence of the figures, Saint Joseph straining at his labors, and the Christ child in his innocence.

At the time of the French annexation of Lorraine, during the Thirty Years' War, Louis XIII arrived in the province. When a plague epidemic broke out, the king ordered a *Saint Sebastian* by La Tour to be hung in his bed chamber. The presence of the work greatly affected him and he felt that it might serve as protection against the scourge.

La Tour enjoyed a considerable reputation in the Lorraine of his day, though it would seem that even the annexation of the region failed to spread his fame to France. In fact, only in the twentieth century did La Tour's prominence begin to reassert itself. Before that, scholars generally ascribed his paintings to the French, Italian and even Spanish schools. Today, the mark of his personality and the intensity of his chosen idiom have been recognized anew.

Saint Joseph the Carpenter

circa 1640–1645
OIL ON CANVAS, 53⅞ x 40⅛ INCHES
LOUVRE, PARIS

[94]

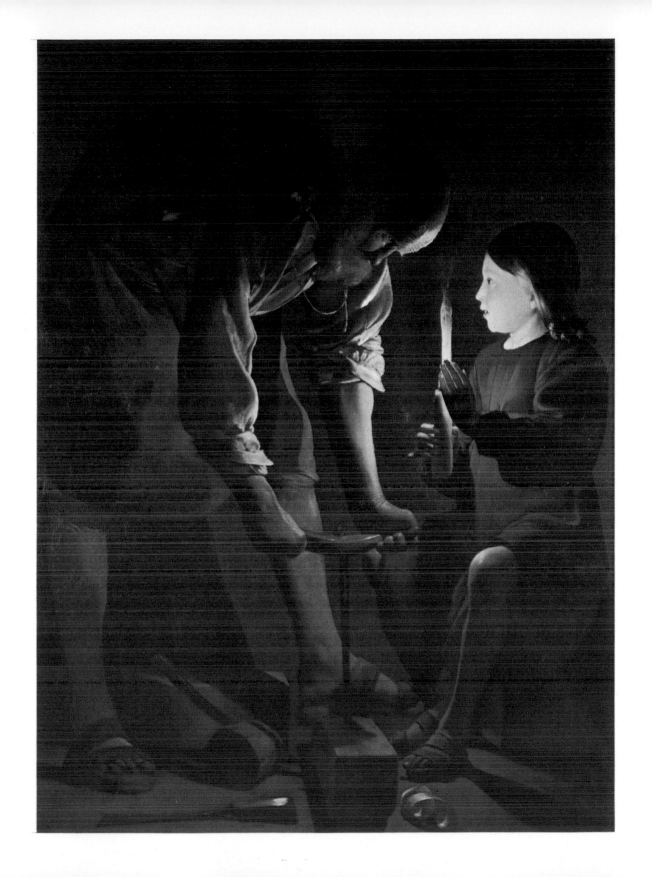

JORDAENS

1593–1678

The painting of Jacob Jordaens was an extension of the school of Rubens, a virile product of the robust Flemish spirit carried into colloquial bypaths. Jordaens was a pupil not of Rubens himself but of Adam van Noort, who had been Rubens' teacher. Yet, the example of Rubens then permeated Flemish painting and after the master's death, Jordaens was regarded as his spiritual heir and worthy successor.

Jordaens' work tended to be less elegant. *Three Itinerant Musicians* is typical of the genre themes he treated with a hearty, almost peasant enthusiasm. The heavy pigment has a life of its own, and each of the three rustics is carved out with a direct and sensuous application of brushwork. This is, in sum, a vividly realistic vignette of rural entertainments, but done with an admirable zest for light and color that raises it above the usual narrative genre piece.

Jordaens lived to the age of eighty-five and led a life of uninterrupted success. Rubens valued him and once commissioned him to do a series of cartoons (basic drawings) to be worked as tapestries for the King of Spain. Jordaens painted a group of murals for the palace of the widow of Frederick Henry of Orange, Stadt-holder of Holland, paintings that survive as his major accomplishment.

He organized a workshop, as was the practice of the time, with many pupils as assistants. He married the daughter of his former teacher, Van Noort, became a wealthy and prominent citizen, and himself a collector of the arts.

Three Itinerant Musicians

N.D.
OIL ON CANVAS, 19¼ x 23⅛ INCHES
PRADO, MADRID

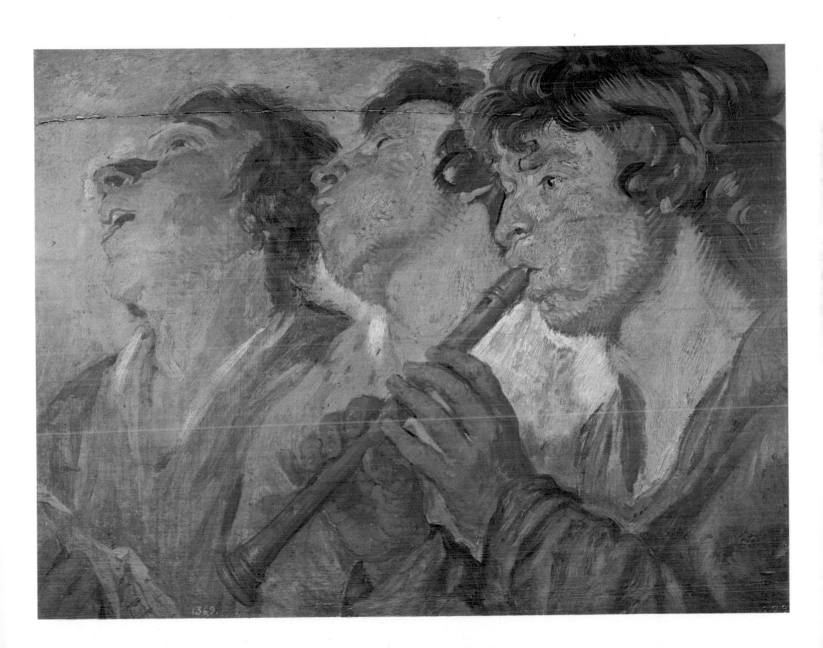

VELASQUEZ

1599–1660

Velasquez can truly be called a painter's painter. His vision was perhaps the least specifically dramatic in Spanish art. Rather, he loved to manipulate pigment and line to create a quiet, plastic elegance.

He was an early master of naturalism and one of the giants of Spanish art. Velasquez was appointed painter to the royal household of Philip IV. The King appreciated his talents despite the fact that the genetically dilapidated Hapsburg dynasty with its moronic jaws and ungainly traits made the painter's role as a realist infinitely delicate.

Velasquez was both a court official and a friend of the king, and his many portraits trace the life of Philip from young monarch—Velasquez in those days used an especially muted palette of Spanish blacks and earth colors and silvery high tones—to mature ruler, in a period of richer color for Velasquez, of crimsons and violet tints.

The birth of Balthasar Carlos, heir to the throne, of course gave the painter an imperative new subject, and the 1635 portrait on horseback is one of the finest results of his many encounters with the prince. The work is cast in a dramatic light with a cold blue aura sweeping the distant Castilian earth and a great thrust of air and movement surrounding the stallion and its little rider. But for all that, the painting is devoid of any kind of artifice, and each surface, each volume, is handled with a characteristically rich, precise and sober intensity.

It would seem probable that Velasquez was influenced by Caravaggio, whose work was known even in isolated Spain. Subsequently, he made several trips to Italy, either in the service of Philip, to acquire paintings for Spain, or—of his own accord—on the advice of Rubens. At times, Velasquez' naturalism turned toward a strongly anecdotal genre representation that even prefigures the Academy.

During his greatest years, his efforts were almost exclusively limited to formal court studies, but there were occasional masterworks of greater conceptual breadth. In *The Maids of Honor (Las Meniñas)*, the king, the painter himself, and the Infanta with her attendants form a remarkable interior composition. *The Surrender of Breda* commemorates a notable Spanish victory in a magnificent panorama of men and arms.

Prince Balthasar Carlos on Horseback

1634–1635
OIL ON CANVAS, 82¼ x 68⅛ INCHES
PRADO, MADRID

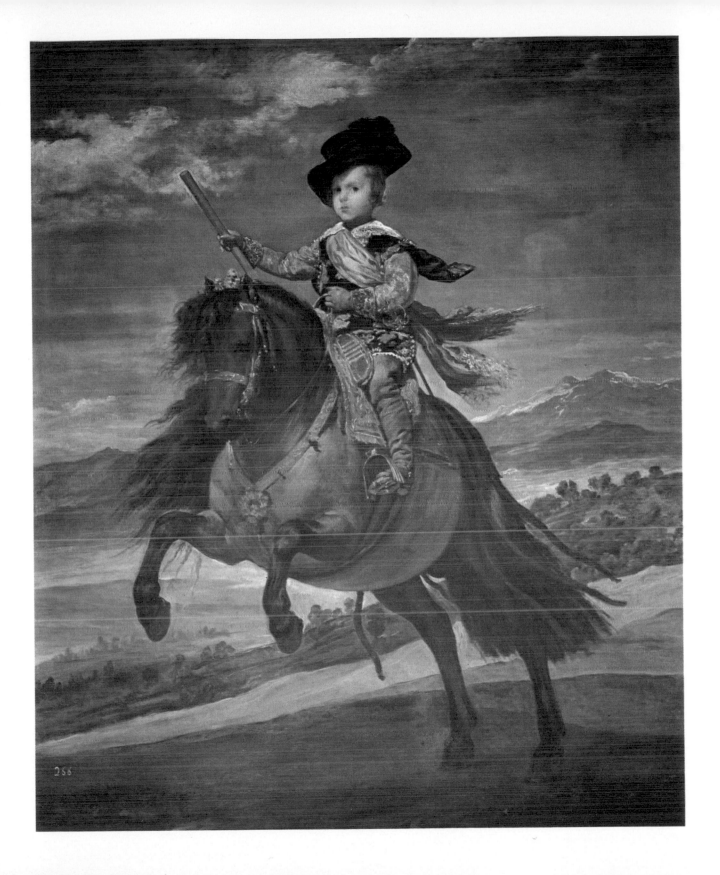

VAN DYCK

1599–1641

Anthony Van Dyck was an elegant painter of international tastes and accomplishments. He was a Fleming, born in Antwerp, endowed with the robust temperament of the nation that gave birth to Rubens. As an expatriate in Italy, he studied the Italian masters, came under the Venetian influence of Titian and Tintoretto, and himself influenced the school of Genoa. As resident painter to the English court, he tempered his Flemish enthusiasms to the cool elegance of the English aristocracy—and in turn established an example that would long affect English portrait painting.

At the age of nineteen, Van Dyck was already an accomplished craftsman and full-fledged member of the Antwerp Painters' Guild. At twenty, he had become a leading assistant in the studio of Rubens, an association that continued to be the foremost single influence upon the whole of his work. During the years that followed, he assimilated into his own style the color of the Venetian masters and developed the technique of vertically elongating his figures to emphasize a quality of elegance and aristocratic dignity. No other integral changes took place. His idiom became famous in Europe and universally emulated.

His *Charles I, King of England*, in the Louvre, is one of several Van Dyck portraits of the Stuart monarch. Though the King in his Cavalier dress and cup-hilted sword stands motionless and austere, the composition as a whole is fluid and turbulent in the manner of Rubens. Typical of Van Dyck, great attention is lavished upon details of physical splendor—Charles's silk doublet, the rich sky, the lustrous foliage—all part of a cohesive psychological fabric. For all the painting's high realism is organized on behalf of a conceptual reality—that of royal hauteur.

Van Dyck's social standing in England was distinguished. His romantic life flourished beyond even the free-wheeling standards of Restoration England, and his friends are said to have precipitated his marriage in 1639 out of concern for his welfare. And yet, his enormous quantity of work was as cool in conception as his personal life was tempestuous.

Charles I, King of England

circa 1635
OIL ON CANVAS, 107 x 83⅜ INCHES
LOUVRE, PARIS

[100]

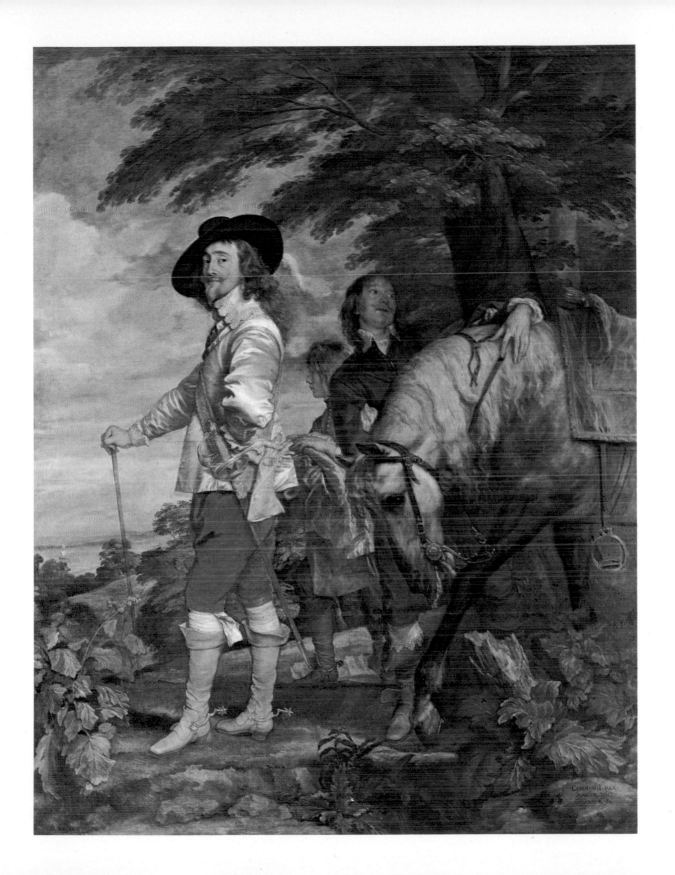

CLAUDE

1600 – 1682

Claude Gellée, known as Claude Lorrain, or simply as Claude, ranks among those French masters of the seventeenth century who found inspiration in Italy and in Italianized mythology. Yet, for Claude, it was the landscape itself that held the greatest fascination. During his lifetime, he came to be recognized as the foremost landscape painter in Italy. His reputation became international. He counted the Pope and the King of Spain among his admirers and patrons, and he found it necessary to compile a complete catalogue of his works as proof against a rash of forgers and imitators.

It was in Rome that he met Poussin, who became a close friend and a significant influence. The *Reconciliation of Cephalus and Procris* blends Claude's own pastoral preoccupations with the classical narratives that attracted Poussin and were to become fundamental to the Academy. In the foreground, Diana, goddess of virginity and of the hunt, reunites the hero Cephalus with his wife. The actors in the Greek legend actually become incidental to the panorama, a kind of obbligato that points up the romantic flavor of the scene.

Claude's use of light is a haunting combination of naturalism and high theater. He spent long hours observing the many phases of light from dawn to dusk in the Roman campagna; and the nuances of sky in the *Reconciliation*, as well as the encroaching shadows of the hillside, reflect a close fidelity to experience. On the other hand, the overall quality of light is arranged for psychological effect. The aura he produces is a romantic sensation of transient drama.

Claude's influence, small during our own century, was considerable for many generations. During the nineteenth century, he was hailed as "the prince of landscapists," and his works had a notable effect upon English painting, particularly upon Turner.

Reconciliation of Cephalus and Procris

1645
OIL ON CANVAS, 40¼ X 52 INCHES
REPRODUCED BY COURTESY OF THE TRUSTEES
NATIONAL GALLERY, LONDON

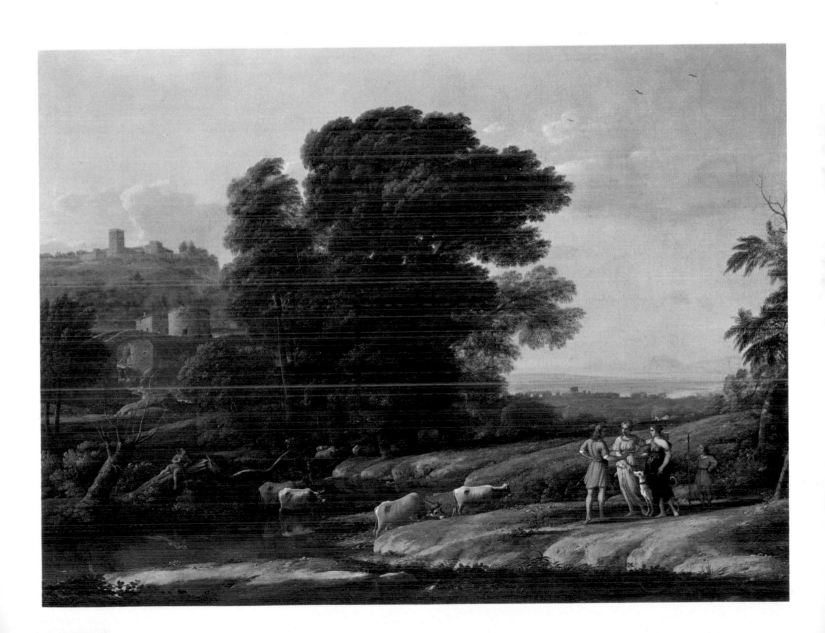

REMBRANDT

1606 – 1669

The work of Rembrandt van Rijn survives as the crowning glory of Dutch painting, and yet as a phenomenon quite apart from any other in Dutch art. The Netherlandish temperament in painting has always been cool, balanced and temporal. The Flemish spirit has always been energetic, lusty and extroverted. The art of Rembrandt, on the other hand, is mystical, introverted, sensual, almost oriental in feeling.

During his sixty-three years, Rembrandt's work evolved technically and spiritually until he arrived at the great and profound masterpieces of his last years, works that are among the most poignant and magnificent ever painted. Unhappily, as his vision evolved, public appreciation waned. His earliest portraits, which constitute the first of three major periods, are able studies in the sturdy, Dutch tradition. But *circa* 1654, the period of *The Night Watch*, Rembrandt began to venture further, cultivating a use of deep shadow and warm light that had a transfiguring effect. *The Night Watch* was commissioned as a portrait of sixteen members of the Amsterdam civil guard, gentlemen who were interested in personal celebrity and not in art. When they saw the dark masterpiece, they complained loudly, a harbinger of Rembrandt's woes. It was also at this period that he lost his first wife Saskia, whom he had so often painted. Three of their four children had already died, and Saskia's death was a hard blow.

In subsequent works, the golden light first seen in *The Night Watch* became still more magical and Rembrandt's drawing even more remarkable. He dealt with religious themes of both Old and New Testaments, often with mythological themes and landscapes, continually with portraits. Rembrandt's power of objective observation and of personal understanding combined to make his portraits, such as *An Old Man in an Armchair*, no less monumental or important than his more ambitious compositions.

After Saskia's death, Rembrandt found a devoted companion in Hendrickje Stoffels, who bore him a daughter, but his circumstances became dire and he lost his only son, Titus, a year before his own death. A series of incomparable self-portraits traces the physical and spiritual change Rembrandt experienced, and these are climaxed by the touching *Self-Portrait as Paul the Apostle* in the Rijksmuseum of his native Amsterdam.

An Old Man in an Armchair

1652, OIL ON CANVAS, 43⅝ x 34⅝ INCHES
REPRODUCED BY COURTESY OF THE TRUSTEES
NATIONAL GALLERY, LONDON

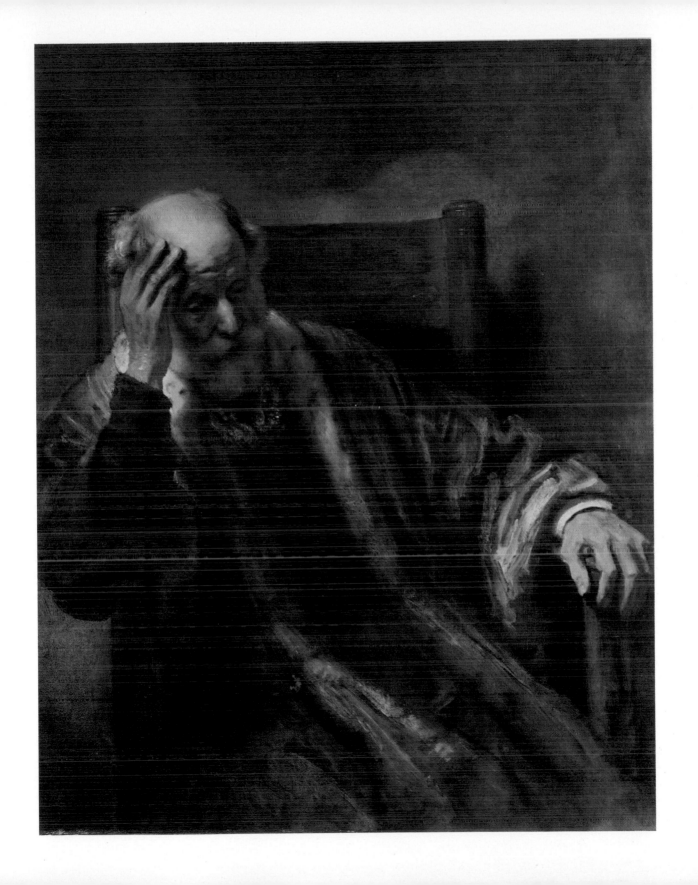

MURILLO

1617–1682

As founder and first president of the Academy of Seville, Murillo applied his talents to a kind of painting that characterizes most academic establishments of modern times—anecdotal, technically proficient and sentimentally inclined. *Boys Eating Melon and Grapes* is typical. Murillo treats the theme of a momentary delight experienced by barefooted street urchins with an almost contradictory technique of polished surfaces and idealized forms. Murillo—orphaned by the age of ten—knew the impoverished but colorful street life of his native Andalusia, which continually reappears in his work.

It was Velasquez who served as Murillo's mentor and inspiration. At the age of twenty-six, the young Murillo traveled from Seville to Madrid expressly to see the great man. Velasquez treated his visitor with interest and generosity, gave him lessons, and made the great royal treasury of art available to him. When Murillo returned to Andalusia three years later, he established a brilliant reputation and married into an affluent family. He received numerous commissions from churches and religious groups, and was hailed as the dean of Sevillian art. His work was imitated to such an extent that a Spanish style known as "Murillo" came to be and lasted into the nineteenth century.

Murillo's religious works tend to be lachrymose and, like the temporal street scenes, anecdotal. It is an odd fact that so militantly religious a nation as Spain produced so little religious art. Its greatest exponent, El Greco, was not a Spaniard. Velasquez rarely treated spiritual themes. Goya channeled his mystical inclinations in other directions. Only Zurbarán and Murillo survive as major Spanish painters of religious themes, with Zurbarán pursuing a restrained and formal plasticity, Murillo a libretto of sweetness and melancholy.

Boys Eating Melon and Grapes

circa 1645
OIL ON CANVAS, 57½ x 40⅞ INCHES
ALTE PINAKOTHEK, MUNICH

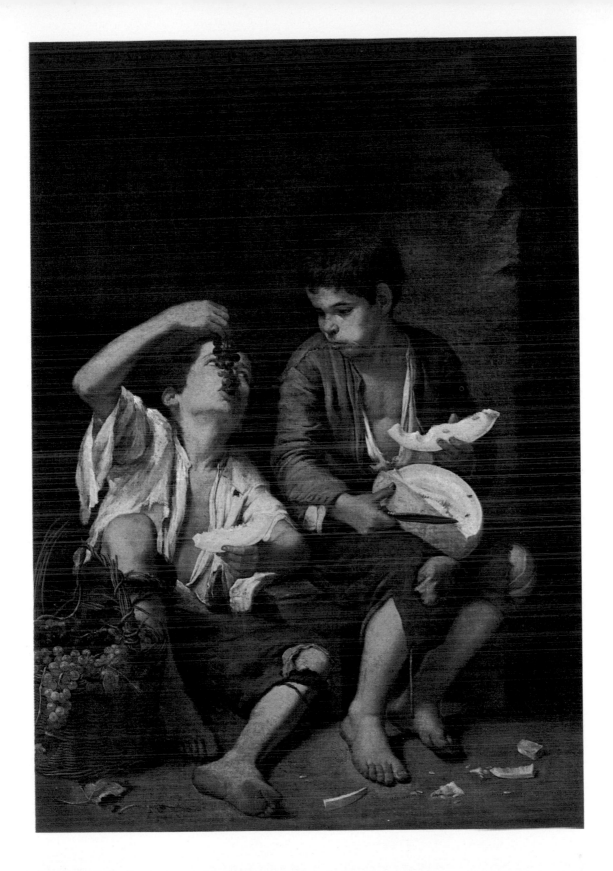

TER BORCH

1617 – 1681

Gerard Ter Borch was a painter of the social elite in Holland, a sophisticated drafts-man, international in experience. He was a painter's son, came to his calling early, and entered the painters' guild in Haarlem at the age of eighteen. He went to England to visit Van Dyck. He traveled to Rome to see the wonders of the Renaissance. In Spain, he came into contact with Velasquez, and was commissioned to paint a portrait of Philip IV. At Münster, he was given an impressive commission to paint a group portrait of the delegates to the Peace of Westphalia, 1648.

Where De Hooch painted a middle class milieu, Ter Borch specialized in genre pieces that portrayed the upper crust in moments of leisure—as in *The Concert*. The work has a compelling quality which results in part from its eccentricities, its strange unevenness of handling. The figure at the harpsichord is muted with a dark tension that may well be a result of Ter Borch's Spanish experience. The red doublet worn by the lady at the cello is painted with a potent but sweet luminosity, in quite another key. Her bright silken dress, meticulously and specifically reproduced, is handled in still another key and creates an unlikely focal point for the canvas. The distribution of shapes among the figures is precariously balanced and is another source of dis-sonance. Because of, or in spite of, which the ensemble has a definite, personal presence.

Ter Borch was born in Seville and trained in Amsterdam and Haarlem. He eventu-ally settled in the city of Deventer, married there and became a prominent citizen and member of the Common Council. He was admired as a painter and engraver, and sought after as a portraitist until his death at sixty-four.

The Concert

circa 1675
OIL ON OAKWOOD, 22 X 17¼ INCHES
STAATLICHE MUSEUM, GEMÄLDEGALERIE, BERLIN

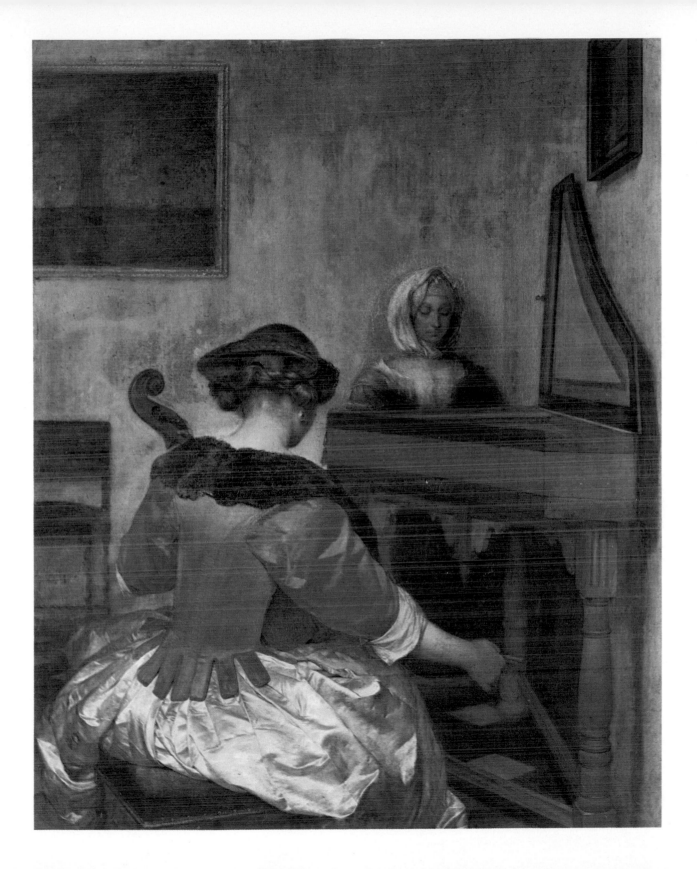

RUISDAEL

circa 1628–1682

 Dr. Jacob van Ruisdael was a Haarlem physician who painted some of the finest landscapes in all of Dutch art. During the seventeenth century, the Dutch landscapists were exploring in two general directions. There were those, like Seghers and ultimately Rembrandt, who experimented above all with the effects and possibilities of light. And there were those who held to a more wholly naturalistic and linear treatment. Ruisdael was the chief exponent of this second impulse. His works have a captivating luminosity. For him light is a means of carving and glazing the landscape, a descriptive force and a source of unity, rather than the focus of his art.

 In *Sunlight*, for example, Ruisdael's descriptive use of light is masterful—the deep, tenebrous areas of the summer landscape and the high, silvery volumes of the summer sky. In capturing the transient moment of darkling light before the storm, he transfigures the mundane facts of his subject. Details set down with admirable tact—the figures in the stream, the blades of the windmills, the walls of the distant town, the birds indicated in the sky—are precisely calculated to accentuate a feeling of spaciousness and grandeur. The painting, for all its Dutch placidity, bespeaks a depth of temperament, a true delight in plastic values and an eye for atmosphere that approaches the romantic.

 Ruisdael's family was steeped in the arts. His father was a painter as well as an art dealer, and his uncle, Salomon van Ruisdael, was a landscapist whose works are esteemed in Holland to this day.

Sunlight

1670–1675
OIL ON CANVAS, 32¾ x 35½ INCHES
LOUVRE, PARIS

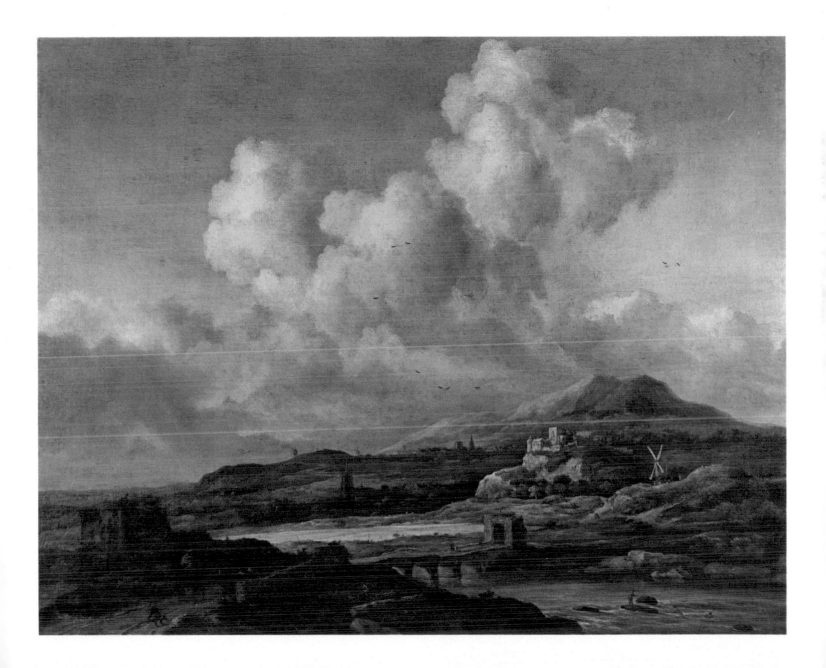

DE HOOCH

1629 – circa 1684

Pieter de Hooch was a modest genre painter of seventeenth-century Holland. His world was that of the middle class burghers of Amsterdam and Delft and he celebrated their comfortable life and times in many interior vignettes. *An Interior,* in the National Gallery, suggests a definite link with Vermeer, who was De Hooch's contemporary. It has none of Vermeer's economy of composition and statement, yet its very awkwardness lends a convincing charm. Each area is painted with a sure sensitivity, cast in the warm light that pours in from the left to carve shapes and planes in gentle contrast. The brilliant red in the dress of the woman at the window was a specialty of De Hooch's, a touch always associated with his name.

De Hooch's father was a butcher who painted as a hobby, and it may have been at home in Rotterdam that the artist received his first training. Later, he studied with Berchem in Haarlem. At twenty-three, he joined the service of a prosperous merchant of Delft as painter and lackey, callings which seemed perfectly compatible at that time and place. Delft was also the city of Vermeer and Fabritius, and it was probably there that contact was established between De Hooch and Vermeer. It was also in Delft that the painter met his wife Jannetje, whose death after the birth of a third child was a cruel blow. After the tragedy, he returned to Amsterdam where he drowned his sorrow in copious work.

An Interior

circa 1658, OIL ON CANVAS, 31 x 25⅜ INCHES
REPRODUCED BY COURTESY OF THE TRUSTEES
NATIONAL GALLERY, LONDON

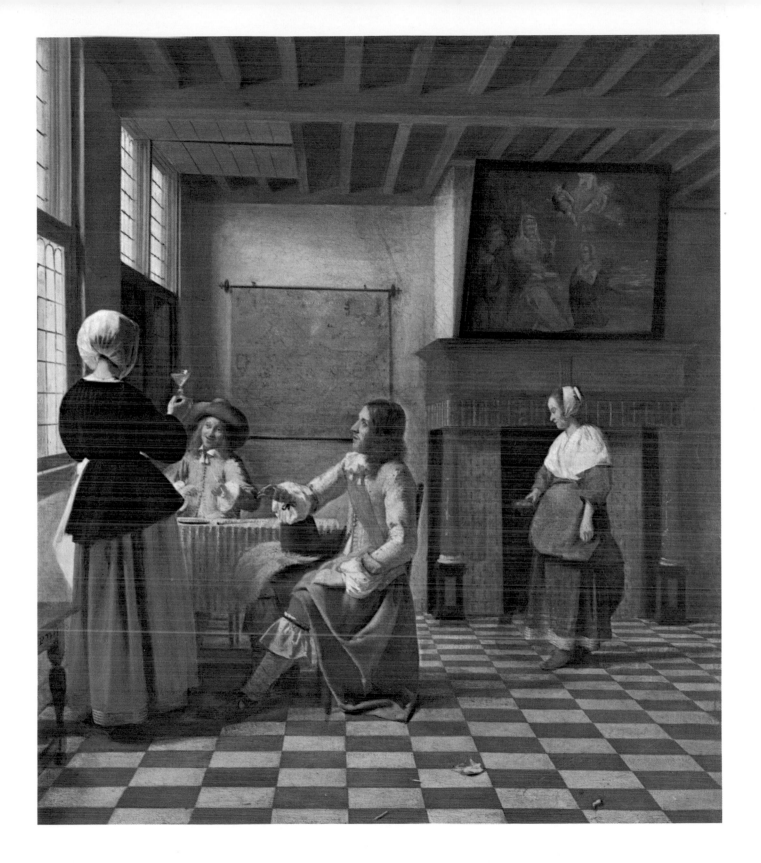

VERMEER

1632–1675

In the true Dutch tradition, the work of Jan Vermeer emphasized the fabric of temporal life and external forms, a tranquility of spirit and a fidelity to balanced composition. And yet, at the same time, his works have a quality beyond temporal concern. Where a Pieter de Hooch transfixed his figures in a moment of time, Vermeer's compositions seem to evade time in favor of a magical and transcendent stillness.

Young Woman with a Water Jug is a moving example of this paradox in Vermeer's work. His use of light is distinctive, and in fact Vermeer was probably the first painter to use a truly *plein-air* technique—that is, to utilize actual daylight as a source of total illumination. Another technique of Vermeer's, though one commonly in use at the time, may have abetted the haunting presence of his work—the camera obscura. This was a box with a lens that projected an image against the back of the device, thus simplifying ambiguities in perspective and composition. The use of the camera obscura may have added a flat and formal dimension, which contributes to the inimitable atmosphere of Vermeer's paintings. Still, their particular balance is unmistakably Netherlandish, and cousin even to the wholly abstract authority of Piet Mondrian three centuries later.

Vermeer made his livelihood as proprietor of his family's tavern, where paintings were sold as well as beer according to the practice of the day. However, his stature as a painter was almost entirely unacknowledged, a fact implicit in the lack of information about him in contemporary archives. Little is known beyond the fact that he married at twenty-one, had eight children, and died at forty-three. Though it is certain that his wife Catherine posed for him, which of his canvases bear her likeness is a matter for scholarly debate. Indeed, it was not until 1866, almost two centuries after Vermeer's death, that his importance was first recognized—in a series of articles published in Paris by the critic Thoré-Bürger.

Young Woman with a Water Jug

circa 1663
OIL ON CANVAS, 18 x 16 INCHES
THE METROPOLITAN MUSEUM OF ART, NEW YORK

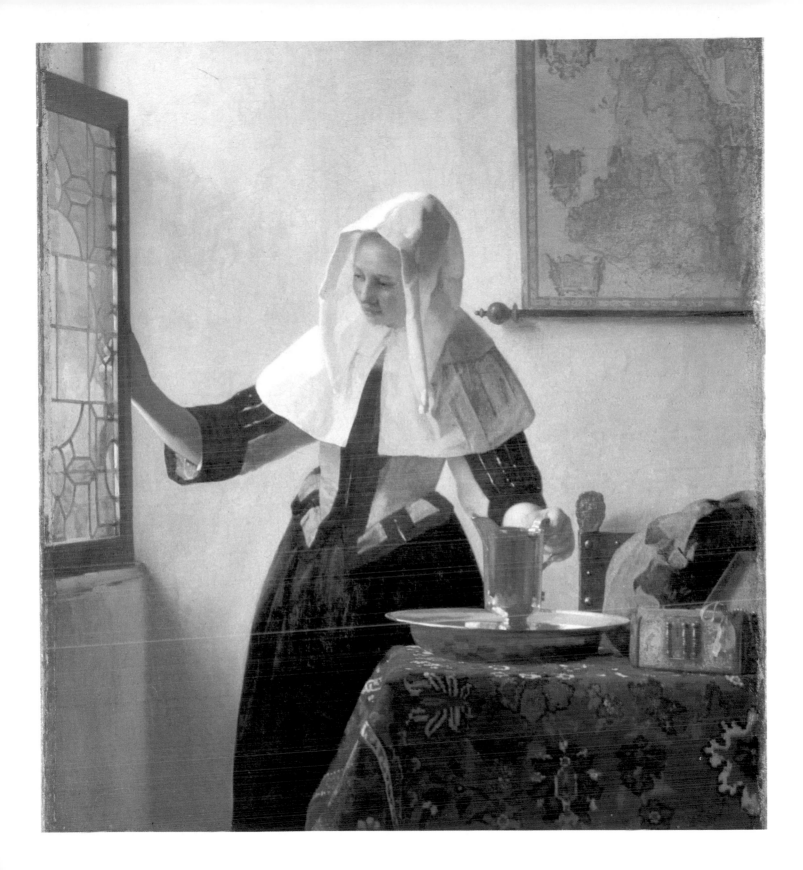

WATTEAU
1684–1721

Jean Antoine Watteau might be thought of as the transcendent hero of eighteenth-century French aesthetics and also as its martyr. For this painter who died of poverty and consumption at the age of thirty-seven made an enduring art out of the transitory values of his epoch.

The Embarkation for Cythera was intended as a fashionable picture and, indeed, it incorporates the myths and conventions of court romance at that time. The principals are gracious, aristocratic figures, preceded by a consort of cherubs. The landscape is lush, idealized, dreamlike. And yet, the work has an authenticity and a magnificence that supersede its formulas. There are those who like to say that Watteau, sick and unrecognized, projected a shadow of his despair upon themes treated by his more successful colleagues with a fatuous enthusiasm. But this explanation is itself a romantic hypothesis and explains little. The talent of Watteau as a painter of light and movement, aside from subject matter, explains much more. *The Embarkation for Cythera*, for example, flows in a vast, elegant sweep from the ascending cherubs, back through the ranks of the revelers, and up into the golden trees. The distant landscape and fluctuations of light in the sky bring the movement around to describe an almost elliptical course. And this movement is as natural and unstrained as it is gracious. The gentle if dramatic modulation of light is itself marvelous, orchestrated in the defined tones of the figures and foliage, and again in the diffused areas of the near foreground and the diminishing background.

The work of Rubens had considerable influence on Watteau, and though their temperaments are very different, a close bond is apparent in the use of warm color and light (p. 86).

Despite Watteau's genius, and despite his efforts to meet the prerequisites of his era, commissions were few and generally unimportant. His health and finances steadily deteriorated.

In 1719, he went to London for medical advice and his condition was pronounced hopeless. He returned to France, worked until he could work no more, and died in utter neglect.

The Embarkation for Cythera

1717
OIL ON CANVAS, 50¾ x 76⅜ INCHES
LOUVRE, PARIS

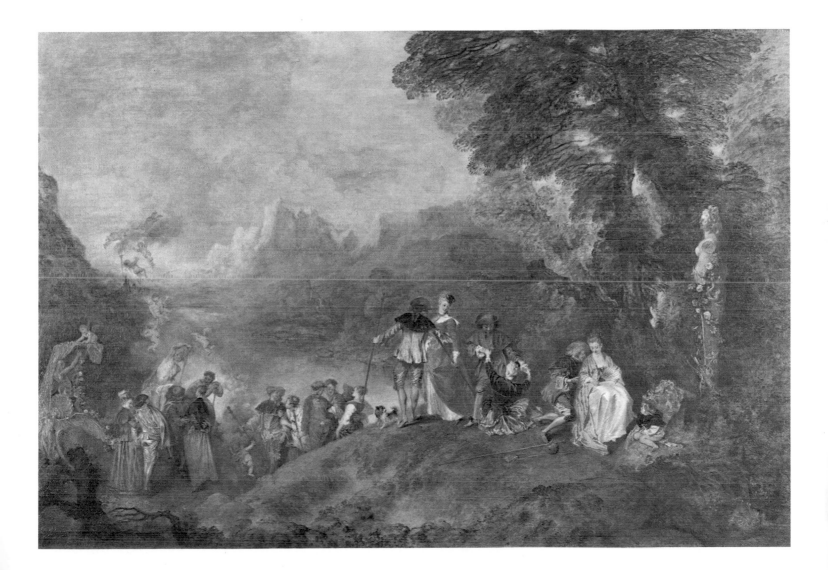

TIEPOLO

1727 – 1804

The Tiepolos, Giovanni Battista and his son Giovanni Domenico, were ebullient poets of eighteenth-century Venice. As masters of the Italian rococo style, they gave themselves utterly to the buoyancy and masquerade of their theatrical city — much as Veronese had done two centuries earlier.

Domenico, painter of the *Carnival Scene*, was predominantly influenced by his father. Together, they traveled to Würzburg in Bavaria to decorate the Archiepiscopal Palace of the Prince-Bishop Von Greiffenklau. Together, they traveled to Madrid for a five-year project involving the Spanish royal palace. It was in Madrid that their work attracted the attention of Goya, whom they interested and eventually influenced. Domenico's vision tended to be more acid and incisive than his father's — he was fond of caricature — and it was undoubtedly he who most affected Goya.

The *Carnival Scene* is generous and expansive in its atmosphere. However intricate the composition, however precious its insistence upon niceties of detail, the work is actually handled with a crisp and decisive touch. A sensation of space, accentuated by a vast blue sky receding into an infinite distance, is a specialty of the Tiepolos. They loved to paint domes and stairways that suggested the materialization of angels or nymphs through an actual sunlit aperture, a theatrical conceit carried off with verve.

Domenico excelled as a draftsman, and the energy of his line is demonstrated in the *Carnival Scene* — a vibrant line that thrusts and parries, that moves from area to area in the great crowd, never becoming in any way monotonous or redundant. The dark masses of animated figures in the background, seen against the blue sky or against the neutral glow of the wall, have an almost Spanish tension, which, along with the carnival grotesque, may point to a link with Goya.

Carnival Scene (Minuet)

circa 1754
OIL, 31⅛ x 42½ INCHES
LOUVRE, PARIS

[118]

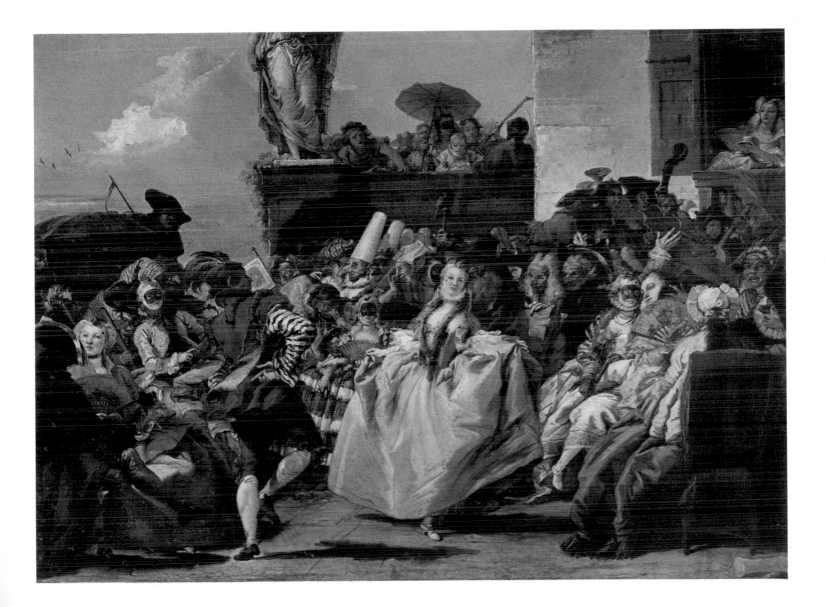

CHARDIN

1699–1779

In the august company of Watteau and Fragonard, Chardin reigns as the great master of eighteenth-century French painting—and yet, paradoxically, as the great creative exception to the art of his place and time. His was the epoch of Louis XV, of Madame de Pompadour, of the calculated pomp of Versailles. It was an age of masquerade in which a baroque infatuation with the cosmetic and the confectionary extended to painting and largely engulfed it. Chardin responded to the eccentricities of his time with a relentless and elegant simplicity. His contemporaries cultivated the exotic, garnishing their works with Turkish, Chinese and neoclassical motifs. Chardin found his material in France, and in the most routine facts of existence at that. His colleagues developed and gilded a conscious pose. Chardin disregarded pose entirely and courted a wise balance. His colleagues sought to perfect their style by a dazzling visual etiquette. Chardin looked to unornamented structure and distilled the purest, most forceful statements possible.

Chardin was a student and admirer of the Dutch school, and in *The Blessing* he developed a modest genre theme that recalls the tranquil interiors of Vermeer and De Hooch. The simplicity of this painting and its quiet anecdotal nature may tend to discourage many modern viewers. But a closer look reveals that its quality lies deeper—a strong and sure sense of architecture, a dexterous counterpoint of textures that is only a secondary delight compared to the powerful ensemble of convincing structural elements. It is in this sense that Chardin, who gave breath to the still life as a major art form in European painting, is both heir to Caravaggio and ancestor to Cézanne.

Chardin's capacity to conjure up poetry from the monotony of daily life was noted by Marcel Proust, whose writing often parallels Chardin's aesthetic. To painters, the genius of Chardin consists largely in his ability to blend the intimate and the monumental, the delicate and the massive, in a spirit of lasting serenity.

The Blessing

1740
OIL ON CANVAS, 19⅜ x 15½ INCHES
LOUVRE, PARIS

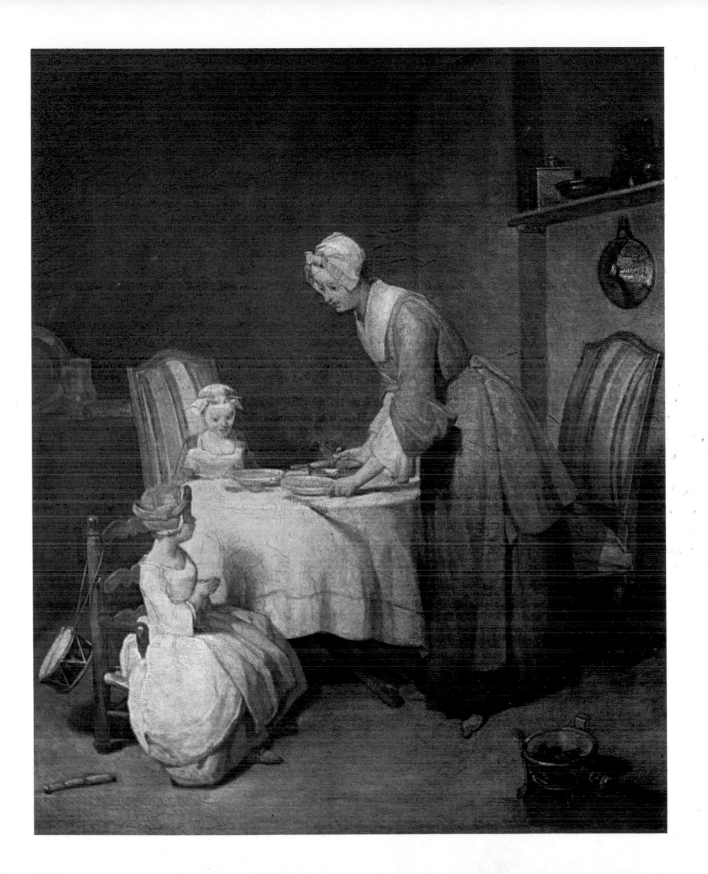

BOUCHER

1703–1770

François Boucher's *Diana Resting* exemplifies the tone of court aesthetics during the reign of Louis XV. The ideals of the age were formally designed in deliberate, artificial patterns, as were the endless corridors and gardens of the palace at Versailles. The elaborate masquerade included a devotion to mythological themes, and many a countess attended balls at Versailles as Diana the huntress. Boucher limned the dreams of the court with a supple hand.

As a personal friend and protégé of Madame de Pompadour, Boucher gained access to the inner circles of the court. With her influence, he became "First Painter to the King" and the most fashionable painter of the day. He illustrated books, made tapestry designs for Beauvais and Gobelins, and decorated Vincennes and Sèvres porcelain. He was a student of François Lemoyne, won the coveted Prix de Rome at the age of twenty, became a member of the Academy just eight years later, and subsequently reigned as its director. Thus, he functioned until his death as the dean of official French art.

Boucher lavished upon *Diana Resting* all his mastery of line and sweet color, glazed surfaces and precisely calculated effects. The painting's harmony of pale blues and roseate overtones is typical of Boucher. And, even more typically, each area of the picture, from the pink flesh of the goddess to the glistening surfaces of the landscape, is not so much observed as idealized.

What is most immediately apparent in Boucher's work is his delight in the female body, and many of his paintings are highly erotic variations upon this theme. At the age of thirty-three he married a seventeen-year-old girl who served as model for many of his expatiations upon the image of Venus or Diana.

Diana Resting

1742
OIL ON CANVAS, 22½ x 29½ INCHES
LOUVRE, PARIS

[122]

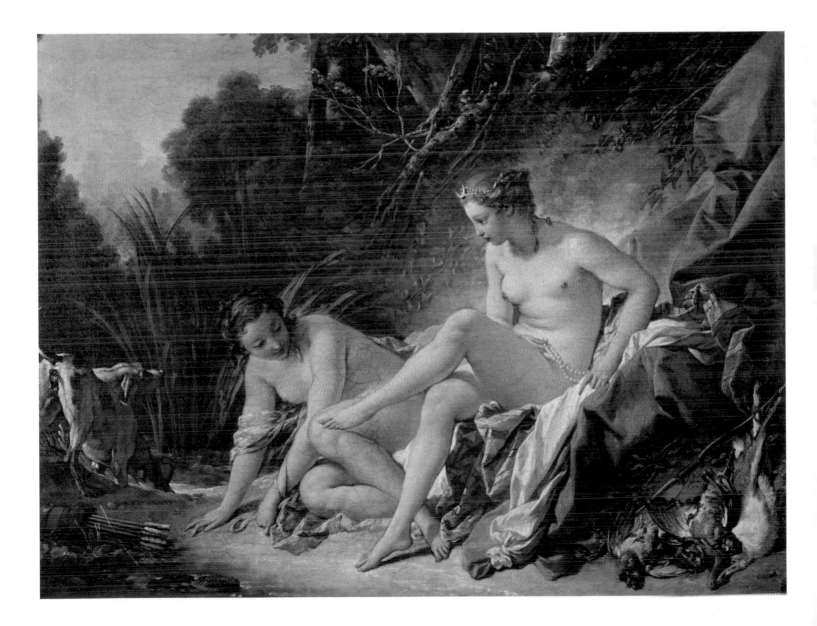

GUARDI

1712–1793

The workshop of the brothers Francesco and Giovanni Antonio Guardi was a vital center of Venetian art during the eighteenth century. Like their brother-in-law Tiepolo, the two Guardis were in tune with the spirit of their shimmering city. Like Canaletto, they became its biographers. The brothers worked together on a good many genre pictures and, as in the case of the Florentine Pollaiuolo brothers three centuries earlier, it becomes difficult to attribute some canvases to one or the other. But Francesco survived his brother by thirty-three years and worked alone on a great series of *vedute,* or views of the city.

This buoyant painting of the Doges' Palace on the banks of the Grand Canal is typical of Francesco Guardi's homages to Venice. His touch approached the impressionistic. He worked for a quality of diffuse, wavering light in order to capture the unique atmosphere of the city, "Bride of the Sea," where a refraction of light upon the water and a reflection of architecture in the canals vibrates everywhere. He had a great capacity for indicating salient detail with precise, miniscule calligraphic strokes. The domes of the Cathedral of San Marco edge up in the distance and the high campanile or bell tower overlooks the city's main artery with its traffic of gondolas — a scene hardly different today.

The Doges' Palace, Venice

1770
OIL ON CANVAS, 22¼ x 29¼ INCHES
REPRODUCED BY COURTESY OF THE TRUSTEES
NATIONAL GALLERY, LONDON

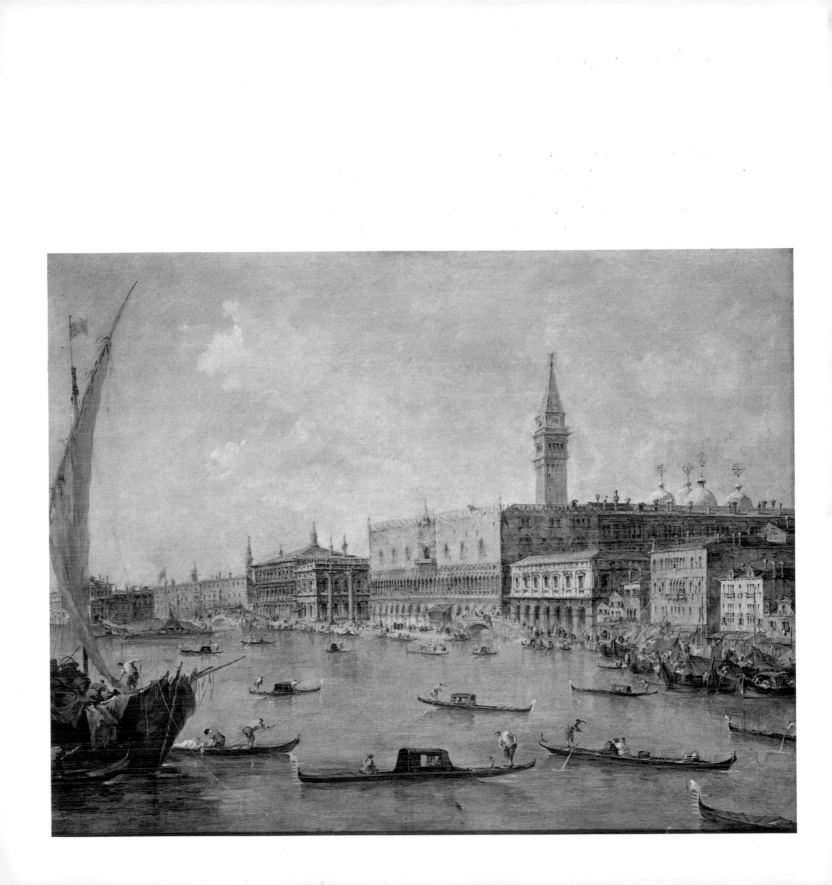

GAINSBOROUGH

1727–1788

Landscape painting was Thomas Gainsborough's first love, but an England bent on portraiture redirected his career. At the invitation of the all-powerful Sir Joshua Reynolds (p. 130) he became a founding member of the new Royal Academy, and subsequently—as portraitist—the arch rival of Sir Joshua himself. Nevertheless, at the time of Gainsborough's death, his studio was filled with landscapes, labors of love, and landscape is an important element even in his portraits.

In *Blue Boy*, the name given to his portrait of young Jonathan Buttall, the background is treated with a spontaneous brilliance—the color is cool, direct, naturalistic. Over the years, Gainsborough's style more and more approached the popular portrait of his day—the studio vignette. The landscaped surroundings became softer, more feathery.

Like Reynolds, Gainsborough began in socially unfavorable circumstances; he was the son of a Suffolk cloth merchant. His career began when he came to the attention of Hubert Gravelot, the French illustrator who ran an art school in London. It was at the fashionable resort city of Bath, however, that his work first became known. Commissions came fast and his reputation was made.

Gainsborough was a brilliant craftsman and a sensitive painter with a light, deft touch. *Blue Boy* is a crisp and resolute bit of painting. The conception may be romantic and the subject idealized, but for all that, a close look reveals that the handling is utterly unaffected and vividly precise.

Blue Boy

circa 1770, OIL ON CANVAS, 70 x 48 INCHES
HENRY E. HUNTINGTON LIBRARY AND ART GALLERY,
SAN MARINO, CALIFORNIA

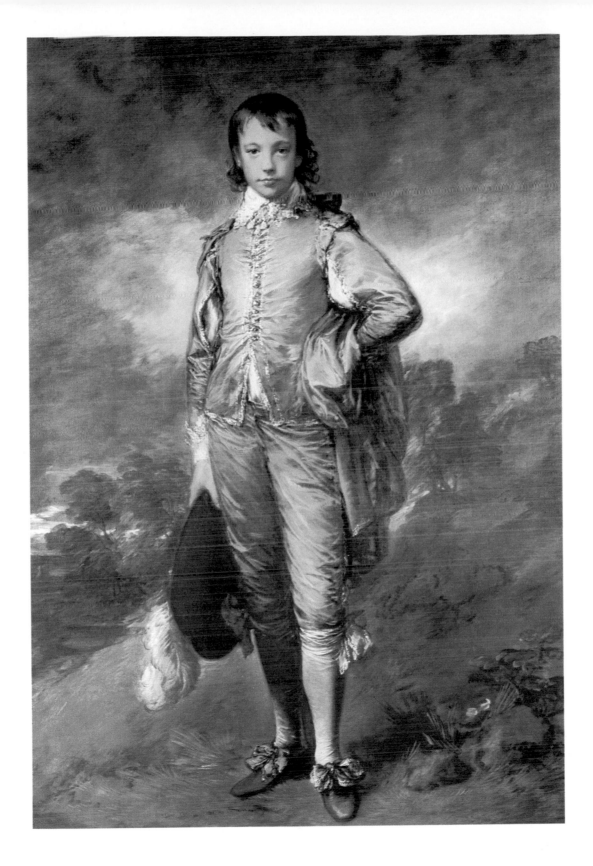

FRAGONARD

1732–1806

Jean Honoré Fragonard came out of the eighteenth-century rococo tradition of Boucher. In the artistic circles that sponsored art, this was an age of facile elegance and ritual sentiment, and only the strongest painters survived the currents of the time.

The Love Letter is a late and particularly rich Fragonard, a painting of great textural warmth. Characteristic of all Fragonard's finest work, it transforms the era's superficial preoccupations with manners and materials into a living poetry of light and line. Fragonard never chose ponderous themes. In Italy, where he traveled as Prix de Rome laureate, he saw the work of Leonardo and Michelangelo, but was much more directly influenced by Tiepolo, whose wit appealed to him, and by Rubens as well. Fragonard celebrated the pleasures of the world; he became immensely successful as a painter of erotic themes, and only turned from them late in life, when the years had oppressed him and when the French Revolution had eliminated his leisured audience.

To a great extent, Fragonard's work even prefigures Impressionism. His vibrant use of light, perhaps suggested by Rubens, was then unique in French painting. *The Love Letter*, for instance, has a shimmering energy that does not depend on linear emphasis. Its vibrance comes of an interplay of light set down in flickering, contrasting strokes of color. A warm, unifying flow bathes the painting and all its precise and delectable parts, each relished for its own sake—the small dog, the bouquet, the bristling "activity" of the dress, the head itself.

As a young man, Fragonard studied with Boucher, and then with Chardin, who complained that he studied very little at all. Yet his accomplishments evolved with remarkable speed. Later, his success was to wane even more rapidly. As a protégé of the aristocracy, he fled Paris when the Revolution began. When he returned, he found a new France devoted to more sober aesthetics and indifferent to his own.

The Love Letter

circa 1776
OIL ON CANVAS, 32¾ x 26⅜ INCHES
THE METROPOLITAN MUSEUM OF ART, NEW YORK

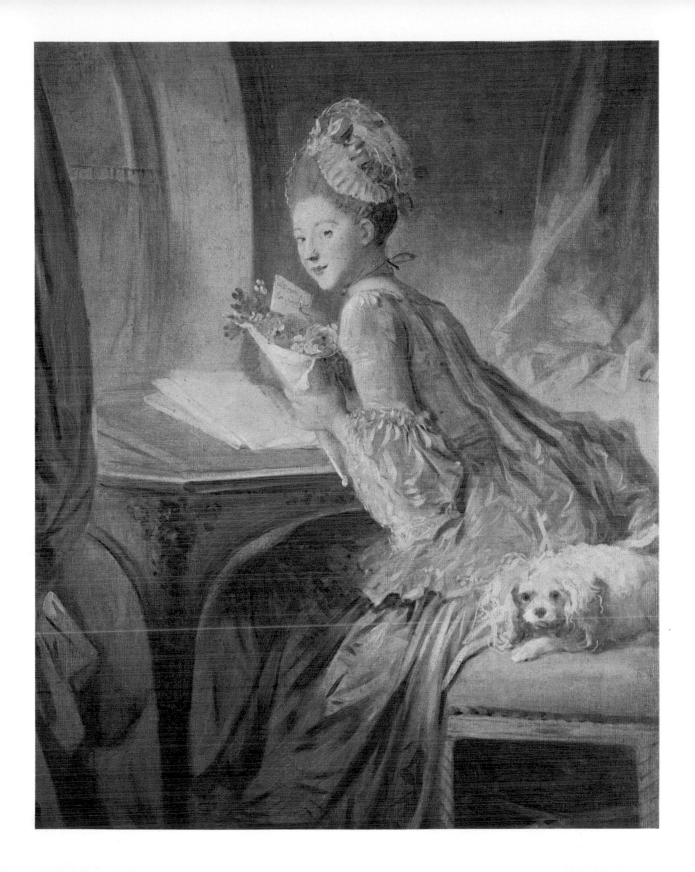

REYNOLDS

1723 – 1792

Sir Joshua Reynolds led the comfortable life of a supremely fashionable portrait painter. Though not born to high social rank—he was the son of a Devonshire clergyman—he gained access, through his work, to the usually impenetrable drawing rooms of the eighteenth-century British aristocracy. He painted some 2,400 portraits, became an indispensable accessory to social eminence in London, and finally won the highest of distinctions as painter to King George III.

The portrait of Master Hare depicts one of the painter's young relatives and was presumably a labor of love. Yet, the grace, warmth and sensitivity with which he handled the picture are typical of all his finest works. Though Sir Joshua knew how to flatter and euphemize, his portraits are often brilliant in their objective perception and in their treatment of plastic qualities—fabrics, foliage, nuances of light. His painting has an authenticity and spontaneity that might be compared to the best of Fragonard.

Something of an institution himself, Sir Joshua became the pillar of the new Royal Academy and its first president. His *Discourses* delivered at the society's annual dinners survive as classic statements of English aesthetic theory in the eighteenth century.

His discovery of Venetian painting had a happy influence upon Sir Joshua's work. As a young man he attracted the interest of the influential Viscount Keppel who took him to Italy aboard his own ship. Three years in Italy brought him into prolonged contact with the legacy of the Renaissance, and especially the work of Titian and Tintoretto. The warm splendor of Venetian color remained a lasting inspiration.

Master Hare

1728
OIL ON CANVAS, 29⅞ x 24⅜ INCHES
LOUVRE, PARIS

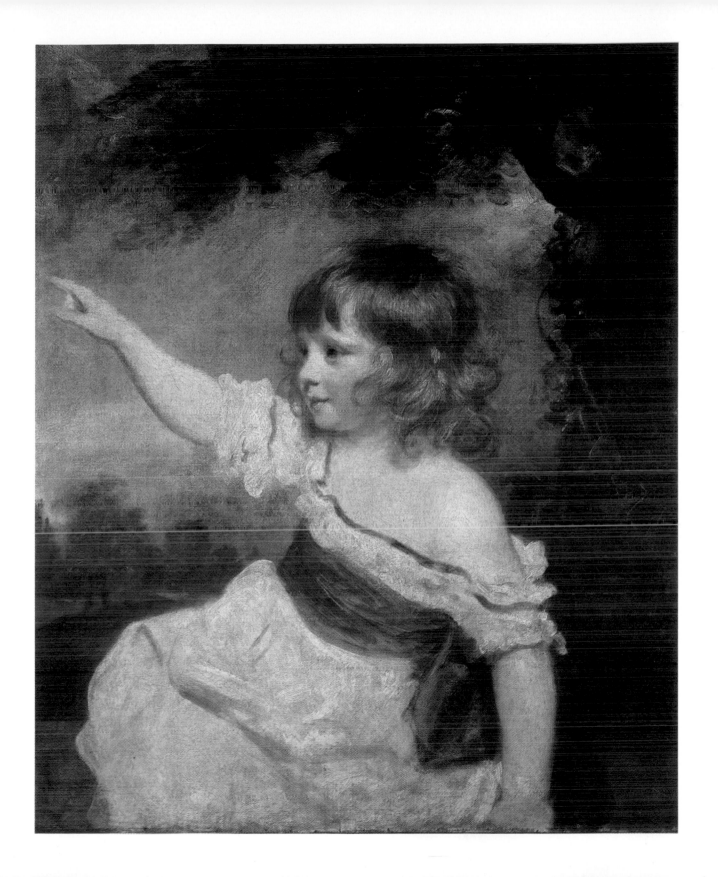

GOYA

1746–1828

The Naked Maja

1799, OIL ON CANVAS, 38⅛ x 74¾ INCHES
PRADO, MADRID

In the work of Goya, critics have seen two distinct impulses—the naturalism of Goya the portrait painter to the Spanish royal house, and the altogether different impulse expressed by Goya the fantasist who conjured up a world of demons. *The Naked Maja* would belong to the first category. A comparison with Velasquez' *Prince Carlos* (p. 98) immediately confirms Goya's debt to the seventeenth-century master. And yet, as in the royal portraits, the nude has another quality. Its light is pitched at a key that goes beyond naturalism to become strongly haunting. But no amount of analysis yields the source of life and mystery pervading Goya's frank and solid portraits.

As observer and draftsman, however, Goya was an uncompromising realist. Many of his etchings of bullfights were considered inaccurate in his own day, only to be corroborated years later when photography documented the swift action of the corrida. Goya also had a brilliant theatrical sense. His series on the *Disasters of War* during the Napoleonic invasion of Spain and his *Caprices* dealing with the bitter social comedy of eighteenth-century Spain are testaments that go beyond narrative to become high theater as well as high art.

INGRES

1780–1867

Jean Auguste Dominique Ingres inherited the mantle of Jacques Louis David as champion of French classicism during the nineteenth century. Historically, his work is always represented as the rival force to Delacroix's romanticism (p. 140), and in fact the two movements stood in arch opposition at mid-century. Yet, the two had much in common for all that, and during the long years of Ingres's critical hardship at the hands of officialdom, it was Delacroix and the romantics who alone credited his work.

The Louvre's *Odalisque* epitomizes the conflicting currents of Ingres's work. It reveals him as the superb draftsman whose sinuous line came of an intense admiration for Raphael. It bespeaks the cool detachment and sculptural vision that mark the classical temperament. But it also reveals an enthusiasm for Oriental exoticism and physical opulence that generally characterized the romantic opposition.

It was only late in life, after years in the Italy he loved, that Ingres was given the honor due him as a French painter. And only after his death was he recognized as a pillar of European art. Ironically, his most distinguished disciple, Degas, was soon to meet the intransigence of an official establishment converted to Ingres's principles in their most literal sense.

Odalisque

1814, OIL ON CANVAS, 35¾ x 63¾ INCHES
LOUVRE, PARIS

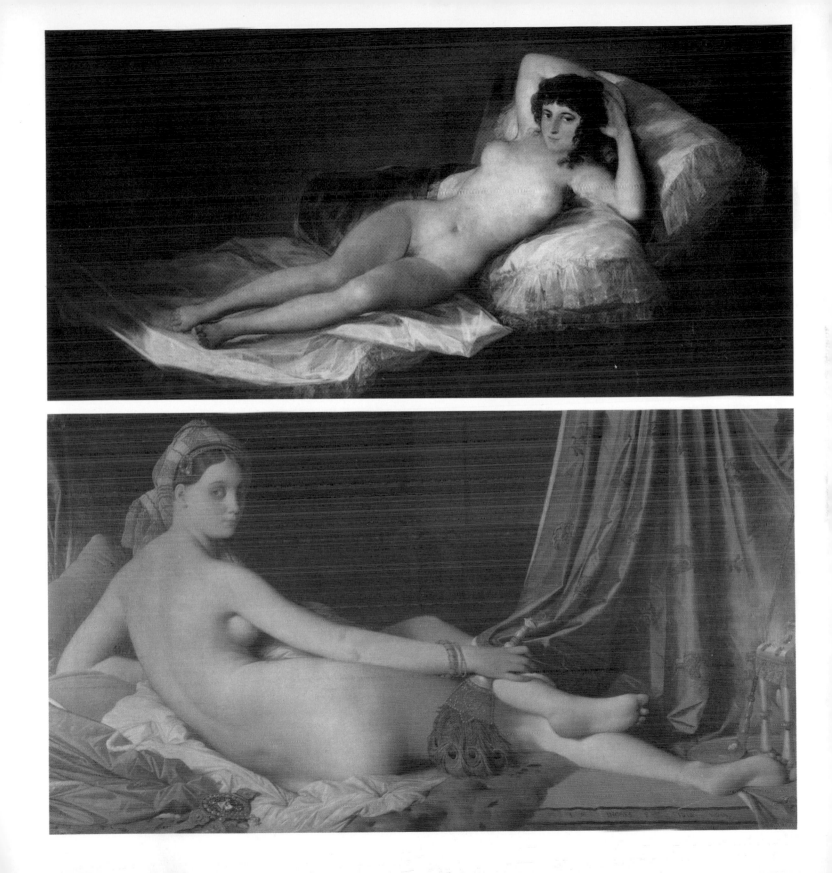

TURNER

1775 – 1851

Joseph Mallord William Turner is the greatest painter England has ever produced. If the work of his contemporary, John Constable (p. 36), prefigured the day of Impressionism, Turner's daring experiments went even further. For the visual sensations of his landscapes and seascapes are as advanced as the very late Monets, while in painting interiors, Turner evoked an abstract brilliance that even Impressionism never reached.

The early Turners are lovely and skillful, though more conventional. Landscape painting was his dominating interest from the first, and he was deeply influenced by the work of Claude Lorrain (p. 102). But his painting eventually became more penetrating and more interpretive. He was always concerned with tackling reality and his most striking works were developed as precise insights rather than as imaginative flights. Thus, the full title of this canvas is actually *Snow Storm—steam-boat off a harbour's mouth making signals in shallow water, and going by the land. The author was in this storm on the night the Ariel left Harwich.* Turner commented, "I did not expect to escape, but I felt bound to record it if I did."

He often painted with a palette knife, conjuring up unexpected tints of rose, silver and yellow in wonderful harmonies of color and effect.

HOMER

1836 – 1910

Winslow Homer was an outdoorsman at heart—a hunter, fisherman, trapper and camper who spent his last years in solitude on the coast of Maine. "If a man wants to be an artist," he said, "he must never look at pictures."

To a great extent, Homer functioned as an illustrator, the calling of his youthful days. He was intent upon reproducing things as they were, and while he spoke about dealing with the "relationship of values," he was primarily concerned with an objective account—as opposed to an impressionistic feeling—of those values. Like the Impressionists, however, he would work at calling up the aspect of a given view at a given time of day under a specific variety of light.

He painted the world he loved and the pursuits he loved. His works are accurate and nostalgic documents of a robust life in an untrammeled landscape and, especially, on the open sea.

Weather Beaten

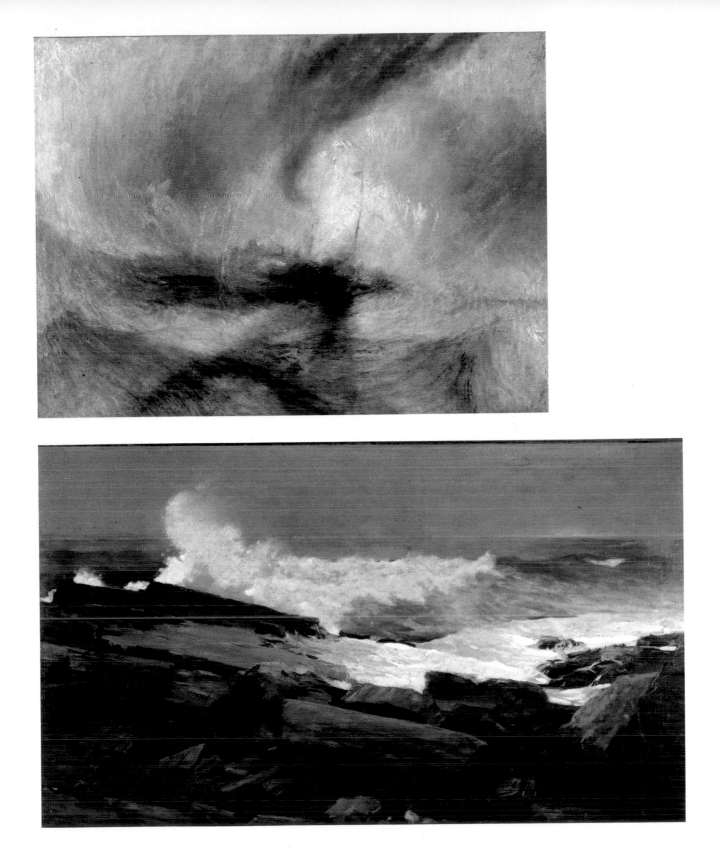

CONSTABLE

1776 – 1837

John Constable was an early prophet of modern painting whose work had considerable influence in France as well as in his own England. As a landscape painter, he sketched in oils directly from nature and produced an immediacy of color and sensation that had an impact upon romantic painting on the Continent. When Delacroix saw Constable's painting for the first time—*The Hay Wain*—he immediately reworked parts of his own *Les Massacres de Scio*. And toward the end of the century, the Impressionists were to look upon Constable, with his fresh and vibrant brushwork, as a forefather of their movement.

The Hay Wain, exhibited at the 1824 Paris Salon, where it took the coveted gold medal, is one of Constable's major canvases. It is a virtuoso piece, though it illustrates his spontaneous technique less than other works. For all its studied detail, however, the painting is conceived primarily in terms of sensation rather than description. This is the source of authenticity in what might easily have been an overlabored work, and the origin of Constable's impact upon so many contemporaries and successors. In his concern for the living quality of a work, he often used a palette knife rather than a brush to set down shifting light and flickering shadow in energetic bursts of color.

Despite the far-reaching effect of Constable's achievements, his work met with resistance among the fashionable and official circles of his day. Landscape painting was then of limited interest in England, and Constable was obliged to make his way by painting portraits, which, in turn, held little interest for him. Though he had already established a reputation abroad, it was not until 1829 that he was elected to full membership in the sacrosanct Royal Academy.

The Hay Wain

1821, OIL ON CANVAS, 50⅜ x 72¾ INCHES
REPRODUCED BY COURTESY OF THE TRUSTEES
NATIONAL GALLERY, LONDON

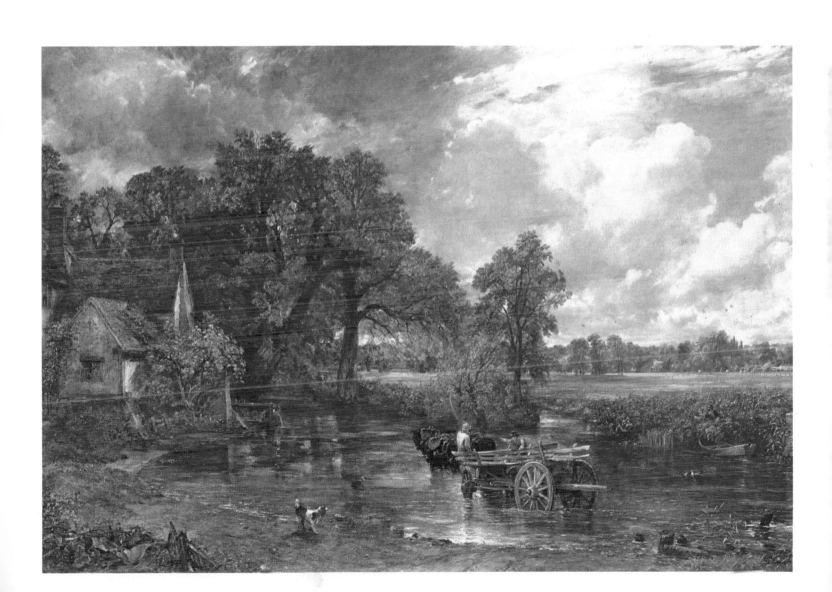

COROT

1796–1875

Jean Baptiste Camille Corot was a poet of quiet voice whose contribution to French painting far outpaced his ambitions. He was a poet of stillness whose vision balanced romanticism with a firm and precise objective perception.

Like most of his French contemporaries, Corot looked to Italy for inspiration, but with the eye of a Frenchman and never with any trace of eclecticism. Thus, he served as an example of artistic integrity to Manet and the Impressionists, who appeared late in his lifetime. Corot was in fact a spiritual predecessor of Impressionism who managed to find high favor at the Salon after an initial critical debate.

As a landscapist, he was able to create a pervasive atmosphere out of limited and concise areas of color. His figure pieces, mostly of Italian girls — he said that French girls made the best lovers but Italian girls the best models — are masterpieces of solid and pure painting. *The Belfry at Douai* is one of his many urban vignettes — actually urban landscapes. It belongs to the last years of his life and its effects are produced with masterful control. It was painted from a first-floor window and developed through eighteen separate painting sessions, each from two to six in the afternoon. At each of these sessions Corot would come to grips with the anatomy of his subject, working and reworking his handling of it until its architecture and its light were fully understood. Only then did he address himself to the accents of detail, the crisp definitions of the tower, the figures.

The man was known for his generosity and was dubbed the "Saint Vincent de Paul of painting." For he gladly helped less fortunate artists, sometimes even signing the painting of an impoverished student who needed desperately to make a sale. During the Franco-Prussian War he refused to abandon Paris and withstood the terrible siege, after selling a number of paintings to benefit war victims. His was a spirit of great equanimity, of devotion to an internal poetry and to an external suggestion, clarified in a world of meditation rather than of objects or events.

The Belfry at Douai

1871
OIL ON CANVAS, 18¼ x 15½ INCHES
LOUVRE, PARIS

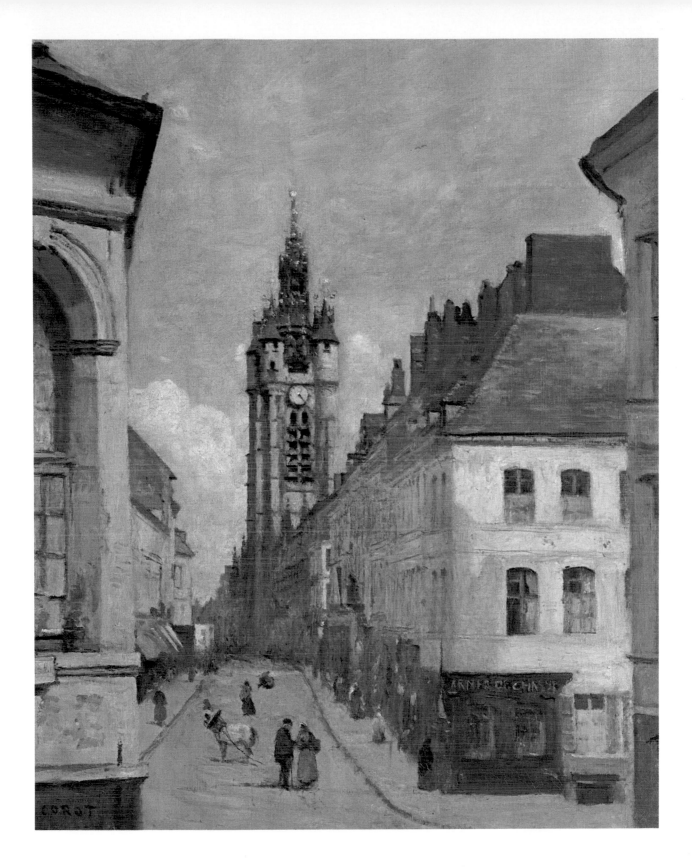

DELACROIX

1798 – 1863

Ferdinand Victor Eugène Delacroix led the romantic movement in nineteenth-century French painting and managed, brilliantly, to survive it. His was an age of growing industrialization in Europe and in France, of a sense of anti-climax that followed the fall of the Empire. A strong nostalgia and an impulse to escape dominated the young romantics. In true artists, such as Delacroix, the desire to turn from present realities to a world of the imagination can be an occasion for strong, valid painting—and Delacroix was an indefatigable worker who approached drawing and color with diligent precision. Yet, for many others, the will to escape produced only a fatuous reverie calculated to squander incipient talent. Ultimately, it can be said that the French classicist tradition with its sense of spiritual balance entered into the work of Delacroix more than his subject matter would suggest.

He looked to literature for many themes. Dante's *Commedia* offered the subject of his first great and controversial work, *Dante and Virgil in Hell*, 1822. Goethe's *Faust* and Shakespeare's *Hamlet* were the source of numerous paintings and etchings. Exotic settings were the inspiration of innumerable works, including the wonderful *Algerian Women* of 1834. Lastly, the idea of political liberty, still new in the world, became a preoccupation among the French romantics as in the English romantic circles of Byron and Shelley. Hence, the fervent *Liberty Leading the People*, 1830.

The work is so grandiloquent and in a sense so naïve that modern viewers often tend to underrate it. It is, however, a masterpiece of direct and opulent painting. The vignette of Paris and Notre Dame de Paris in the background is a marvel in itself. Each of the heads, and especially the bourgeois with the rifle, is a solid triumph of drawing and brushwork. The color is rather more muted than is typical of Delacroix, but the central portion of the work, culminating in the French tricolor, provides a climax that parallels the structure and sweep of the composition. The flag's intense red is very much Delacroix's color, the signature of a palette that has been described as "Rubeniste," after the Flemish master (p. 86).

Liberty Leading the People

1830
OIL ON CANVAS, 102⅜ x 128 INCHES
LOUVRE, PARIS

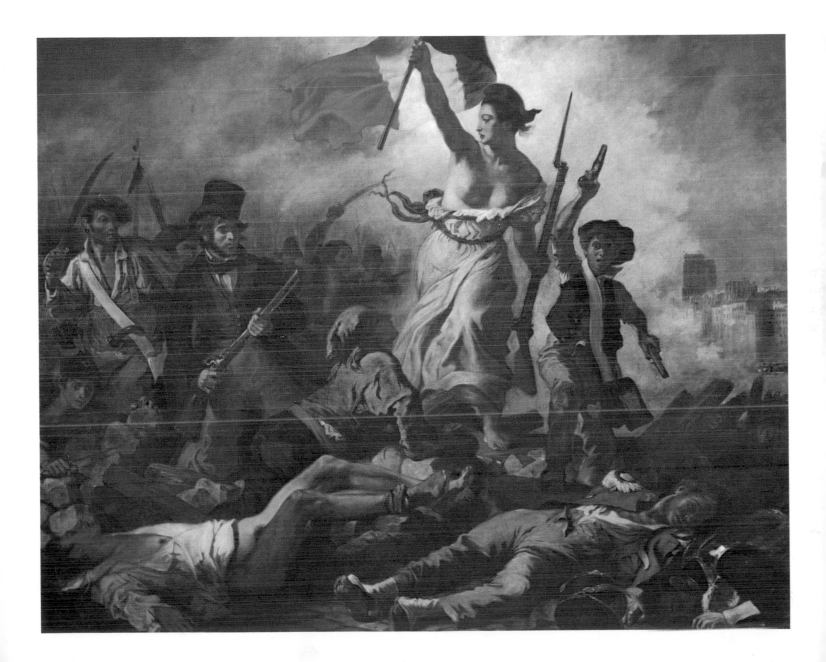

DAUMIER

1808–1879

At a time when the forces of Ingres's Classicism, Delacroix's Romanticism and Courbet's Realism dominated the course of significant French painting, Honoré Daumier developed an art of relentless contemporary observation and innate satire. In painting, in lithography and even in sculpture, Daumier's great contribution closely paralleled the literary triumph of his contemporary Balzac. Both men composed vast "human comedies" of life in France at a moment when the bourgeoisie occupied the center of the stage.

There were many able satirists then active in Paris. In the absence of photographic reproduction, newspapers relied upon drawings and engravings for pictorial matter, and the many satirical weeklies made special use of the caricaturist's brush. Yet, only Daumier's work lives on as art that transcends its journalistic and social goals.

Daumier was committed to ideas of political and social reform. He served six months in prison for lampooning the king, Louis Philippe, and then promptly resumed his masterful heckling. Today, though, it is possible to admire a Daumier without involvement in its subject. His manipulation of line and shadow produced figures that are life-size in volume and brilliant in their intuitive grasp of gesture and expression.

Under the far more censorious Second Empire of Napoleon III, Daumier turned to social satire and began to devote himself more intensively to painting. His use of oils paralleled the incisive black brilliance of his lithographs. He constructed massive shapes that answer to a liquid delicacy of line. He built up successive strata of opaque and transparent pigments to produce a heightened luminosity.

Crispin and Scapin is one of his many works dealing with the theater—in this case a key moment on stage during Molière's *Les Fourberies de Scapin*. As a nexus of reality and illusion, the theater offered Daumier an abundant opportunity. Like Degas or Lautrec in the next generation he loved to deal with the transient yet sculptural effects of stage light. *Crispin and Scapin* is a brilliant study of masks and meanings encapsulated in a moment of vivid stagecraft.

Unhappily, Daumier ended his life in poverty, nearly blind. It was Corot who saved him by renting a house in which Daumier spent his last years. Less than a year before his death, a large Daumier exhibit in Paris brought critical acclamation, for the first time.

Crispin and Scapin

[142]

1858–1860
OIL ON CANVAS, 23¾ x 32¼ INCHES
LOUVRE, PARIS

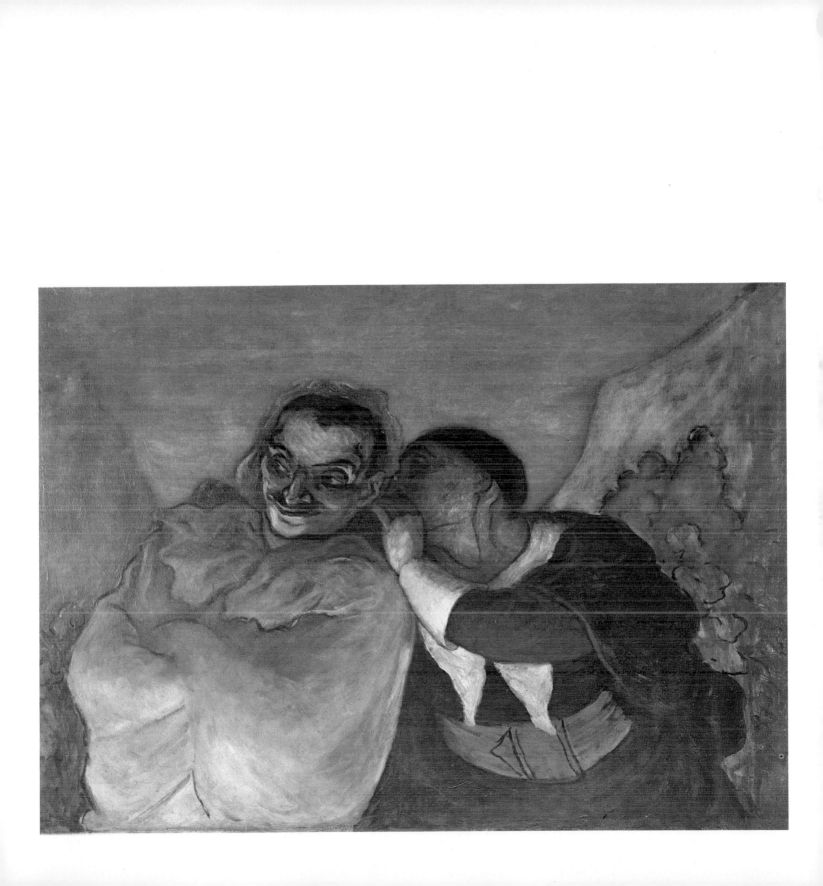

MILLET

1814–1875

Just before the middle of the nineteenth century, Jean François Millet turned from religious and mythological subjects to the theme of Norman peasants and the land they worked. It was a time of pose in official art and of broad, imaginative flights among the romantics, and Millet's themes seemed anticlimactic to some, dangerous to others. In certain bourgeois circles, works such as *The Gleaners* were thought to propagate a subversive brand of "socialism."

Millet left the studios of Paris to paint in the open, along with Diaz, Tourneux and Théodore Rousseau—the group that came to be known as the Barbizon school. He had an extraordinary memory and was able to record at will impressions he had received during long hours of study in the Barbizon countryside. The prevailing political interpretations of his work were wide of the mark, for he concerned himself with two objectives—to interpret the dignity of the peasants in their attachment to the soil, and the quality of rustic light in its nuances from morning to evening. There is a religious quality in his studies of farm laborers, and the spirit of his work was to be deeply appreciated by the young Van Gogh.

Millet was himself of peasant origins, born near Cherbourg in Normandy. He studied under Paul Delaroche at the École des Beaux-Arts in Paris but soon bridled at the inflexible academicism of the school. He set off on his own with the example of Daumier as a guide.

Millet's career was arduous, and recognition came only after years of public resistance and derision. Late in life, he received a commission to paint decorative panels of *The Four Seasons* for the Panthéon, the shrine in Paris where many of France's most illustrious figures, including Voltaire, are buried. Unhappily, he had time only to make sketches for the project before his death at Barbizon. He was buried alongside his friend and admirer Rousseau.

The Gleaners

1857
OIL ON CANVAS, 32⅞ x 43⅝ INCHES
LOUVRE, PARIS

[144]

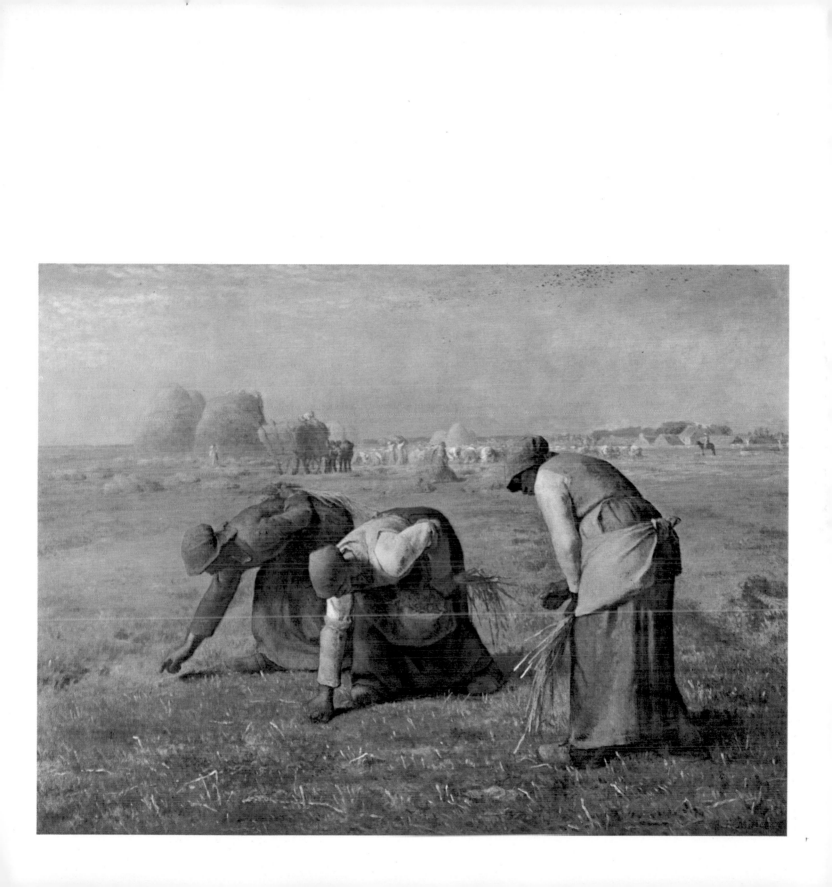

MANET

1832–1883

The painting of Édouard Manet opened a new era in the history of modern art. As a personality, the man was a paradox, a revolutionist despite himself. For though the integrity and originality of his vision created a new direction in painting, his stated aims were entirely conservative. *Le Déjeuner sur l'Herbe* was the first masterpiece of his career and remains the most celebrated landmark of the Manet era.

When he painted the *Déjeuner,* Manet hoped for acclamation at the Salon. Responding to the official predilection for Italian themes and Italianate forms, he chose a subject inspired by Giorgione's *Le Concert Champêtre* (p. 58) and utilized a composition direct from a Raphael drawing. Of course, Manet's version was painted in contemporary dress, and with an eye unfettered by the technical formulas of the Salon. He instinctively found in the living world of Paris a more valid inspiration than the studio concoctions based on idealizations and nostalgias. Manet had already had differences on this score with instructors at the École des Beaux-Arts. Yet, he was unprepared for the shock that followed the submission of the *Déjeuner.* The Salon rejected it, the Emperor insulted it. And as an entry in the Salon des Refusés, the first ever held, it became a public spectacle and object of derision. Had Manet painted a Venus surrounded by Arcadian shepherds, no one would have objected. The simple use of a contemporary idiom startled and shocked.

Young painters such as Pissarro and Monet championed the picture and Manet could have joined their ranks as a leader. Ironically, he held aloof, still hoping to win over the official powers. The son of a magistrate, a bourgeois disdainful of bohemia, he had set his sights on a Légion d'Honneur and even election to the Institut de France. Yet, in 1865, the originality of his great nude, *Olympia,* in the Jeu de Paume today, caused another scandal. Again the inspiration was Italian—Titian's *Venus of Urbino* (p. 66). But Manet's Venus was a courtesan of the boulevards, a modern Venus unacceptable to official taste.

In later years, Manet joined the Impressionists, whose work he himself had fathered. The young Monet had been a disciple of his—of the Manet blacks and silvers so closely allied to Goya and the Spanish temperament. The elder Manet later became a disciple of Monet, abandoning his studio to paint the natural light of day.

Le Déjeuner sur l'Herbe

[146]

1863
OIL ON CANVAS, 84¼ x 106¼ INCHES
LOUVRE, PARIS

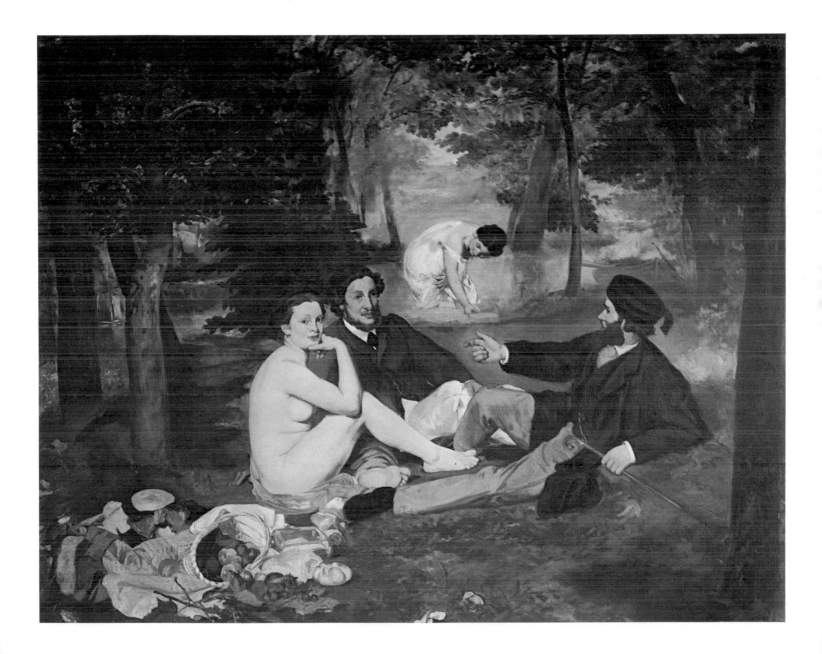

WHISTLER

1834 – 1903

During the brilliant years of the *belle époque,* James Abbott McNeill Whistler left Lowell, Massachusetts, for Paris, London and the brightest artistic circles of the age. In Paris, he came under the influence of Manet and the Impressionists. In London, he became the friend and verbal sparring partner of Oscar Wilde and the Café Royal set. Like Degas, he was a caustic wit, but unlike Degas, he had little interest in the graphic realities of life. Whistler cultivated an aesthetic detachment closer to the spirit of the London Pre-Raphaelites. It was a precarious aesthetic, one that turned easily to facility and posturing, and one that trapped and limited many an artist and writer of the time. The critic Ruskin, Whistler's archenemy, once gibed, "Why does Mr. Whistler dress as though he had no talent?" However, despite all the dandyism, his sensitivity and authority were such that Whistler's delicate works survived their generation.

The original title of the painting known as *Portrait of the Artist's Mother* was actually *Arrangement in Gray and Black.* Whistler insisted that the subject was of no interest to anyone but himself. He once wrote, "Yes, I have a mother and a pretty bit of color she is too." He thought of the work as an abstract harmony of colors and tones—in that sense probably the first painting ever consciously proclaimed an abstraction. The composition, like the painter's famous butterfly signature, is influenced by Japanese art, a major aesthetic enthusiasm of the day.

Whistler lived to see the painting purchased by the French Republic and hung in the Musée du Luxembourg. In Paris, he took a room nearby in order to be close to it. Today, the *Arrangement* hangs in the Louvre—the museum's only work by an American.

Whistler described his art as "the result of harmonies obtained by employing the infinite tones and varieties of a limited number of colors." His poetic method of entitling his portraits and landscapes "symphonies" or "nocturnes" only mystified contemporary skeptics, and once, when invited to America, he declined with the excuse that "I hesitate before exasperating another nation."

Portrait of the Artist's Mother

1871 – 1872
OIL ON CANVAS, 57 x 64½ INCHES
LOUVRE, PARIS

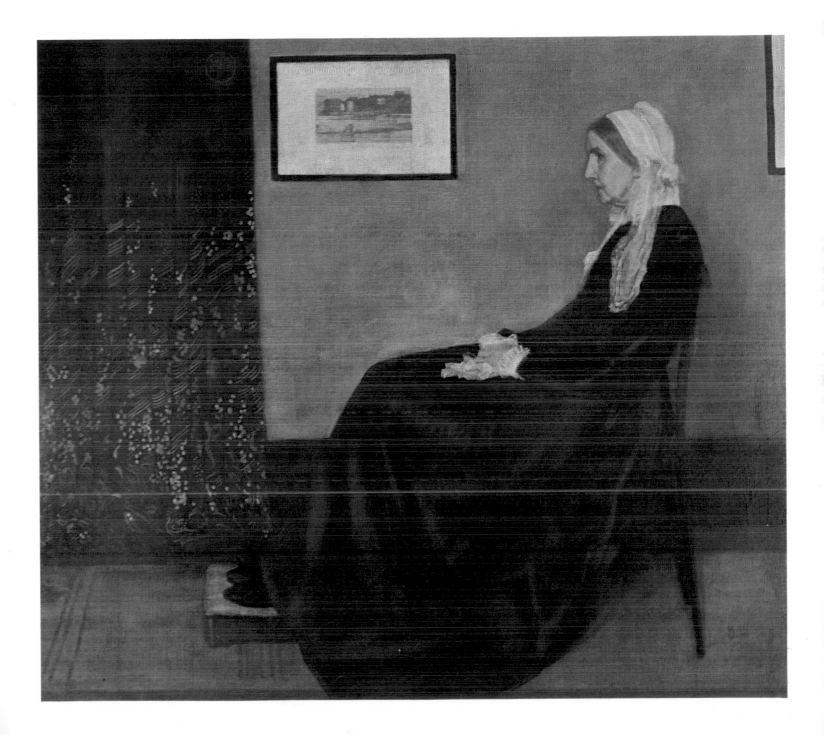

DEGAS

1834–1917

The work of Degas was born of the great impulse in modern French painting that began with Manet and flowered anew in Impressionism. Yet, while a member of the Impressionist ranks, the caustic and wry Degas developed his own predilections. He was an urban painter who disdained landscape and chose to observe the life of Paris—its café society, its shopgirls, its dancers, its theater, its underworld. He was a linear painter who studied and admired the graphic clarity of Mantegna and Holbein. Among the French masters, it was Ingres who held overwhelming fascination for the maturing Degas.

Fin d'Arabesque is one of many paintings Degas devoted to the dance, both in the glimmering aura of an evening's performance, as in this case, or in the studied routine of rehearsal. He had an abiding interest in the human figure and loved to draw his models in positions of extreme tension, whether in the midst of an arabesque or in the muscular thrust of a bather emerging from the tub. *Fin d'Arabesque* maximizes two great assets of Degas's work. One is his taut and revolutionary sense of composition in which great areas of sheer space separate the major figures to create a precarious and disturbing balance. The other is an admirable manipulation of light, an Impressionist skill in this instance adapted to emphasize the pale brilliance of a theatrical moment.

The name Degas was a democratized version of the aristocratic De Gas, a transformation for which the man himself had little use. Politically he was a royalist. Socially he was a virulent anti-Semite who also hated women, regardless of religion. He detested the scent of flowers and was quick to make a scene if invited to a dinner table that held a floral centerpiece. Personally he wielded a biting wit that acquaintances often chose to avoid. And yet, while a thoroughly unpleasant gentleman, Degas possessed an incisive aesthetic intelligence that in fact often blossomed into statements of sympathetic splendor.

Fin d'Arabesque

1877
PASTEL AND OIL, 27⅜ x 14⅞ INCHES
MUSÉE DU JEU DE PAUME, PARIS

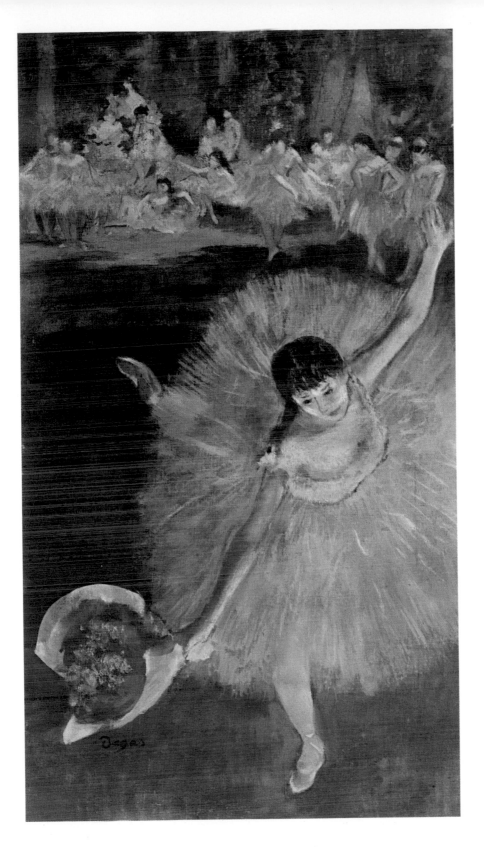

CÉZANNE

1839–1906

The revolutionary genius of Paul Cézanne paved the way for the whole of twentieth-century painting. Originally a young disciple of Manet and later of Pissarro, Cézanne became involved with the Impressionist movement. But his application of contemporary ideas went far and deep, and he blended the light of Impressionism with the solidities of the Classic vision, reflected in France in the work of Poussin. He approached form and shape through dynamic geometrical forces: the sphere, the cube, the solid rectangle, the cylinder, the cone.

Still Life with Basket is a monumental example of Cézanne's work and one that shows with particular clarity how he opened the way for the next great generation of French painters—the Cubists. The subject is absolutely uneventful, yet charged with an architectural energy that creates a state of dramatic power. Each element of the canvas is expatiated in its own right, and each has its own resonance. Yet, each contributes to a larger magnitude, the architectural power of the whole—just as in a fugue of Bach's the repeated, incremented phrases build up a spiritual whole larger than its parts. Even the successive elements of the background, with its table and palette, its door, its chair, muster a tremendous force.

It was Cézanne's example that suggested the immense possibilities of abstract art to his successors, the potential of an expression that in no way depended upon its subject. In his own day, however, the achievements of Cézanne were understood by few. Even when the Impressionists began to find some success in a changing world, Cézanne met with unyielding opposition. It was only as a man of independent means—he was the son of a banker—that he was able to withdraw to his native Provence and work away from the antagonisms of Paris. It was there, in the Midi, that he created his late paintings of the Mont Sainte-Victoire, the most advanced, most resonant, and perhaps most magnificent of all Cézannes.

Still Life with Basket (The Kitchen Table)

1888–1890
OIL ON CANVAS, 25½ x 31⅞ INCHES
LOUVRE, PARIS

[152]

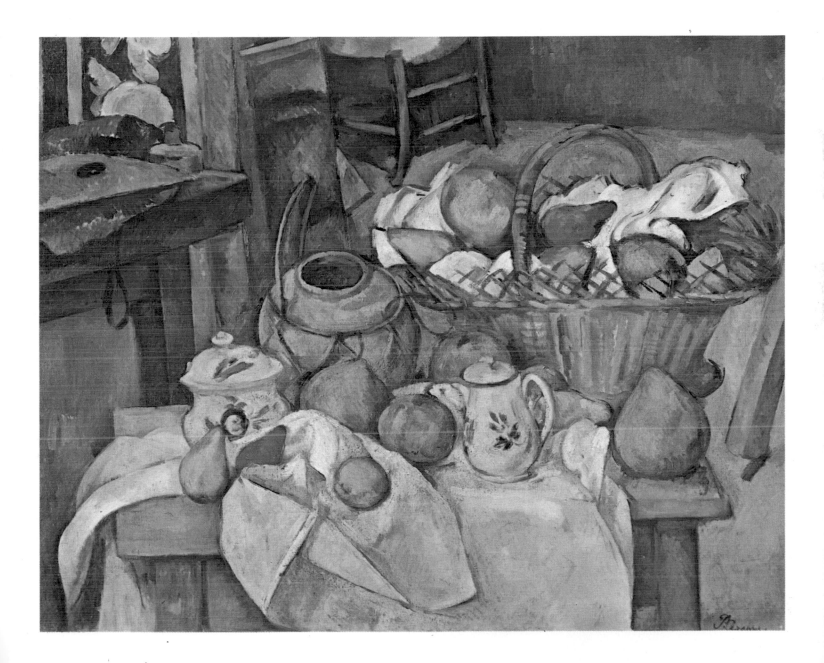

REDON

1840–1916

"My originality consists in making incredible beings live according to credible laws, in placing the logic of the possible at the service of the invisible." So spoke Odilon Redon, the lyrical mystic who worked during an age of Impressionism but who preferred the imaginative intelligence of the mind to the perceptual logic of the eye.

The most imaginative works of Redon were his black-and-white lithographs, delineations of the fantastic which prefigure formal Surrealism by almost half a century. Yet, in color, Redon developed another facet of his inner world by translating mundane objects into poetic ambiguities and clarifications. He felt the necessity to tackle nature as the source of his inspirations, and in this spirit he painted a great number of flower pieces. The Jeu de Paume's *Vase of Flowers* is a particularly fine example. Its color is the source of its magic—each color charged with a penetrating resonance until the ensemble ceases to be a flower piece at all but becomes instead a galaxy of compelling vibrations. There is a certain kinship between Redon's work and that of Gustave Moreau, though Moreau's mysticism as a colorist often tended toward more ornate and more obviously narrative paths.

It was the Symbolist poets, and principally Mallarmé, who opened the way for an appreciation of Redon's talents. Later, Bonnard, Vuillard and Matisse looked to him as a master colorist and prophet of twentieth-century innovations. Redon died in 1916, just prior to the age of Surrealism and its acknowledgment of his importance as a poet of the imagination.

Vase of Flowers

AFTER 1895
OIL ON CANVAS, 10⅝ x 7½ INCHES
MUSÉE DU JEU DE PAUME, PARIS

[154]

MONET

1840–1926

As the guiding force of Impressionism, Claude Monet dominated the most important movement in European painting during the second half of the nineteenth century. In his early years, he was a disciple of Manet, and hostile critics enjoyed confusing the names of the two upstarts. It was from Manet that Monet learned an immediacy of vision regarding the physical world, and a revolutionary diligence in exploring the possibilities of light. Monet took to open-air painting and made of his painstaking efforts an aesthetic and a science.

The great *Rouen Cathedral* series was painted late in Monet's career—a pure and dramatic distillation of the principles of a lifetime. To the Impressionists, color was a medium of light. Monet and his associates, especially Pissarro and Sisley, worked to capture the architecture of a subject as it became transformed by successive states of light and to let the eye of the viewer "mix" the pure elements of color juxtaposed on the canvas. Thus, the vibrant effect of bristling light produced by chords of precisely calculated hues.

When Monet painted massive haystacks metamorphosed by the nuances of morning, afternoon and evening, the results were no less structural than his treatment of the great Gothic cathedral—though no linear element whatsoever is involved. The cathedral series is especially rich and resonant. Its poetry is overwhelming. When a viewer approaches the canvas to a proximity of one or two feet, the entire effect dissolves into a bewildering mass of heavy pigment, but when one steps away, the magic immediately reassembles itself.

In his younger days, Monet was active in the heated battles that involved French painting. He assumed a role as leader of the young Impressionists, participating in group exhibitions and defending the integrity of the movement. But in later years, he retired to the landscape of Giverny where his vision continued to evolve significantly, even into his eighties. At the age of eighty-six, he died in the arms of one of his oldest admirers, *le tigre* Clemenceau.

Rouen Cathedral

1896
OIL, 42⅛ x 28¾ INCHES
MUSÉE DU JEU DE PAUME, PARIS

[156]

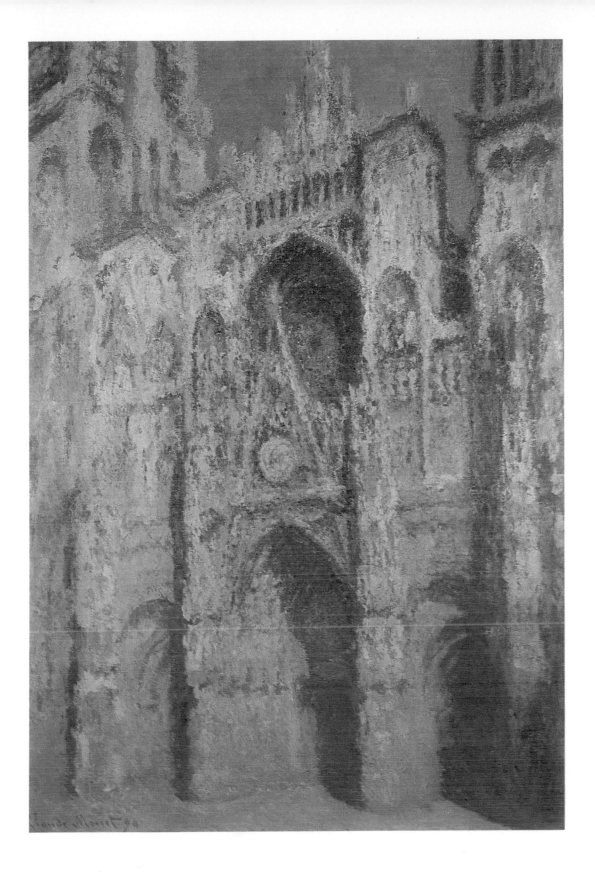

RENOIR

1841–1919

Pierre Auguste Renoir looked upon nature as an inexhaustible source of loveliness—a faith that illumined every phase of his career and survived the challenges of war and illness. His *Moulin de la Galette* is a landmark of Impressionism—a work in which Renoir's optimism triumphed over the less innocent atmosphere of old Montmartre. The moulin, which still exists today, was then a popular *café-concert* where friends met to talk, dance and drink. Toulouse-Lautrec also painted it, and so did Picasso years later, each pointing up a raffishness closer to fact, which Renoir chose to ignore. His revelers are lovely, charmingly clothed, modest in their entertainments. His scintillating brush strokes are put down with a slashing, vibrating electricity that creates a brilliant façade of light. The heads are painted with a softer, less impressionistic attack, but the harmonies and dissonances flashing about them establish a life of their own. Twenty years earlier, Baudelaire had published a book that directed the course of poetry into darker channels: *Les Fleurs du Mal*. Renoir read it and had no use for it.

As a youth, he worked as a painter of porcelain in his native city of Limoges but abandoned the trade for painting and Gleyre's studio in Paris. There he met the men who influenced him and who were to share his high place in the history of modern painting: Monet, Sisley, and Bazille. When Gleyre's studio closed in 1864, Renoir went to the country and painted the gracious landscapes of Fontainebleau. Later, he and Monet worked together in Paris and in Bougival until the Franco-Prussian War came as a savage interruption. Renoir served as a cavalry officer.

After the war, he traveled, became closely acquainted with the Italian schools, visited Algeria and, upon returning to France, began working with Cézanne at L'Estaque. "I had come to the end of Impressionism," he wrote, "and I was coming to the conclusion that I did not know either how to paint or draw." His subsequent development emphasized volume, line, greater solidity and less specific concern with the phenomena of light. In his last years, he was stricken with arthritis but continued working relentlessly. He painted the great nudes of this final period—among the greatest of all his works—with brushes strapped to crippled wrists.

Le Moulin de la Galette

1876
OIL ON CANVAS, 51½ x 68⅞ INCHES
LOUVRE, PARIS

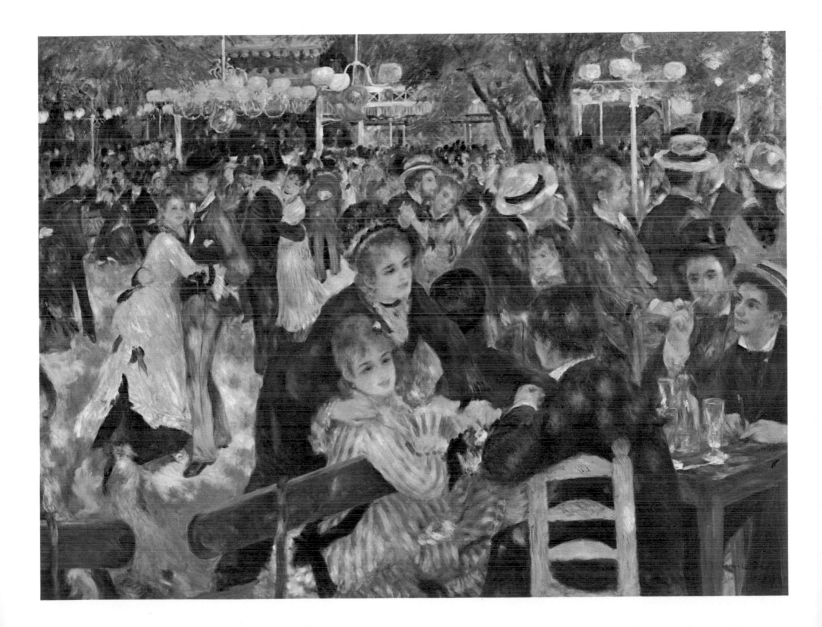

EAKINS

1844–1916

Said Walt Whitman, "I never knew but one artist, and that's Tom Eakins, who could resist the temptation to see what they thought ought to be rather than what is." The tribute matched Eakins' intentions in painting. He was an avowed realist to whom realism meant as accurate a representation of objective fact as possible. As a student in Paris, he worked under Gérôme and vastly admired the famous academician. The Impressionists, who were then making their appearance, had no effect upon him whatsoever.

In his realist enthusiasms, he worked out problems in perspective with the aid of trigonometric tables and made a careful study of caustics, the science of the reflection and refraction of light by curved surfaces, in order to perfect his understanding of light effects on water. *The Pathetic Song* is an interior vignette that might illustrate an episode out of Henry James, and yet, while Eakins worked toward an authenticity of expression and mood, he was more interested in the physical moment than in the narrative implications of the scene.

He would have liked to have placed more emphasis upon the nude as a subject, but the epoch was one of obsessive prudishness in America and Eakins was hard pressed to oppose the taboo. In one of his finest canvases, *William Rush Carving the Allegorical Figure of the Schuylkill River*, he carefully introduced a chaperone knitting beside the nude model as a major element of the composition.

The Pathetic Song

1881
OIL ON CANVAS, 45 X 32½ INCHES
CORCORAN GALLERY OF ART, WASHINGTON, D. C.

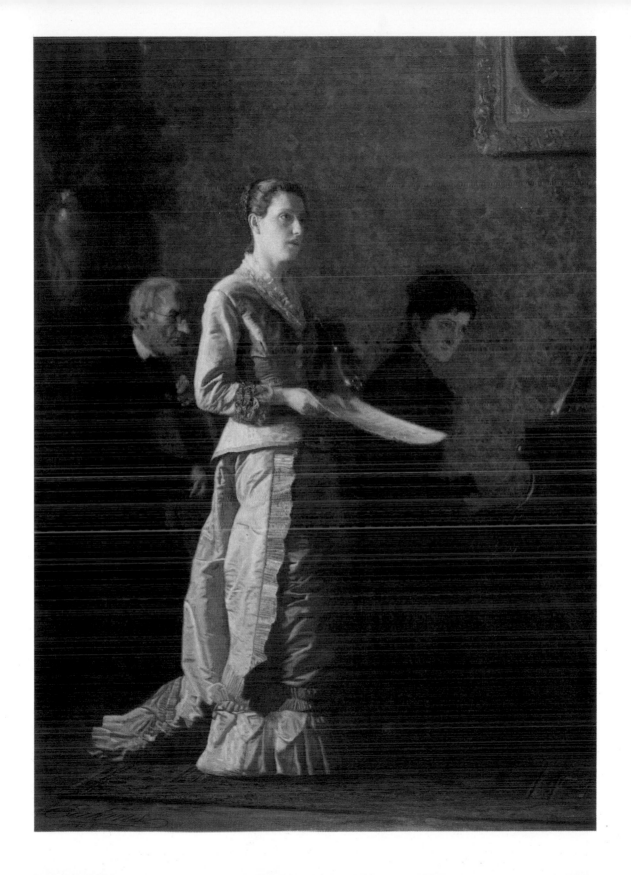

GAUGUIN

1848 – 1903

The story of Gauguin is one of the strangest in modern painting. For it was not until he was in his thirties that this Parisian stockbroker, married to the daughter of the Danish minister to Paris, began to devote himself exclusively to painting. His marriage disintegrated and, deeply imbued with mystical concepts, he sought a new life and a new vision in the South Seas.

Gauguin initiated a daring vocabulary of color which, along with Van Gogh's, was far in advance of its time. In Paris, while still married, and still only a Sunday painter, he had come to know Japanese art and was greatly influenced by it. No less important, he knew the Impressionists, listened to their debates, exchanged ideas, and even exhibited with them. After the breakup of his marriage he spent four years in Brittany, where his painting began to evolve rapidly. But it was in Tahiti that Gauguin's work came to fruition. He adopted not only the hot colors of the tropics but the heraldic simplicity of the primitive arts as well. As in *Ia Orana Maria,* he translated Christian themes into the exotic *mise-en-scène* of the South Seas. In his journal, he kept an articulate record of reactions and observations. The chronicle confirms that Gauguin had a keen sense of the dimensions of his work:

"Once upon a time, the wild animals, the big ones, used to roar; today they are stuffed. Yesterday I belonged to the nineteenth century; today I belong to the twentieth. . . . Life being what it is, one dreams of revenge — and has to content oneself with dreaming. Yet, I am not one of those who speak ill of life. You suffer, but you also enjoy, and however brief that enjoyment has been, it is the thing you remember. . . . I like women, too, when they are fat and vicious; their intelligence annoys me; it's too spiritual for me."

All of which well reflects the spirit of Gauguin — his mystical sense, his directness, his earthy, unequivocal temperament.

The Gauguins that returned to France had a powerful effect on painters, most directly upon the *Nabis* — Bonnard, Vuillard, Maurice Denis — and also upon the principal currents of twentieth-century painting. Gauguin himself went back to France once, in 1893, only to return permanently to his spiritual home. There he died early in the new century, which he had declared to be his own.

Ia Orana Maria

1891, OIL ON CANVAS, 44¾ x 34½ INCHES
THE METROPOLITAN MUSEUM OF ART, NEW YORK
BEQUEST OF SAMUEL A. LEWISOHN, 1951

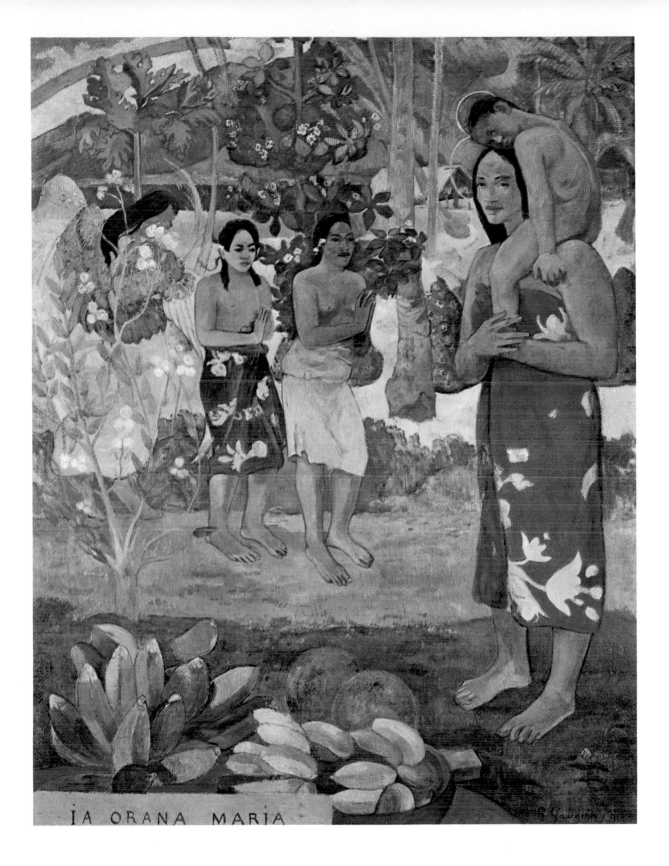

IA ORANA MARIA

VAN GOGH

1853 – 1890

Vincent van Gogh is at once one of the most appreciated of modern painters and one of the most misunderstood. His works mirror a formidable intensity and his life makes a dramatic story of moral turbulence and conviction. As a painter, however, Van Gogh's history is one of intellectual development and ever-increasing control. His last works, among them the Jeu de Paume's *Roses and Anemones* of 1890, are as much an intellectual consummation as an emotional climax. Because mental anguish, possibly epileptic in origin, drove the painter to suicide during that same year, many have been tempted to trace his evolution as a matter of emotional momentum. But the works themselves contradict such a conclusion.

Van Gogh, son of a Dutch Calvinist parson, at first aspired to the ministry. He preached to the miners of the Borinage, a Belgian coal region, lived among them and adopted their penurious life. His passionate zeal and unecclesiastical ways displeased the church, and he was dismissed. When next he returned to the Borinage, it was as a painter in the first phases of another journey of faith and conviction.

His early work was distinctly Northern, weighty in form, dark in color. But after his first experience in Paris, in 1886, his painting changed dramatically. Under the influence of Impressionism and the post-Impressionists, after meeting Toulouse-Lautrec, Degas, Pissarro, Gauguin and Bonnard, the famous Van Gogh palette came to be brilliant and intense. It can be said that Van Gogh contributed a revolution in color comparable to Cézanne's revolution in structure.

He worked at Arles, in Provence, for a time with Gauguin and for a longer period alone. This last and greatest period of Van Gogh's career lasted scarcely two years. In Paris, his brother Théo—with whom Van Gogh conducted one of the most important correspondences of modern letters—helped sell the works that were shipped up from Arles. But public resistance was almost total.

Because of sudden, periodic seizures, Van Gogh himself requested hospitalization at the asylum of Saint-Rémy—where he continued to work. During the last year, Théo van Gogh arranged for his brother to become the private patient of Dr. Gachet, a specialist who also loved painting and who was among Van Gogh's strongest supporters. While at work during the summer of 1890, Van Gogh suffered a fit, wounded himself, and died two days later.

Roses and Anemones

1890
OIL ON CANVAS, 20 X 20 INCHES
MUSÉE DU JEU DE PAUME, PARIS

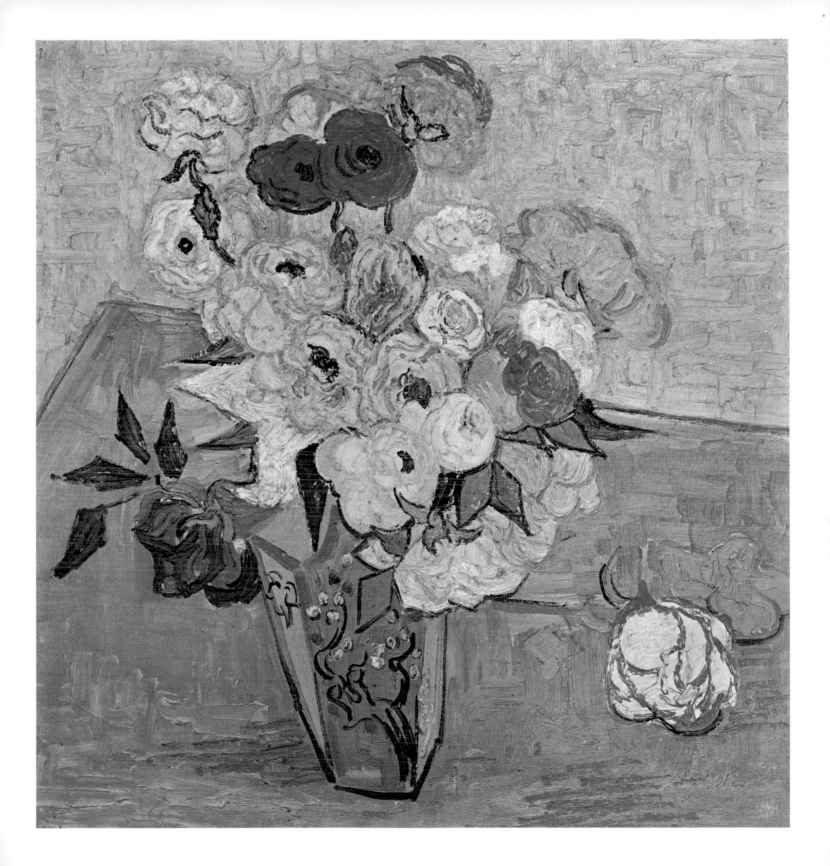

CORINTH
1858–1925

The painting of Lovis Corinth constitutes a spiritual link between the German "Impressionist" school that took its cue from French painting and the "Expressionist" impulse that dominated German art in the twentieth century. Corinth himself was a Prussian whose fluid and spontaneous work stands out in surprising contrast to the typical austerity of the Prussian personality. He studied in Germany at Königsberg and at Munich, and later in Paris at the Académie Julian, for a time under the academician Bouguereau.

Carmencita, painted a year before Corinth's death, is a study of his wife Charlotte dressed for a costume ball. The painting has a strong presence that results in part from the brisk and fresh brushwork, in part from its unconventional handling of space. There is a sense of precarious balance and of transience in the *Carmencita*, making the painting immediately alive. Although a major work, it breathes the informality of a sketch. Amid the shimmering diffusion of the entire painting the head stands out as a point of focus and climax that gives depth and coherence to the rest of the canvas.

If Corinth found a legacy in French and German expression, however, he also drew upon the spirit of Flemish painting or at least manifested a feeling parallel to it. A kinship to the hearty ebullience of Jordaens and even, to some extent, to the cooler vivacity of Hals can be read into his painting. After an illness in 1911, he turned to a series of self-portraits in which he concerned himself with psychological exploration as well as with plastic considerations. He wrote continually about painting and was esteemed in his day as an articulate teacher.

Carmencita

1924, OIL ON CANVAS, 51⅛ x 35⅜ INCHES
STÄDELSCHES KUNSTINSTITUT, FRANKFURT
COURTESY CHARLOTTE BEREND-CORINTH

[166]

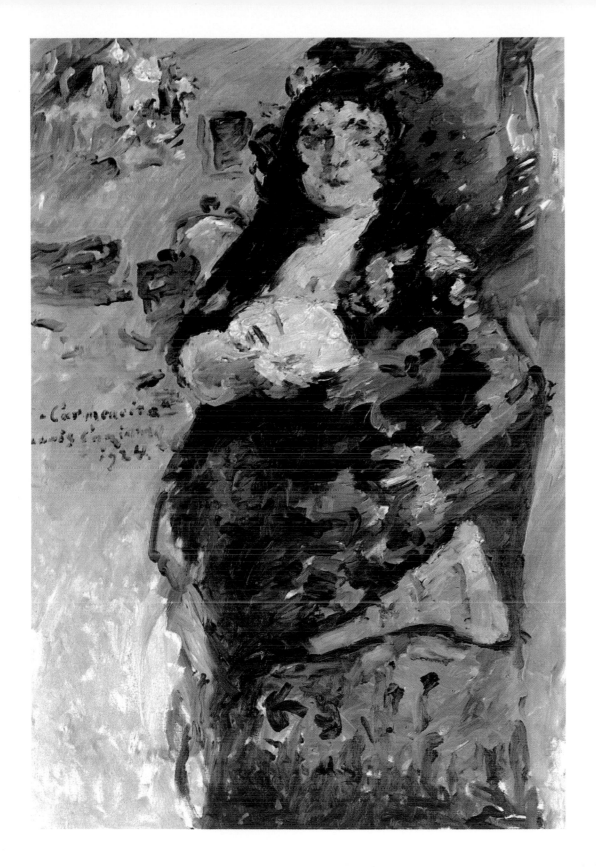

SEURAT

1859–1891

When he painted *The Sideshow*, in its sonorous dignity, Georges Seurat had in mind the Parthenon marbles of Phidias. He wrote, "I want to show moderns moving about on friezes in the same way, stripped to their essentials, to place them in paintings arranged in harmonies of color—through the direction of hues—in harmonies of lines—through their orientation—line and color fitted for each other."

In *The Sideshow*, Seurat turned for the first time from a use of sunlight to an independent scale of light values that functioned according to formal, abstract, psychological intention. In so doing, he inaugurated a major break with Impressionism. At the same time, he took a great step forward, along with Cézanne, as progenitor of the main direction of modern painting.

Before beginning his adventure with color, Seurat had devoted a year, 1880, to an exploration of light in black-and-white only. In 1883 he produced his first major work in color, *Une Baignade*. He had become fascinated by scientific works dealing with the mechanics of light, and especially with the work of the scientist Charles Henry, who had developed a comprehensive theory of the psychological implication of color and form. Seurat delighted in the possibility of utilizing color according to definable laws, and he developed a method of fragmenting light into intense, interacting particles of calculated value. This method was actually a further extension of Impressionism and the label of post-Impressionism soon made its appearance. Seurat felt that the term "pointillism" failed to embrace the full scope of the method. He preferred the term "divisionism."

Though his career barely spanned ten years, he produced a great body of work in which the methodical application of light was carried through a variety of plastic explorations. As a founding member of the Société des Artistes Indépendants, Seurat attracted a core of adherents including not only such young "divisionist" disciples as Signac and Cross, but even the elder Impressionist, Pissarro. Unhappily, Seurat's significant career was to be brief. He died in Paris at the age of thirty-one.

The Sideshow

1889, OIL ON CANVAS, 39½ x 59½ INCHES
THE METROPOLITAN MUSEUM OF ART, NEW YORK,
BEQUEST OF STEPHEN C. CLARK, 1960

[168]

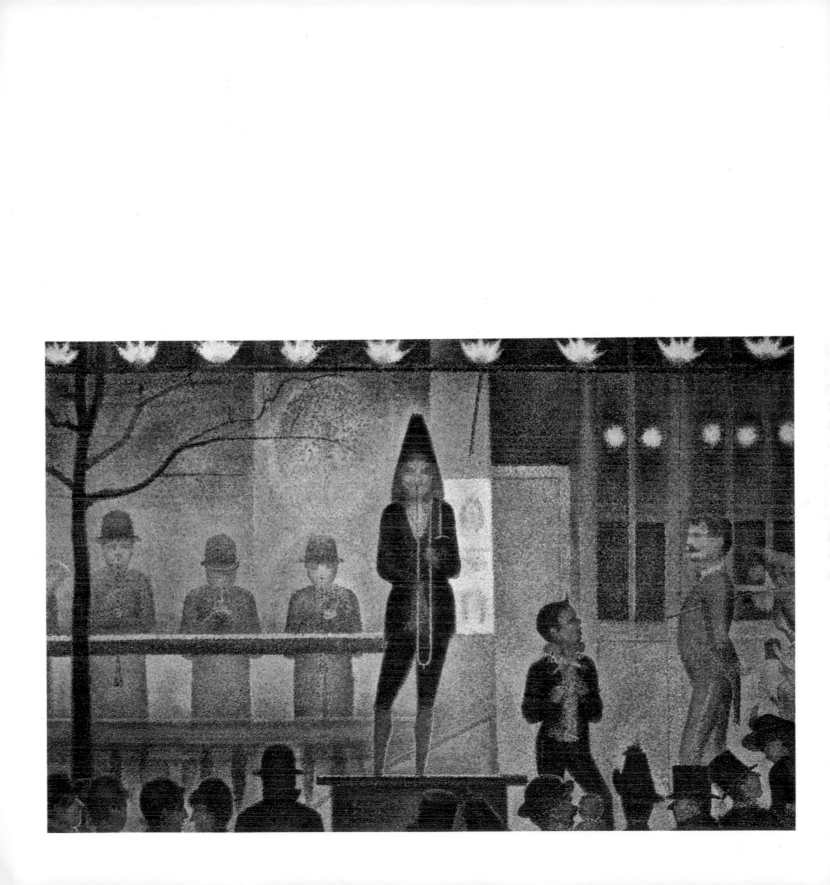

MUNCH

1863–1944

The art of Edvard Munch explicates a troubled world of metaphysical doubt and moral torment. Munch left his native Norway to travel and study, and came in touch with the most creative circles of Paris and Berlin. Mallarmé and Strindberg became his friends and inspirations, and in their searching literature he found a wealth of poetic insight that paralleled his own and nourished his work.

As a child, he lost his mother and two sisters, disasters which may have been at least partially the source of his later anguish. In 1908, he struggled with mental illness, underwent treatment in a Copenhagen clinic, and then returned to Norway to live and work for the rest of his life.

Thus, Munch's explorations were psychological and often literary. The potent, acid color of *Girls on the Bridge* is highly personal, and its quality of shifting, undulating line is entirely his own. He was far more concerned, however, with emotional and subconscious expression than with plastic form. He had begun as a disciple of Impressionism, the result of his first trip to Paris, where he discovered Gauguin and Van Gogh. But it was Van Gogh's emotional intensity rather than physical splendor that Munch chose to follow. He was a true Expressionist and can be thought of as a founding father of that broad and much abused vein of exploration.

Munch's view of the universe, as an object of terror and vessel of devastating loneliness, seems to mesh with known patterns of psychoses in which the afflicted is cut off from contact with the world and with himself. Munch even conceived of love as a danger, and he was obsessed with death. Yet, it would be a mistake to view his work as a product of madness. Only rational control and intellectual firmness could have made his cogency as a painter possible. At the turn of the century, he painted the great *Frieze of Life* in which his personal world of joy and terror comes into harmony with the rhythms of nature.

Girls on the Bridge

1905
OIL ON CANVAS, 21¼ X 21¼ INCHES
WALLRAF-RICHARTZ MUSEUM, COLOGNE

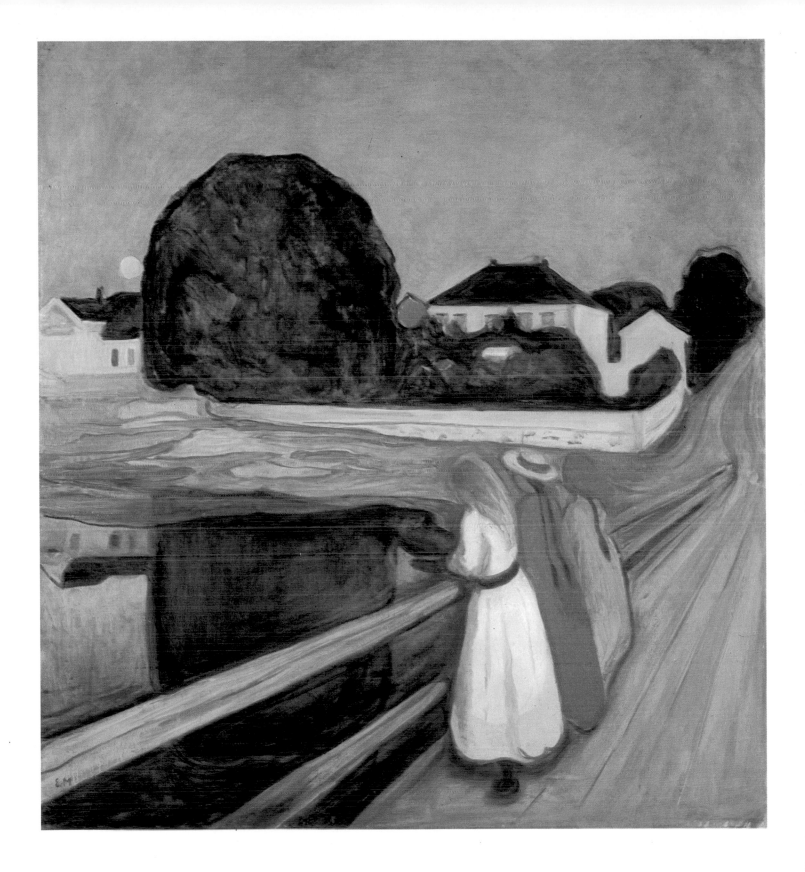

TOULOUSE-LAUTREC

1864–1901

The brief career of Henri de Toulouse-Lautrec produced one of the richest achievements and most startling documents of modern French painting. To borrow a phrase of Lautrec's contemporary, Maupassant, it was "an error of destiny" that cast the painter in his tragic if fateful role. For under normal circumstances, Lautrec would probably have been a skillful dilettante of the brush, an aristocrat as devoted to fine horsemanship as to the arts. His ancestors included kings of England and France, his father was a nobleman who yearned to see his son a sportsman. But in childhood Lautrec suffered two accidents, each of which resulted in his breaking a leg. His legs never healed properly and he was forever condemned to bear the appearance of a dwarf. Centuries of inbred marriages, plus the fact that his own parents were cousins, may have been responsible. And so the noble heritage of Count Henri contributed to his exile from normal society.

Thus, as a man and as a painter, he pursued people and places where abnormality or social ostracism were accepted as the rule—the circus, the brothels, the *demi-monde* and the *sous-monde* of Montmartre. He was not a bitter man, but, on the contrary, a brilliant wit with a great capacity for human sympathy. He was a tireless worker who slept almost not at all and whose life resembled the determined and unequivocal shapes of his famous posters—absolute work, absolute revelry, absolute concentration.

Few painters have ever possessed Lautrec's gifts of observation. He knew the drama of a gesture and a glance, and in his work, the worlds he frequented become larger than life-size, voluminous in proportion. He could be caustic in his reportage, and absolutely uncompromising. Yet all his work is enriched by an understanding that goes far beyond ridicule. At Aristide Bruant's Le Chat Noir or at the Moulin Rouge he drew incessantly and gathered material for countless paintings. La Goulue (The Glutton) was the stage name of the Moulin's star dancer and singer. Lautrec drew and painted her many times, etched against the white lights of the cabaret, now with her sister, who worked there in less public performances, then with Valentin le Désossé (The Boneless), the craggy-chinned dancer.

In drawing, painting and lithography, Lautrec contributed a unique mastery of light and line as well as a poignant human panorama in the tradition of Goya and Daumier.

La Goulue at the Moulin Rouge

1891–1892
OIL ON CARDBOARD, 31⅝ x 23⅝ INCHES
MUSEUM OF MODERN ART, NEW YORK

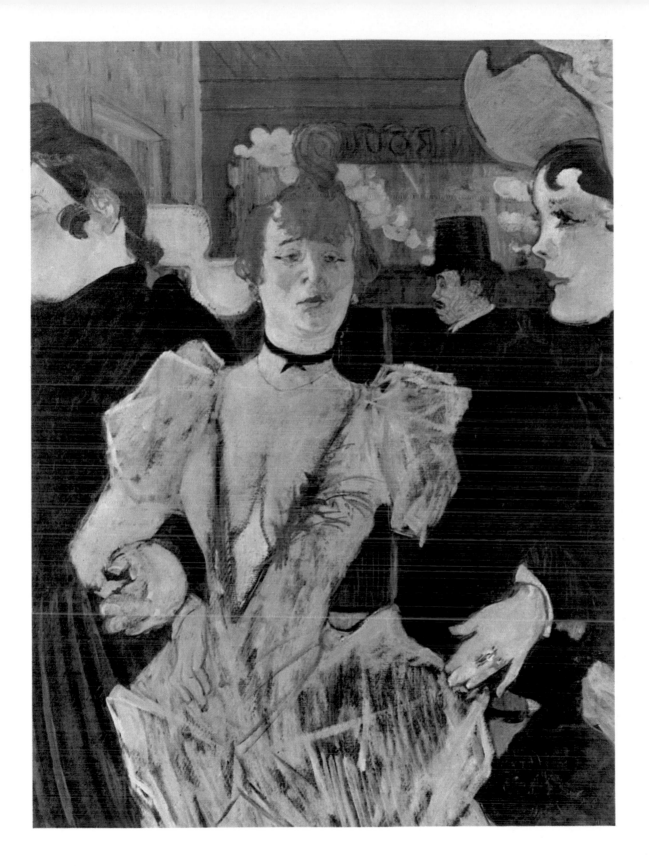

KANDINSKY

1866–1944

Vasili Kandinsky was a pioneer of modern painting whose daring experiments with color produced the first wholly non-objective art. A series of widely varying influences molded his work. He was a Russian, born in Moscow, and he possessed a Slavic warmth and turbulence. As an early admirer of modern French painting — he discovered Monet before the end of the nineteenth century — he was enormously influenced by the innovations of the flourishing school of Paris. As an expatriate in Germany, he adopted and amplified the methodical spirit of the Bauhaus, an influence that dominated his later work.

Improvisation 35 was painted after Kandinsky had settled in Germany and had already exhibited as a founder of the *Blaue Reiter* group, whose name (Blue Rider) was taken from one of Kandinsky's own titles. Yet it projects his Russian sensibility and his interest in French painting. Kandinsky was primarily interested in the psychological value of color. His written works on the subject treat it as a scientific process developed in the cause of emotional impact and expression. His intention in *Improvisation 35* was to organize color in harmonies directly analogous to the sensations produced in a work of music. References to external realities, he felt, would only detract from the pertinent spiritual experience. Piet Mondrian evolved a similar theory, which he expressed in the placid terms of a Dutch temperament just as Kandinsky constructed his own with a Russian ardor.

World War I drove him to Switzerland and then to Russia, where he became a prominent administrative figure for cultural affairs in the Bolshevik government. Subsequently he returned to Germany, became a professor at the Bauhaus in Weimar and encountered difficulty with the Nazis during the early thirties. This time he fled to Paris where he died in 1944. In the meantime, his painting had changed to a highly geometrical, less fluid and more frigidly applied idiom than his original efforts during the epoch of *Improvisation 35*.

Improvisation 35

1914
OIL ON CANVAS, 43½ x 47¼ INCHES
BASEL KUNSTMUSEUM, HANS ARP COLLECTION

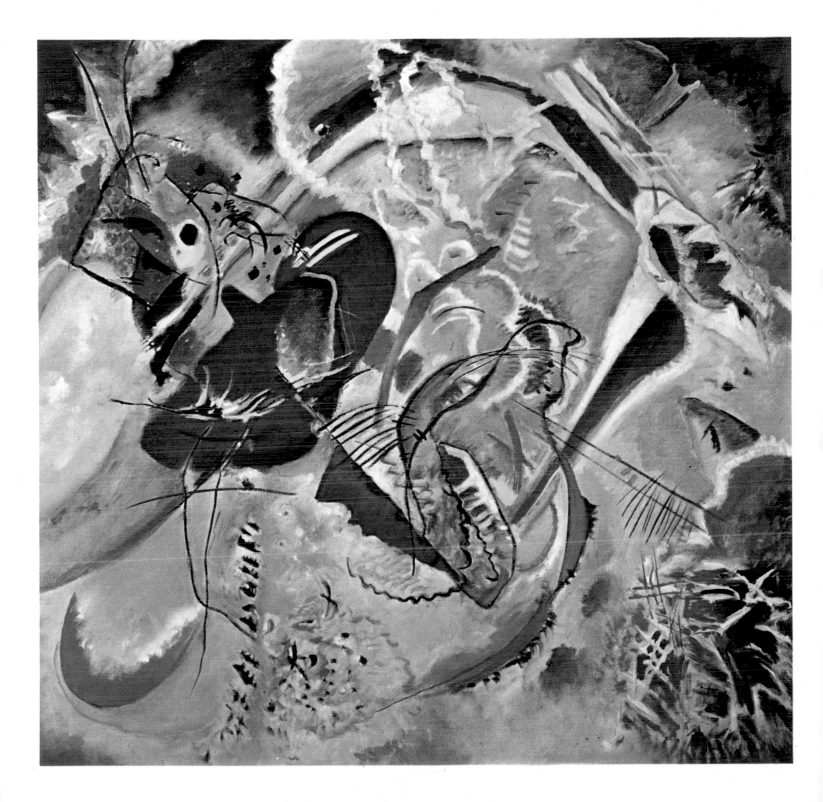

NOLDE

1867–1956

Emil Nolde was a leading figure in the school of German Expressionism that flourished before the rise of Nazism. He was the son of peasants in Nolde on the Danish frontier and grew up in an atmosphere of rustic piety that affected his life-work. As in *Christ among the Children*, he utilized an idiom of color and line that was calculated to explain a fundamental, primitive faith.

Nolde painted the first of his religious subjects, *The Last Supper*, after a grave illness in 1909. The period of recuperation led to a burst of productivity during which he painted a ninefold altarpiece depicting episodes from the life of Christ. Yet, Nolde's career was to be neither sheltered nor limited in scope, for he was a great and restless traveler. Before World War I, he visited the South Seas, where he was profoundly affected by the color and atmosphere of New Guinea and its surrounding islands. The experience confirmed and nurtured his impulse toward direct and primitive expression.

Nolde saw color as a highly symbolic force that might be harnessed with specific spiritual intent and as a vocabulary of emotional experience appropriate to his mystical inclinations. This concept of color pervades his landscapes as well as his religious themes, often bold and even raw in intensity, often turned to penetrating registers of lower key. Whereas Kandinsky (p. 174) deliberately sought to divorce color from any external associations, and whereas his French contemporaries sought to integrate color with external forms, Nolde directed his use of color toward a conceptual goal independently conceived.

Like all the truly creative spirits in Germany during the thirties, Nolde was condemned by the Nazi regime. Over one thousand of his works were confiscated and he was forbidden to paint. Yet he lived through the war in Germany and remained there until his death.

Christ among the Children

1910
OIL ON CANVAS, 34¼ x 41⅞ INCHES
MUSEUM OF MODERN ART, NEW YORK

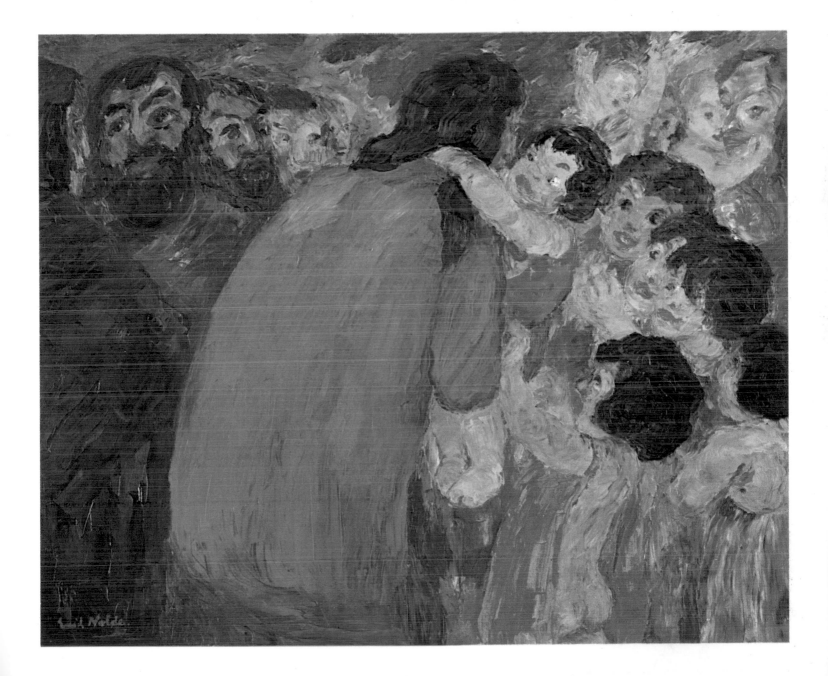

MATISSE

1869–1954

Henri Matisse found the spirit of his own work reflected in a famous line by the poet Charles Baudelaire, a line that describes an inaccessible paradise: *"Là, tout n'est qu'ordre et beauté, /Luxe, calme et volupté."* ("There, all is but order and beauty, /Luxurious, calm and voluptuous.") These words sum up the motivation and accomplishment of Matisse as a painter. He loved nature, its harmony, its simplicity and its richness. And to these qualities he brought a lifetime of intellectual strength and poetic imagination.

Matisse is best known as a revolutionist in color. What is less generally realized is that he founded his work upon a commanding concern for drawing and structure. He advised young painters to tackle color only after years of preparation. And of his own work he asserted that "I have always tried to hide my own efforts, and wished my works to have the lightness of a springtime which never lets anyone suspect the labors it has cost." His apprenticeship under the academician Bouguereau and the romanticist Gustave Moreau was long and devoted. But when he felt strong enough to give vent to his expansive personality, the results were startling. By 1905 Matisse became acknowledged as leader of the Fauves—a group of painters who experimented with the use of brilliant, often unmixed, colors. The name, meaning "wild beasts," was the contribution of an appalled critic. Later, Matisse's Fauvist colleagues Braque, Derain and Vlaminck all turned to less vivid palettes. It was Matisse who remained preoccupied with brilliant, sonorous and abundant color, which he subjected to a long and happy series of encounters with visual inquiry.

Odalisque is one of a number of Matisse's orientally inspired works. As a thoroughly Mediterranean spirit, he utilized color that harks back to the work of Delacroix. In this case, the subject is also kin to the romantic traditions of the nineteenth century. But the work is not romantic. Its vision is modern and simple. Its expansiveness bears out Picasso's tribute to Matisse: "That man has a sun in his belly."

Odalisque

1928
OIL ON CANVAS, 23⅝ x 28¾ INCHES
MUSÉE D'ART MODERNE, PARIS

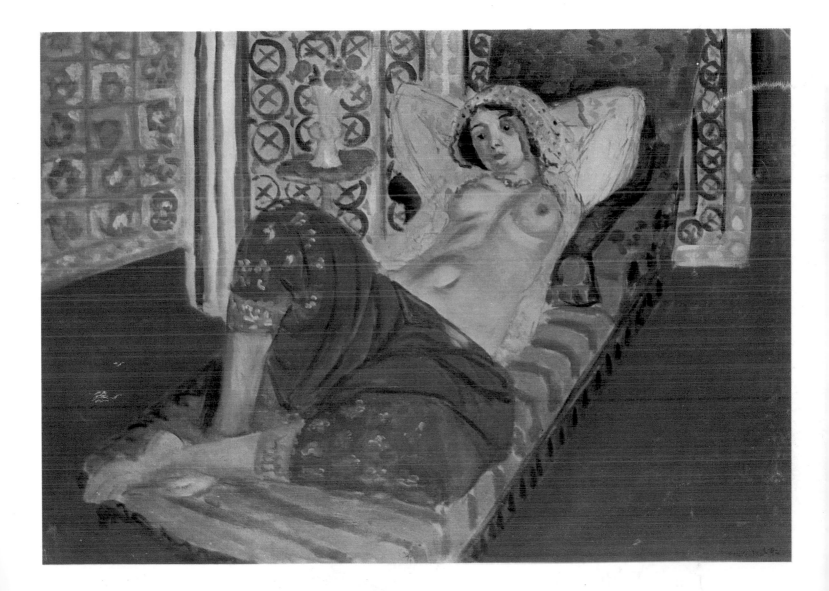

ROUAULT

1871 – 1958

To Georges Rouault, painting was less an opportunity for personal expression than an experience, a sacrament, a field of devotion and inquiry. Like the poetry of Baudelaire, which he greatly admired, Rouault's work recognized the spiritual extremities of heaven and hell and eulogized or lamented the life of man as a fleshly reflection of each. He was a friend of both the Catholic writer Léon Bloy and the sensualist J. K. Huysmans. The views of each seemed relevant, a duality preserved in Rouault's paintings of the Christ passion, of clowns, judges and prostitutes.

Though his art became deeper and more resonant during his career, Rouault's basic vision changed little. The early water colors of the circus, the courts and the brothels later yielded to a more consistent emphasis on religious themes. His color brightened, his pigment became heavier. He subscribed completely to Paul Valéry's thesis that a work of art is never finished, only abandoned, and no canvas reflects this conception with more poignancy than *The Old King.* It was painted over a period of twenty-two years, from 1916 to 1938. Its rich areas of effulgent color combine a formal and even medieval dignity with a bouquet of light that is Rouault's most personal and perhaps most remarkable achievement.

He was born in the shelter of a Paris cellar while the gunfire of the Commune signaled the end of the disastrous Franco-Prussian War. Upon hearing the news, Rouault's grandfather said categorically, "Let's hope he grows up to be a painter." And destiny co-operated. For the young Rouault left a Protestant school where he had been placed by his ardently anti-Catholic father and took a job as a glazier. Fortuitously, he was put to work doing restorations on the great stained-glass windows of Notre Dame de Chartres, medieval masterpieces which later served him as a major influence—plastically, spiritually, and as an ideal of artistic dedication that supersedes personal invention. In 1892, he began studying with Gustave Moreau —along with Matisse—and Moreau's opulent tastes may have further intensified Rouault's strong tendencies to a richness of color and light. To that richness he brought a visual and conceptual lucidity that produced one of the great landmarks of twentieth-century painting.

The Old King

1916 – 1938
OIL ON CANVAS, 30¼ x 21¼ INCHES
MUSEUM OF ART, CARNEGIE INSTITUTE, PITTSBURGH

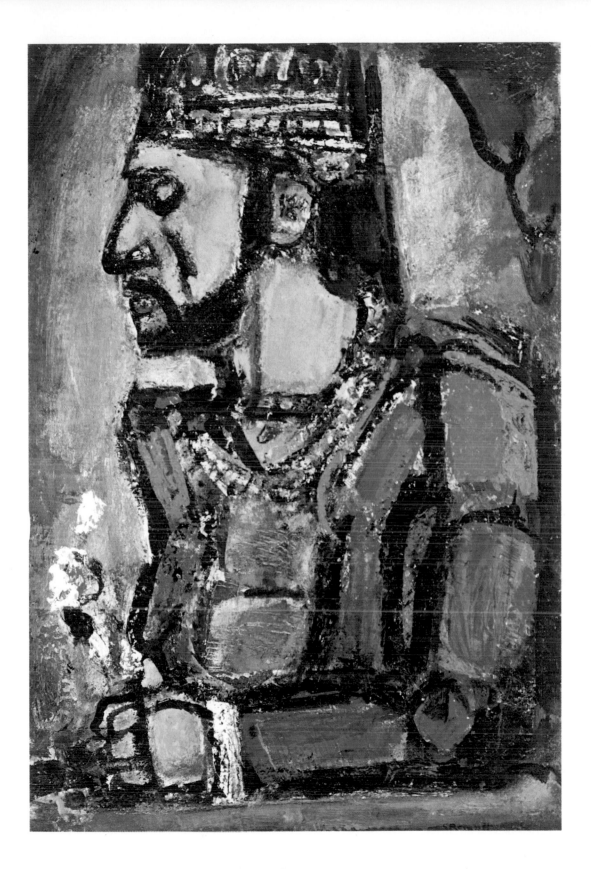

MONDRIAN
1872 – 1944

Piet Mondrian was a lyric poet, an uncompromising purist and one of the most important innovators of modern painting. His was a typically Dutch temperament and his work takes its place in the lineage of Vermeer. But at the same time his vision was naturally tuned to the dynamics of modern art, and capable of influencing French and German painting alike through an innate kinship.

Mondrian's work passed through a complete and logical metamorphosis that is rarely appreciated, since his early works are so seldom seen. He progressed from a phase of high realism to successive stages of abstract exploration. It was in Paris, about 1911, that he began his series of *Trees* in which his vision as an abstractionist began to mature. These paintings, accompanied by numerous drawings, distill a wealth of spatial dignity and linear simplicity from their theme. In them, Mondrian's brushwork and line are still nervous and spontaneous. Later, he addressed himself to increasingly pristine experiments in color and space. And he explained his ideas and intentions in detail in articles he wrote for the art review, *De Stijl*, of which he was co-founder.

"We need a new aesthetic based on pure relationships of lines and pure colors," he wrote, "because only the pure relationships of pure constructive elements can achieve a pure beauty. Today, pure beauty is not only a necessity for us, it is the only means to a pure manifestation of the universal force that is in everything. It is identical with what was known in the past under the name of divinity." He referred to his method as "Neo-Plasticism," a process of "denaturalization." "To denaturalize," he said, "is to deepen."

Thus, he consciously eliminated not only curved lines but even evidences of brushwork as vestiges of the natural. And his method applied to color as well. He eliminated green as nature's color, though he continued to use blue.

Broadway Boogie Woogie, painted in New York a year before his death, is one of Mondrian's most important and most spirited canvases, showing the familiar Mondrian dignity heightened to a pulsating key. Even the coldest and most calculated of the late Mondrians somehow preserve a warmth and sympathy that can only be called human, more so, paradoxically, than the less puristic experiments of Delaunay or of the late Kandinsky.

Broadway Boogie Woogie

1942 – 1943
OIL ON CANVAS, 50 X 50 INCHES
MUSEUM OF MODERN ART, NEW YORK

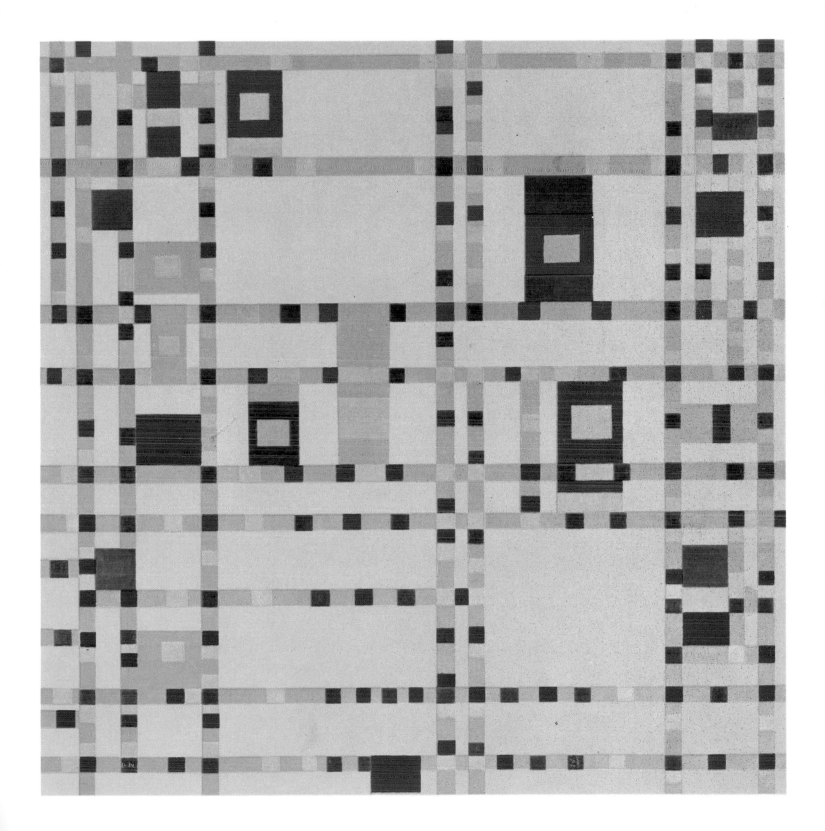

KLEE

1879–1940

Paul Klee's unique blend of innocence and sophistication produced a complex poetic art. Though for several years he worked exclusively in black and white, he eventually became one of the most original colorists of modern times. He was an intellectual who interjected a great body of symbolism into his work, and yet as a true poet he was able to create vivid metaphors that express themselves brilliantly without demanding any recourse to philosophical analysis. Thus, the faultless harmonies of *Around the Fish* create an aura and a sense of fantasy through so simple a theme. One can ponder the intent of the human flower, the arrow, the fish itself, or one can accept the tableau as a poetic harmony composed of symbolic mysteries. "Art," said Klee, "does not reproduce what we see. It makes us see."

He was born in Bern. His mother was Swiss, his father was of Bavarian origin. Before World War I, he exhibited as a leader of the famous *Blaue Reiter* (Blue Rider) group, the others being August Macke, Franz Marc (p. 186), and Vasili Kandinsky (p. 174). Before World War II, he taught at the Bauhaus, then the center of creative innovation in Germany, and later as a professor at the Fine Arts Academy in Düsseldorf. Yet, his sense of color was far closer to the school of Paris than to any of his northern European contemporaries, save perhaps Mondrian. In 1933, the Nazis broke into his Düsseldorf studio, ousted him from his post at the academy and hung nine of his works in an exhibition of "degenerate art." Fortunately, he was able to flee to Switzerland with his paintings and his writings.

Klee was one of the first modern painters to cultivate a childlike quality in many works as an instinctive recognition of preconscious associations. The Surrealists took up the same idea, yet in a more premeditated and calculated spirit. Klee's paintings, on the other hand, conjure up a heraldry of the inner eye, a private balance of the inner ear, a flourishing garden of the mind and heart.

Around the Fish

1926, OIL ON CANVAS, 19 x 25¾ INCHES
MUSEUM OF MODERN ART, NEW YORK
ABBY ALDRICH ROCKEFELLER FUND

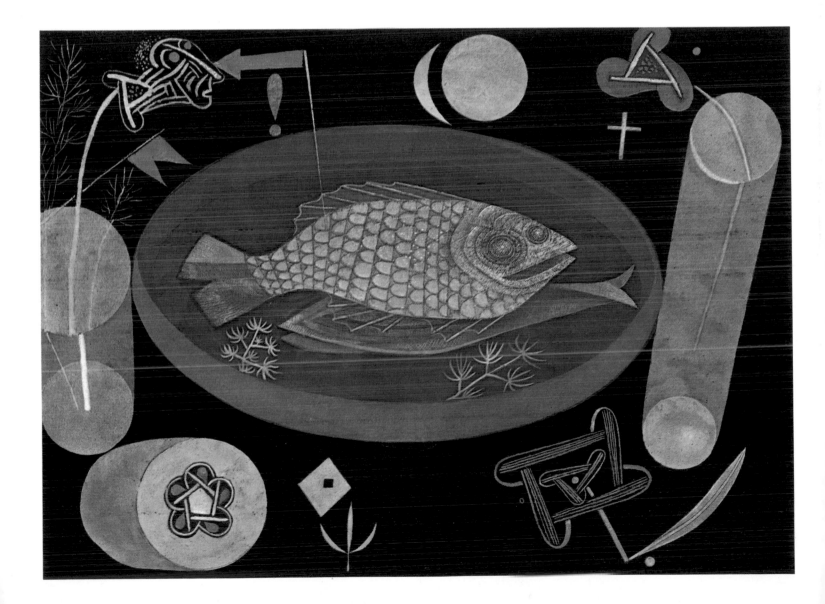

MARC

1880 – 1916

Franz Marc was a painter of methodical temperament who applied a series of varying discoveries and experiments to his work until his premature death, at thirty-six, in the First World War. Before turning to art, he had been a student of theology and philosophy—in Marc's case the classic pattern was reversed: his father, a painter, urged him to paint, and yet it took a circuitous route of inquiry to lead Marc to the Munich Art Academy in 1900.

He made two visits to Paris, each of which had a determining effect upon his work. In 1903, he had his first encounter with Impressionist art and also came to admire the direct and deliberately "primitive" vision of *Le Douanier* Rousseau. In 1907, after his exposure to the avant-garde *Jugendstil* in Munich, he returned to Paris and discovered the milieu in which he was to make his career. He discovered Van Gogh, whose color influenced him enormously. He became a close friend of August Macke and an associate of Kandinsky. With the latter two, Marc formed the famous *Blaue Reiter* group. And during the same period he came under the influence of Robert Delaunay's methodical experiments with color and abstract shape.

Blue Horses is a major work in a large series. Marc painted animals in order to disassociate himself from emotional connections with the human figure and so pursue an inquiry into color with greater detachment. Successive "horizons" of hot color succeed one another, the horses' backs and the rolling terrain repeated in a counterpoint of undulating line. In the course of his brief development, Marc's observations became increasingly abstract. In 1916, his body was found on the battlefield of Verdun, a sketchbook of non-objective drawings by his side.

Blue Horses

1911
OIL ON CANVAS, 41¼ x 71½ INCHES
WALKER ART CENTER, MINNEAPOLIS

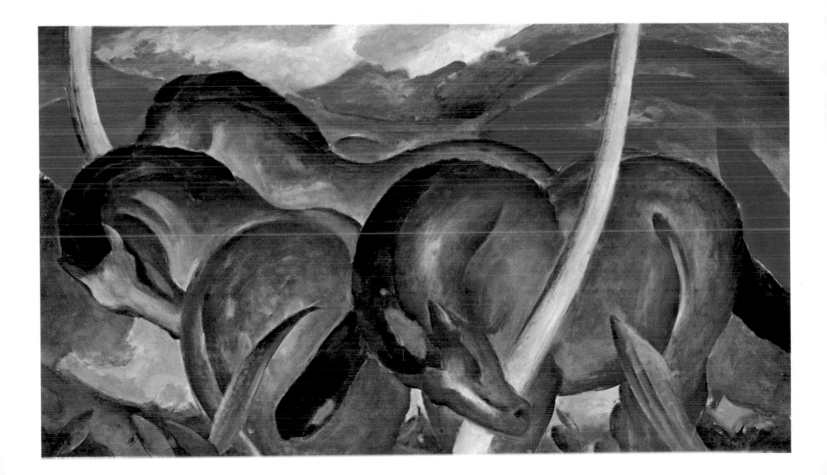

PICASSO

1881 –

Throughout the entire history of art, no painter has ever mastered so broad a range of expression or produced so diversified a set of aesthetic innovations as Pablo Picasso. At various moments in his career his painting has reached back to the Classical past, embodied primitive rhythms, encompassed and generated an anthology of modern forms, embraced the indigenous spirits of Spain and France, brushed wings with Surrealism, explored numerous avenues of symbolic expression. In 1907, he painted his startling *Les Demoiselles d'Avignon,* in which a strong African "primitive" influence appeared along with the tendency to structural abstraction that led to high Cubism. Then, until about 1915, he, Braque and Juan Gris developed the Cubist movement—whose abstract purity was derived from Cézanne (p. 152)—and precipitated a major revolution in European art. Gris never veered from Cubism. Braque always remained close to it in spirit. But Picasso, as the greatest draftsman of modern times and the most dynamic visual dramatist since Goya, soared high and far.

The *Family of Acrobats* is an early work, the climax of a series of circus studies that immediately followed the Blue Period. Picasso painted it at the age of twenty-four, just five years after coming to Paris from Barcelona. The composition incorporates figures and themes dealt with earlier in 1905, either individually or on a less panoramic scale. Its atmosphere is one of deep nostalgia that approaches romanticism, but its structure and intent are strongly architectural. Throughout Picasso's career, his genius has drawn much from an ability to incorporate contradictions within a functioning whole, and in a power to maintain a dynamic but deliberately precarious equilibrium. The *Family of Acrobats* is an example of such daring, all the more impressive for coming at a comparatively early stage. It is unorthodox in composition, in its juxtaposition of circus figures and landscape, and in its synthesis of objective and subjective observations.

Because of an unparalleled mastery of technical skills, Picasso has been able to draw each of his statements into a relentless course of inquiry, each with contradictory impulses, developing each in harmonic and dissonant scales. Thus, the harlequin theme appears and reappears throughout his work, the subject of an entire theater of realities, illusions and plastic constructions.

Family of Acrobats

1905
OIL ON CANVAS, 83¾ x 90⅜ INCHES
NATIONAL GALLERY OF ART, WASHINGTON, D.C.

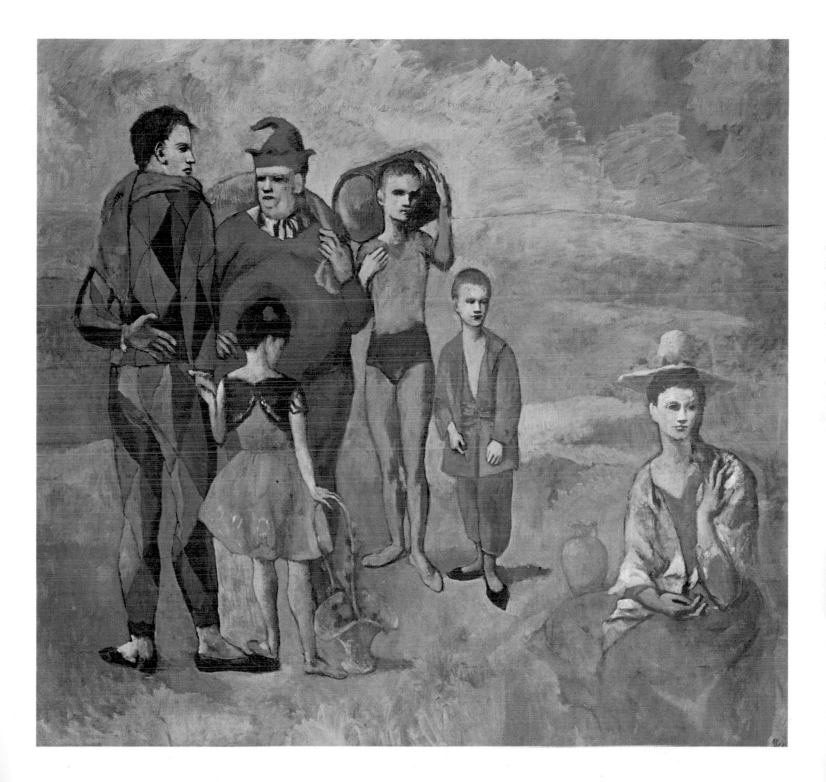

LÉGER

1881–1955

Fernand Léger was a man of the people who brought the industrial dynamics of contemporary times to modern French painting. About 1910, he met the leading innovators of an abstract vision—Picasso, Braque, Delaunay, Kupka—and found immediate kinship with the emerging vocabulary of Cubism. The very early Légers were highly abstract and formalized, juxtapositions of curved and straight lines. He applied a forthright palette of blue, white and red in diffuse, almost soft, areas. Later, while Léger's color became more concerted and defined, pure abstraction gave way to a rapport with subject matter—the modern city, its laborers, country athletes. There is a heroic aspect to Léger's conceptions. His is a heraldic poetry of the colloquial present.

Three Musicians is a major work in one of Léger's most descriptive periods. In a harmony of tubular, uncomplicated shapes, three café entertainers or *bal publique* musicians become epic figures, detached and monumental. He once said of the men who inspired such works: "I found them poets, inventors of everyday poetic images—I am thinking of their colorful and adaptable use of slang. Once I had got my teeth into that sort of reality, I never let go of objects again."

As in his *Three Musicians*, Léger often used the device of outlining his shapes in black, a controversial procedure which some critics condemn as an evasion of the problems of color but which was nevertheless entirely consistent with Léger's vision. He worked in major, never minor, keys, and the consistent force of his personality is undeniable. In painting, as in life, he was a robust figure who projected the unshakable health of the peasant world into which he was born.

Three Musicians

1944
OIL ON CANVAS, 68½ x 57¼ INCHES
MUSEUM OF MODERN ART, NEW YORK
MRS. SIMON GUGGENHEIM FUND

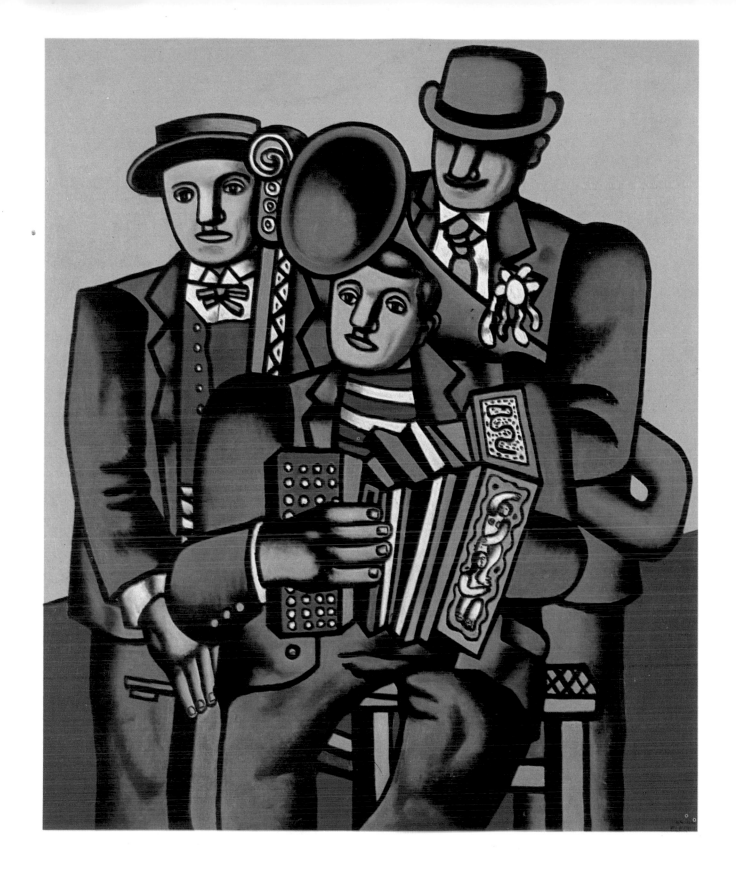

HOPPER

1882–

Edward Hopper found stern inspiration in some of the most temporal aspects of modern American life. He has painted not only the dour loneliness of austere architecture by the railroad tracks but also the cold atmosphere of highways, gasoline stations, interiors that seem devoid of air. A famous Hopper in the Whitney Museum of American Art, New York, depicts a movie usherette poised in languid boredom, awaiting the end of the spectacle. Hopper himself described his goal as "a pristine imaginative conception," and his spare poetry of the modern world is set down without any counterpoint of emotional response. He made three trips to Europe, none of which resulted in any visible rapport with or influence by European art. The style he established *circa* 1908 has remained a consistent idiom to this day.

Nighthawks, bathed in a chill, clear light, describes a stark anecdote of city life that might illustrate John O'Hara's *Hellbox* or F. Scott Fitzgerald's *May Day*. Hopper meets the barren terms of the subject head on, in no way garnishing or softening it, and the effect is unequivocal. Each element of the composition—the tired principals, the raw light of the diner, the bleak expanse of empty street—is handled in firm areas of solid color.

Nighthawks

1942, OIL ON CANVAS, 33⅛ x 60⅛ INCHES
COURTESY OF THE ART INSTITUTE OF CHICAGO
FRIENDS OF AMERICAN ART COLLECTION

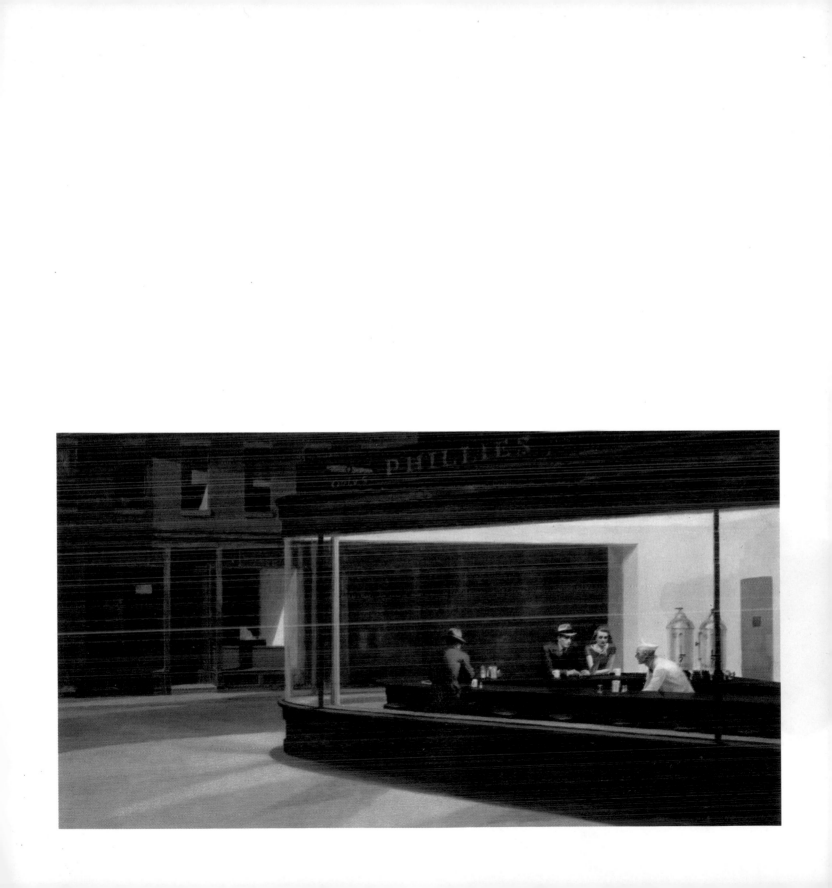

MODIGLIANI

1884 – 1920

Among the great figures of French painting between the two world wars, Amedeo Modigliani was the only master to be denied a glimmer of success or recognition. His.death at the age of thirty-six came at a time when the painters of Montparnasse were persevering against a wall of skepticism and miscomprehension. Modigliani's genius—aristocratic, elegant and poetic—was appreciated only by a small coterie.

Redhead with a Pendant is one of his most vibrant portraits. Its color is far less natively Italian than his usual palette. The treatment of line and shape is typical, derived largely from the stylized dignity of Romanesque sculpture. His work reflects this aloof and pure aesthetic, but it also radiates an intimate poetry of wholly human proportions.

Modigliani dealt exclusively with the human figure, and in both portraits and nudes he used a terse vocabulary of forms. Limbs and features are almost always elongated. Eyes, often indicated rather than delineated, are reduced to simple elliptical shapes. The broad areas of the body and dress are treated with a flat, spacious simplicity. And yet, despite the repetition of familiar conventions, Modigliani was able to produce a formidable poetic range. His variations in color are always sonorous and explicit. His portraits are remarkably incisive. Many of his subjects, such as Jean Cocteau, have been photographed many times and are well known, and yet Modigliani's version, however stylized, is always sharply revealing. His nudes, while sculptural and austere, are at the same time brilliantly sensual. In all his work a great vivacity of brushwork helps to vary the surface and heighten its living presence.

Modigliani was born in a Jewish ghetto in Livorno. When he arrived in Paris in 1907, he may have already contracted tuberculosis, and the circumstances in which he was compelled to live only catalyzed the disease. He worked intensely and exchanged drawings for drinks in the cafés of Montparnasse. Despite commissions offered by his few admirers—who were usually far from affluent themselves—his financial means never improved. Food was scarce and the alcoholic provender of the cafés eventually overcame him. In Paris, he married the devoted Jeanne Hebuterne. When Modigliani died, his heartbroken wife took her own life.

Redhead with a Pendant

1917
OIL ON CANVAS, 36½ x 23½ INCHES
COLLECTION HENRI BELIEN, BRUSSELS

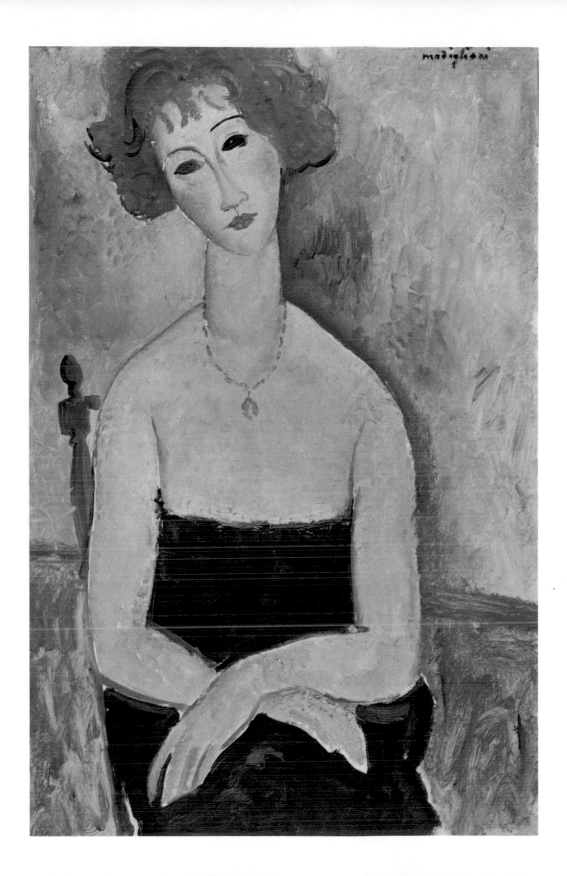

BECKMANN

1884–1950

The most important work of Max Beckmann can be divided in two parts—the huge allegorical triptychs inspired by the horrors of war, and a large series of intense and introspective self-portraits. World War I had a traumatic effect upon Beckmann. His view of humanity was scarred by the experience, and his complex compositions designed to suggest a modern mythology are peopled with the crippled and the flayed. His self-portraits exist as a logic in counterpoint, again sober and intense, but cast in simpler, purer and less literary terms.

He was born in Leipzig but worked in Berlin and Frankfurt until the German armies mobilized again for World War II. Hitler took a no more kindly view of Beckmann's work than he did of the painter's Bauhaus contemporaries. Beckmann fled to Amsterdam. After the war, he went to the United States, where he spent the last years of his life, working until the end. In New York, he painted the last of his important allegorical triptychs, *The Argonauts*.

As in the self-portrait shown here, Beckmann mixed his paints with a milk preparation to achieve a flat and dry quality of pigment. The method works against any touch of fluidity or sensuality. Instead, it reinforces the frontal assault Beckmann intended as an emotional and intellectual contact with the observer.

Self-Portrait

1944
OIL ON CANVAS, 37½ x 22¾ INCHES
BAYERISCHE STAATSGEMALDESAMMLUNGEN, MUNICH

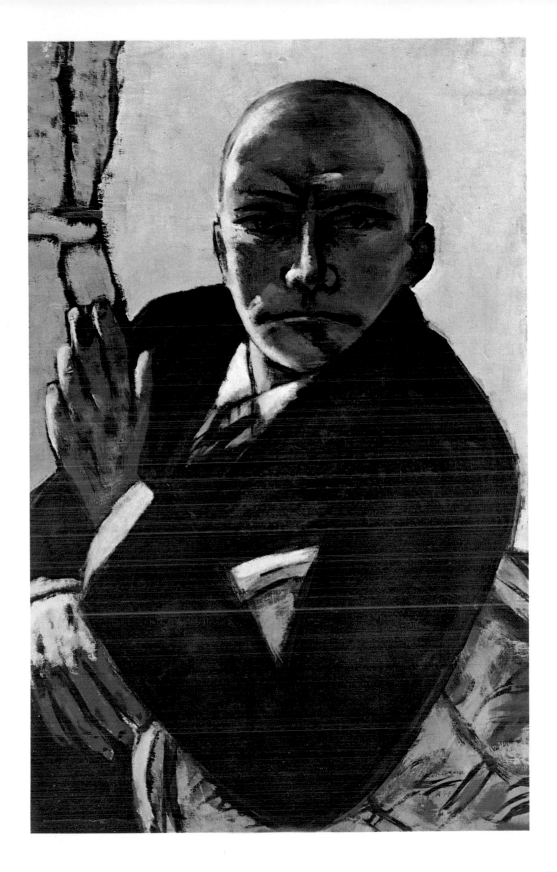

CHAGALL

1887–

Marc Chagall devotes his work to the cultivation of a dream. The Chagall fantasy goes back to his childhood in the Russian city of Vitebsk. It is told with a developed and highly Russian sense of theater, and draws a still more fundamental influence from the traditions and innovations of French painting. It meshes the heritage of both Old and New Testaments while registering the wholly sensual suggestions of nature. It balances a gentle, Slavic sadness with a sense of whimsey. It begins and ends in an innocence that only a very disciplined sophistication can preserve.

The Eiffel Tower clusters a bouquet of symbols used over and over by Chagall in repeated encounters with luxuriant color: the Eiffel Tower, a shimmering spray of flowers, a woman with a fan, an angel in flight, a roseate sunset coexisting with a brilliant sun, a plumed cock. These are symbols that need not be unraveled or interpreted. The impact of their warmth and brilliance is immediately felt. Here, the dream is not an enigma but a solution.

Chagall's early work, formulated before World War I amidst the world of Picasso, Apollinaire and Delaunay, was involved with the theories and examples of Cubism. By the 1930's, however, Chagall had broken all ties with Cubist influence. What remained was an innate, mystical exuberance and an intimate tie with the spirit of the school of Paris. Subsequently, his work changed little. Paris and Vitebsk, sacred devotions and physical loves, appeared and reappeared in counterpoint until the voice of Chagall became a familiar and harmonious note of sympathy in a complex world. He worked in oil, in gouache, in lithography and etching, illustrated the Bible, recalled fragrant nights in Vence on the Côte d'Azur, and enlarged upon his poetic vocabulary. During the 1960's, he fulfilled a number of special commissions that established his stature as a mystic-at-large to the modern world: a set of stained-glass windows for a synagogue in Jerusalem, another series of windows for the war-torn French Cathedral of Metz, and—in quite another mood—a decorative ceiling for the Paris Opéra, requested by the French Republic.

[200]

The Eiffel Tower

1929
OIL ON CANVAS
PRESENT LOCATION UNKNOWN

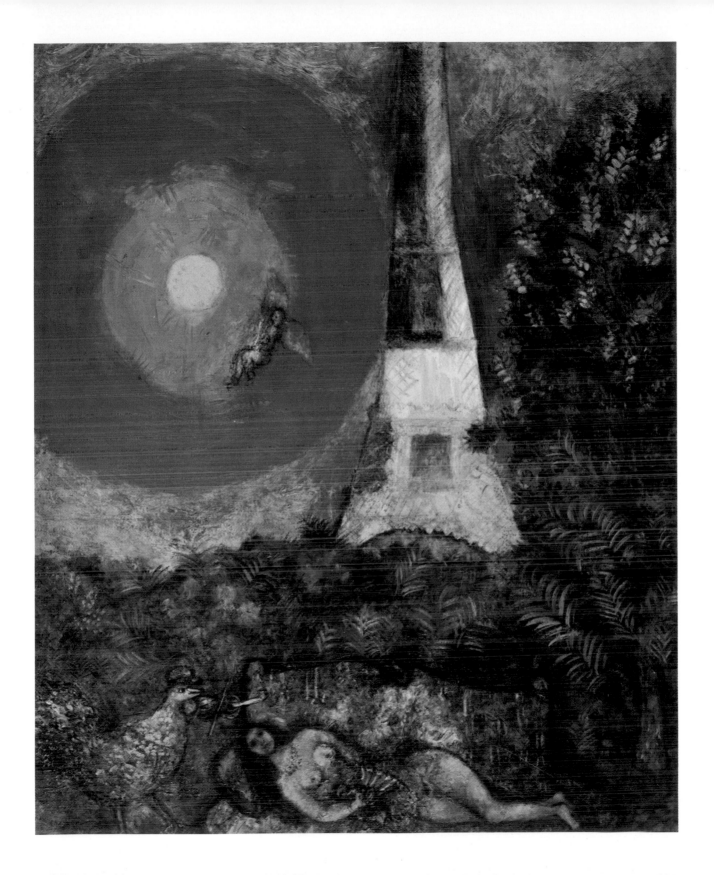

DALI

1904–

The men who espoused Surrealism during the 1920's and '30's held two basic precepts. First, that art ought to function as a magical force capable of transforming the viewer rather than simply as an object of admiration. Second, that the subconscious is the path to truth and that paranoiac distortions of the subconscious might be used to broaden that path.

Such is the origin and underlying program of Salvador Dali's *The Persistence of Memory*. The work is a metaphysical *mise-en-scène* in which symbols of time and space are deliberately confused, in which insects are introduced as suggestions of putrefaction and change amid a landscape of unreal, unfleshly surfaces.

During the late 1930's, Dali began introducing simulated Renaissance figures and techniques into his work, an eclectic process which André Breton, high priest of Surrealism, denounced as reactionary—whereupon Dali was formally and dogmatically dropped from the Surrealist ranks.

He continued synthesizing a strange mixture of academic technique and startling subject. The blend is frequent among Surrealist painters, but Dali carried it to deliberate extremes. He has always had a brilliant sense of theater and has carefully constructed an image of himself, with his immense, waxed mustache—the image of a wild and mystic genius claiming to remember his prenatal days.

The Persistence of Memory

1931
OIL ON CANVAS, 9½ x 13 INCHES
MUSEUM OF MODERN ART, NEW YORK

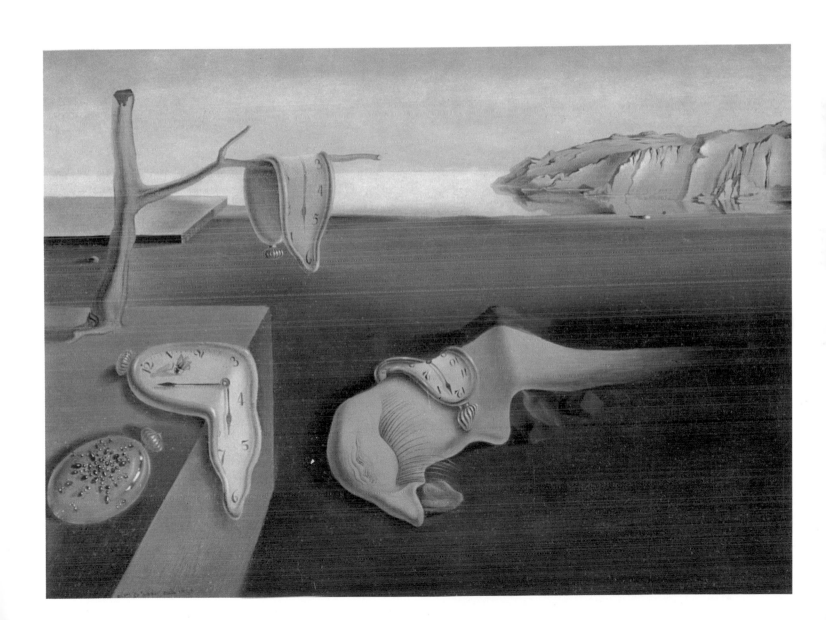

Broadway

1937, GOUACHE, 26 x 19¼ INCHES
ARTHUR H. HEARN FUND, 1942, THE METROPOLITAN MUSEUM OF ART, NEW YORK

TOBEY

1890–

Mark Tobey's *Broadway* is the work of a painter who traveled extensively and who brought to his painting a synthesis of Eastern and Western cultures. Born in Wisconsin, Tobey became a frequenter of New York, Chicago, Seattle and the landscapes of the Pacific Northwest. He worked in England and in Mexico, but it was the Far East that gave him his most important inspiration. In Shanghai, he worked with the painter Teng Kuei and came to love the spirit and technique of Chinese painting. He experimented with the calligraphic draftsmanship of the Chinese and found the Oriental concept of art as a vessel of rhythms beneath and beyond the ego a challenge and a goal.

Tobey painted a series of wholly non-objective works that follow this line of thought, and in a later *Broadway* series of the 1950's, he applied his new idiom to an external, contemporary subject. The pullulating lights of the giddy avenue shimmer up in a flat, abstract expanse of sensitive line which he describes as "white writing." Paradoxically, the attributes of Oriental art were soon to be ascribed to "Action Painting," which repudiated the devotion to intellectual control Tobey so admires.

DE KOONING

1904–

The work of Willem de Kooning constitutes a decisive step in American abstract painting. During the late 1940's, he participated in the Abstract Expressionist movement and worked, along with Jackson Pollock and Franz Kline, without reference to subject matter. But in 1950, De Kooning began his *Woman* series, in which he applied the emotional tenor of "Action Painting" to the human figure. He handled paint in bold, slashing attacks, and divided his canvas into conflicting, often dissonant areas of impetuous color. The subject is implicated in the maelstrom of plastic activity rather than explicated by it.

De Kooning was born in the Dutch port of Rotterdam and first came to the United States at the age of twenty-two. There he became a leading figure among the artists and writers who subsequently acquired the title, "School of New York." He still lives and works in New York.

Woman VIII

1961, OIL ON CANVAS, 28½ x 22 INCHES
FROM "ART: USA," THE JOHNSON COLLECTION

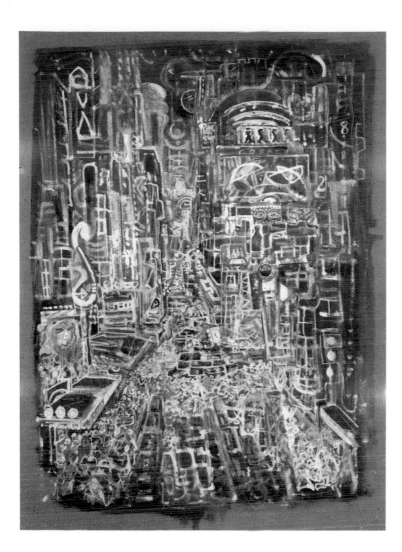

POLLOCK

1912–1956

Jackson Pollock was the guiding spirit of the Abstract Expressionist movement—later dubbed "Action Painting"—that became the dominant impulse in American art following World War II. After having gone through a series of experiments with abstract images, Pollock devised a method of painting in which external forms disappeared entirely and internal urges took over. He stopped using either brushes or palette knife and instead bombarded his canvas with paint, spattering and washing vast areas according to spontaneous whim until the result became a screen of turbulent color. The painting is intended not as a decorative surface but as a field of activity in which the viewer can be absorbed and overpowered.

During the Abstract Expressionist period, the movement went through successive stages of critical explication. In the late 1940's, the method was described as a clean break with all existing traditions of Western art, a "new art" to which all precedent was meaningless. Later it became general to equate Action Painting with the spontaneous internal rhythms that are the object of certain oriental thought, chiefly Zen Buddhism. The idea was conceived of as a negation of matter and circumstance in favor of internal harmonies. Yet, at no time were the precepts of Zen dealt with in their difficult entirety. Lastly, Abstract Expressionism came to be regarded as a natural extension of the traditions of modern painting, an addition or conclusion to the evolution of abstract art that began during the nineteenth century.

Unfortunately, Pollock never had a chance to extend his experiments. He was killed in an automobile crash on Long Island, New York, in 1956.

Number 27

1950
OIL ON CANVAS, 49 X 106 INCHES
WHITNEY MUSEUM OF AMERICAN ART, NEW YORK

Index

Titles of paintings are shown in italic type.